NEPAL

Art Treasures from the Himalayas

Ernst and Rose Leonore Waldschmidt
Translated by David Wilson

UNIVERSE BOOKS · NEW YORK CITY

Published in the United States of America in 1970
by Universe Books
381 Park Avenue South, New York City, 10016

© Verlag Aurel Bongers, Recklinghausen, 1967
This English translation © Elek Books Ltd., 1969

Originally published under the title
NEPAL: KUNST AUS DEM KÖNIGREICH IM HIMALAJA
by Verlag Aurel Bongers, Recklinghausen

Library of Congress Catalog Card Number: 72-96964
SBN 87663-104-9

*Illustrations printed in Germany,
text printed in Great Britain*

Preface

This book is based on a catalogue written by the authors for an exhibition of works of art from Nepal, held in February-April 1967 at Villa Hügel, Essen-Bredeney. The exhibition consisted exclusively of objects sent to Europe on loan from Nepal, coming from the collections of the museums at Katmandu, Lalitpur (Patan) and Bhaktapur (Bhatgaon); some archaeological finds were also made available by the Archaeological Department, Katmandu. The original descriptions had been written in a catalogue 'Nepalese Art', Calcutta 1966, by Ramesh J. Thapa, Director of the Department of Archaeology, Katmandu, and his colleagues, for an exhibition in Paris. In compiling the Essen catalogue the authors, though benefiting from the preceding book, worked independently of it, and were fortunate enough to enjoy the assistance and invaluable advice of Purna Harsha Bajracharya, Chief Research Officer, Katmandu, to whom they are much indebted.

For the most part, the introduction and descriptions written for the Essen catalogue have also been used in this volume, but the illustrations section has been improved by photographs of objects from the Museum for Indian Art, Staatliche Museen, Berlin, Stiftung Preussischer Kulturbesitz, while some of the less important illustrations in the catalogue have been left out. Those that are new are nos. 39, 42, 43, 45, 53, 56, 71, 73 and 75; our grateful thanks are due to Herr Direktor Professor Dr Herbert Härtel in Berlin for procuring these photographs and for his kind co-operation. Thanks are due also to Herr Professor Dr S. Lienhard, Stockholm, for his contribution to the description of Plate 71, through the translation of the Newari inscriptions.

Ernst Waldschmidt

Göttingen, October 1967

A NOTE ON THE ORTHOGRAPHY
AND PRONUNCIATION OF
INDIAN NAMES AND WORDS

A stroke above a vowel means that it is lengthened. In Sanskrit words, e and o are always long; ṛ is pronounced as ree. The sibilants ś (palatal) and ṣ (cacuminal) are rather like the English sh; the sound of the nasals ṅ (guttural), ñ (palatal), ṇ (cacuminal), ṃ (variable) depends on the nature of the consonants following.

Contents

Nepal

1. GEOGRAPHY

The kingdom of Nepal, which covers approximately 54,000 square miles and in 1965 had a population of almost 10 million, is remarkable as much for its scenery as for its religious and artistic achievements. The landscape, taking in a large part of the central Himalayas, is the loftiest on earth. On the border with Tibet stands the highest of all mountains, first conquered in 1953—Mount Everest (29,028 feet); elsewhere, along the border, and in the interior of Nepal itself, are other whitecapped giants of the 'High Himalayas', such as Kanchenjunga (28,168 feet), Annapurna (26,391 feet), and Dhaulagiri (26,797 feet).

The mountain range of the 'Land of Snow' (*himālaya*) stretches from west to east, and before it, in the south, lies a strip of level land, part cultivated and part jungle, called tarai, or 'wet land'; it is divided up between Nepal and India. In former times travellers reached Nepal through the North Indian towns of Sagauli and Raxaul, in the tarai region. Roads and mountain paths led more or less due north from the railway stations across two chains of mountains to the Nepalese capital of Katmandu. Until after the Second World War, however, Nepal cut herself off completely from Europeans and foreigners, and so only a few visitors ever had the privilege of entering the country, and access remained extremely difficult. In 1898, the mountaineer and explorer Dr Kurt Boeck was fortunate enough to be allowed to spend four weeks in the valley of Katmandu. In his book 'Through India to the Inaccessible Land of Nepal' (Leipzig 1903), he wrote a vivid report of his journey. The swampy fever-ridden primeval forest of the tarai presented a typical picture of rich, tropical vegetation. The Maharajah of Nepal was actually on his way there to hunt tigers at the time, and on the road to Katmandu, Boeck, crossing two mountain ridges with passes 6,500 and 8,500 feet high, found himself face to face with a long procession of officials, officers, and ladies-in-waiting. As was then the custom for travellers of rank, they sat in palanquins or on chairs, or were wrapped in woollen rugs tied to poles, and in this way were carried over mountains and valleys as they followed the Maharajah to the hunting-grounds. The view from the second of these passes, on the Candragiri, or 'Moon Mountain', was magnificent. There was revealed, Boeck writes, 'as if by magic, a picture of fairytale beauty, such as is not to be found anywhere else in the world . . . here . . . I had a view . . . from a distance, but thus all the wider, of the most magnificent mountains on earth—Gauri-Sankar, Kanchenjunga, and

Dhaulagiri, the noblest background imaginable, in front of which Great Nepal, the fertile valley of the Bagmati river with the capital Katmandu, lay at my feet. These dazzling white peaks on the horizon were beginning to glow in the last rays of the setting sun, and my eye was caught by the shimmering gold spires of temples down below, and there I saw countless towns and villages nestling in the midst of well cultivated fields.'

Since Nepal has been opened up and modernised, access has become much easier. It has been linked with India by means of a mountain road built by Indian military engineers, which is 75 miles long and, if at times still somewhat hair-raising, can take both lorries and cars. It goes from Thankot, west of Katmandu, to Amlekhganj, from where a Nepalese narrow-gauge railway runs to Raxaul. The main means of travel to Nepal nowadays is, however, the aeroplane, and from the nearest large Indian town (Patna) this journey takes less than an hour. Various places in the interior of Nepal have flight connections to the capital, and recently the Chinese have built a motorway from Katmandu to the Tibetan frontier, from which there is already a road to Lhasa.

2. THE PEOPLE

While the people of the Nepalese tarai are similar in race, language and clothing to their Indian counterparts, the main, mountainous part of Nepal is inhabited predominantly by people of mixed Mongolian origin; among these are the Sherpas, who live in small settlements some 10,000 feet up, and have attained fame as the steadfast companions of many Himalayan expeditions.

The extreme heights are obviously of very little use to man, so that the majority of the people live down in the valleys. One of the most enchanting of these is the wide valley of Pokhra, 100 miles west of Katmandu and a good 3,600 feet above sea-level. Clear mountain lakes lie embedded in green fields, surrounded by beautiful hills from which can be seen the peaks of such giants as Annapurna and Dhaulagiri not far away (Fig. I). With its healthy climate and its magnificent scenery, this plateau can be said to rival the politically troubled Kashmir valley in the western Himalayas. Narrower, but of greater historical importance and more densely populated than the plateau of Pokhra, is the valley that was formed long ago by a lake in the lower Himalayas and contains the present capital, Katmandu (Sanskrit: Kāṣṭhamaṇḍapa). This fertile plain extends over some 20 miles at a height of 4,430 feet, and is surrounded by mountains some 10,000 feet high. This part of Nepal contains on an average over 1,500 people per square mile, and is one of the most densely populated regions in the world. In the markets, alongside the colourful variety of wares, and fruit and vegetables (such as oranges, cauliflower, tomatoes, radishes, and leeks), one finds an equally colourful variety of races. Mingling with many different types of Mongolian people, there are men of Indian or mixed Indian blood and pure Tibetans. The lively mountain people who come flocking to the markets, often carrying heavy loads, are cheerful and good-humoured.

10

Historically the most important tribes are the Newars (from them is derived the name Nepal), who live in the Katmandu valley and speak a Tibeto-Birman language, and the war-like Gurkhas who are now in power, and whose Indo-Aryan idiom, Nepali, is the official language.

The annals of the Chinese T'ang dynasty contain several references to the people of Nepal around the middle of the 7th century AD, and these are certainly of interest, even if there is a tendency to generalise from individual observations. They report that it was then the custom for people to pierce their ears and place pieces of bamboo or horn in them (see Fig. XVI), as extended ear-lobes were considered a sign of beauty. The people did not eat with spoons or chopsticks, but only with their fingers. All utensils were made of copper. The country was huge and mountainous, and there were very few farmers but (presumably in the valleys) a relatively large number of merchants, both resident and itinerant. The noses of bulls were not pierced. For dress, people used a single cloth, which they wound all round the body. They bathed several times a day. The houses were made of wood, and the walls were decorated with carvings and painted over. Theatrical performances were very popular, and at these trumpets were blown and drums beaten. The literate were good at fortune-telling, interpreting natural phenomena, and making calendars. The people worshipped five deities and made stone idols which they washed every day with holy water. The King, whose Sanskrit name was Narendradeva, had jewellery of real pearl, rock-crystal, nacre and coral, and in his ears he wore golden rings with jade pendants. His waistband was adorned with a figure of the Buddha. At receptions, he would be seated on a throne with lion's legs in a hall that was sweet-scented and strewn with flowers. Noblemen, officials and courtiers would squat in front of him to the left and right, and the sides of the hall were lined with hundreds of armed soldiers.

3. THE HOME AND BIRTHPLACE OF THE BUDDHA

In the Nepal tarai, a little to the west of the road we have already mentioned, there took place, in the 6th century BC, an event of exceptional historical importance. A prince of the Śākya clan renounced all worldly possessions, left his father's palace, and began the life of a wandering ascetic. He was named the Buddha, the 'Enlightened One', and became the founder of one of the world's principal religions. In his home, at the foot of the most southerly range of the Lower Himalayas, he had spent a carefree youth, until he became conscious of the inevitable fate of man—sickness, old age, and death. Then he began his search for a way out of the sufferings of existence.

The archaeological finds illustrated in Plates 1–8 were all made in the ancient tribal home of the Buddha. Tiraulakot, the place from which the terracotta figures 2–7 originate (they were excavated in 1962/63) is believed to be the ruined site of the former capital of the Śākyas, Kapilavastu, where the father of the Buddha lived. The region would seem to have been destroyed by

war some two thousand years ago, and left to decay. The Chinese pilgrims Fa-hsien (403 AD) and Hsüan-tsang (636 AD) both visited the area, and recorded that Kapilavastu lay in ruins and the land around was waste and scarcely inhabited. Hsüan-tsang estimated that the palace grounds in the ancient city covered some four to five square miles, and he was still able to recognise clearly the foundations of some of the buildings. He mentions that there were the ruins of up to a thousand former monasteries and in many places he saw the remains of shrines or relic-mounds (Stūpas) connected with events in the life of the Buddha.

A journey which I undertook in 1958 to Tiraulakot (= Kapilavastu) led over a difficult route through Taulihawā, the local seat of government, and thence on foot across cultivated fields to a broad expanse of seemingly impassable jungle. If one looked down, it was easy to understand why no ploughs had attempted to break the soil there. Everywhere, fragments of brick were sticking out of the earth or glinting amongst the bushes and brambles. And yet nothing worth mentioning had been preserved above the ground, and the city wall and moat were barely recognisable. All round was an overgrown expanse of ruins, which simply cried out to be cleared and excavated (this work was in fact begun in 1962/63). In the midst of the green wilderness lay a pool, covered with marsh plants, and at one spot where the jungle was not so thick, a boy was watching over his cows. We learned that the royal palace had once stood here. In the shadow of a stately tree lay a small building of red brick, ancient and gloomy, dirty and dilapidated. In 636, the Chinese pilgrim Hsüan-tsang had found a chapel there with a statue of King Śuddhodana, the father of the Buddha. 1,322 years later, not a trace of it could be found.

The ornamental clay bricks in Plate 8 were also excavated in 1962/63 in the district of Taulihawā. They come from Kudān. When I was there in 1958, I was struck by the sight of two brickwork mounds facing each other, which were known to the people as Lori-ki-Kudān and were obviously ancient religious monuments. Villagers told of a nearby pool which they said had been formed by the fountain that had spouted forth when the Buddha had won an archery contest for Śākya youth, and his arrow had gone through the target and bored deep into the earth.

Of especial note in former times for Chinese visitors to the home of the Buddha were some detached stone columns that had been erected by the mightiest ruler of Indian Antiquity, King Aśoka (c. 272–236 BC). Remains of these were still to be found in the 19th century. The most important find was made in 1896 by the archaeologist Dr Führer, near Rummindei in the tarai; this consisted of a column without a capital, its shaft buried deep in the ground, and with a wide crack at the top. When it was excavated, it showed an inscription of great historical value which was in an excellent state of preservation, thanks to the earth that had covered it (Fig. II). It states that His Majesty King Priyadarśin (= Aśoka), 20 years after he had been anointed king (i.e. in the middle of the 3rd century BC), had passed this way in order to worship, for 'here the Buddha Śākyamuni was born' (hida budhe jāte śākyamunīti). He had

12

erected the column because 'here the Exalted One was born' (*hida bhagavaṃ jāte ti*). Thus the inscription refers twice to the fact that the column was erected on the spot where the Buddha was born. In Hsüan-tsang's time (7th century), the monument was already in a similar state of ruin to that of 1896, when it was re-discovered. It had probably been struck by lightning. The pilgrim wrote that it had been crowned with the figure of a horse. 'Later there came a wicked dragon which, with a crash, shattered the column, so that it broke down the middle and fell to the ground.' After the excavation, the shaft of the column was put together again and re-erected, but only a few fragmentary remains of the capital and the horse have come to light. The shaft with its highly polished surface which occurs in Indian art only in the 3rd century BC, thus provides clear evidence, through its inscription, of the exact place where the Buddha was born. Tradition names this place as the Lumbinī Grove, a few miles away from the capital, Kapilavastu; the Buddha's mother was travelling to the grove from there just before giving birth.

When the author first visited this Bethlehem of the Buddhists, in 1933, Nepal was—as has already been indicated—cut off from the outside world. The frontiers in the tarai were not, however, closely guarded. With the help of some Buddhists, I was able to go secretly on foot across what seemed an almost impassable area of borderland, and then to penetrate some six miles into Nepalese territory along narrow paths that led ultimately to the Lumbinī Grove, where the pilgrim was politely halted. I was, however, allowed time to visit this holy place, which was then isolated from the outer world. Near the column (Fig. IV) were a few abandoned excavations, the remains of archaeological explorations undertaken by a Nepalese General at the turn of the century. Behind, half overgrown and in the shadow of some old trees, lay a small shrine, crudely constructed from the debris of ruined buildings, but newly whitewashed and well kept. The entrance was a narrow doorway, and beyond this were some steps leading down to a vaulted cellar—a tiny windowless room, the darkness of which was relieved only by the faint light that penetrated through the entrance. Once one had grown accustomed to the atmosphere, the outlines of a sandstone relief emerged, depicting the birth of the Buddha, a work dating probably from the 2nd or 3rd century AD in the Mathurā style of Indian art (Fig. III). The surface had deteriorated, having been worn away or perhaps washed away by rain through the course of the centuries; nevertheless one could see from what remained that this was a work full of character. As in the birth scene depicted in Plate 13, Queen Māyā, mother of the Buddha, stands close to a tree and is reaching up into its branches. At this moment the child is issuing out of the right side of the mother, to be received by the God Indra, whilst the God Brahma and a serving-woman remain somewhat in the background. Below, in a subsidiary scene, one could see another picture of the child immediately after the birth, taking, amid prophetic utterances, the legendary seven paces. Peasants from the surrounding countryside had laid a humble gift of flowers in front of the image. Not far from the little shrine was a pool— probably that in which, according to Fa-hsien (early 5th century), the mother of

the Buddha had bathed shortly before the birth. Hsüang-tsang (7th century) also saw this pool, and commented on the clearness of the water and the flowers floating on its surface.

When I paid my second visit to the Buddha's birthplace, in 1958, a surprising transformation had taken place. Nepal had ended its isolation from the outside world, and for the celebration of the 2,500th anniversary of the Buddha's death, in 1956, a road had been built from the Indian tarai right to the memorial site in the Lumbinī Grove. Now, from the Indian railway station of Naugarh, one could take the bus, which covers the thirty miles or so to the Lumbinī Grove two or three times a day. On the border, there were the usual customs and police formalities, and on the way one went past several settlements. In Lumbinī itself, the Nepalese authorities were busy transforming a large area around the holy place into a centre for pilgrims. Already a tall obelisk had been put up in rather barren surroundings, with an inscription listing the achievements and institutions of the present king, Mahendra Bir Bikram Shah Deva, who succeeded to the throne in 1955. An accommodation centre was ready, and a modern temple in Nepalese style almost completed. The Aśoka column had been surrounded by an iron railing in order to protect it. The little shrine with the picture of the birth had been greatly enlarged by the addition of terraces all round, and extended flights of steps (Fig. V). The narrow room within had been given two approaches from the side, so that as one went past one could see the relief in better light, which was certainly an advantage, in view of the large number of pilgrims who wanted to see it. But the earlier intimacy and serenity of the shrine had been lost. The picture of the birth, already in poor condition, had suffered even more through having been daubed with red paint and stuck with gold-leaf—both expressions of reverence. And so next to the old and now scarcely recognisable relief, a modern replica in Birman marble and Birman style had been placed, as a kind of explanation. Compared with the atmosphere of the place before, the over-all effect had become rather prosaic although it is possible that it may improve again.

Plate 1 shows a terra-cotta head, which was found during the 1964/65 excavations not very far from the birthplace of the Buddha.

4. ANCIENT AND MEDIEVAL HISTORY

King Aśoka (3rd century BC), whose memorial column at the birthplace of the Buddha has already been described, is traditionally believed to have visited the plateau of Nepal. That he did travel in this direction is proved by three inscribed columns left in the Indian region south of Raxaul, in Rāmpurva, Nandangarh, and Ararāj. It is, however, difficult to justify the attribution to the great king of the five beautiful Stūpas, or relic-mounds, in Patan (Lalitapattana, Lalitpur), the oldest centre of political and cultural life in the Nepal valley. The design of these so-called Aśoka Stūpas is certainly rather ancient. A massive brick tumulus, hemispherical in form, bears a simple canopy construction, and

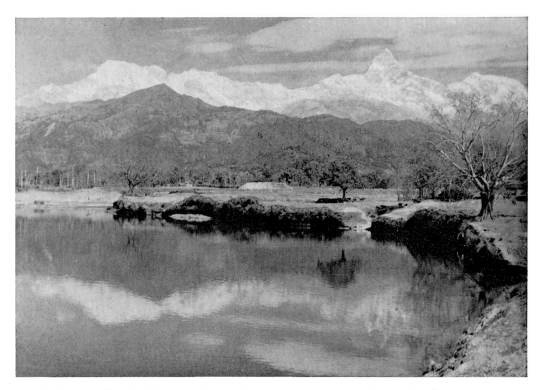

Fig. I Valley and lake of Pokhra. In background, range of 'High Himalayas' with pointed peak of Machapuchre ('Fishtail', over 22,000 feet).

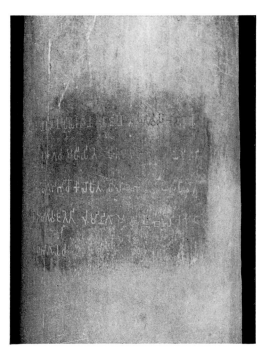

Fig. II Inscription in column of King Aśoka (*c.* 250 BC) in Lumbinī Grove, birthplace of the Buddha (photograph taken 1933).

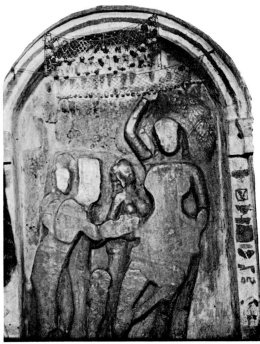

Fig. III Depiction of Buddha's birth in chapel at Buddha's birthplace (photograph taken 1933), cf. Plate 13.

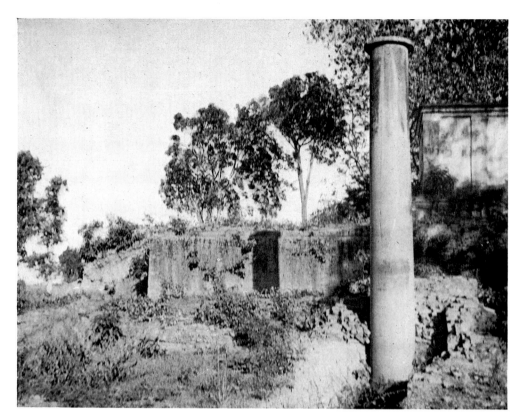

Fig. IV Aśoka column and chapel at Buddha's birthplace (photograph taken 1933).

Fig. V Chapel at Buddha's birthplace (photograph taken 1958).

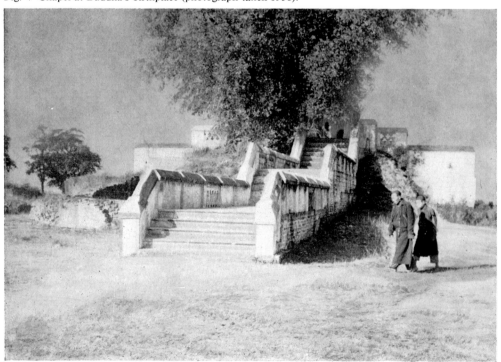

is otherwise virtually without decor. One of these Stūpas stands in the middle of the town, and the others are at each cardinal point, in the north, south, east, and west. The belief that these constructions date back to the time of Aśoka seems, however, rather far-fetched. The traditional claim that a daughter of Aśoka, Cārumatī, founded the monastery that is still in existence at Chabahil, near Deo Pattan, not far from the Temple of Paśupatināth, is probably equally unlikely. In any case, the authenticated history of the valley only begins at 400 AD, and is divided into four periods, called after the ruling houses. These are:

(a) The Licchavis and their successors (c. 400–750 AD)
(b) The Thākuris and the early Mallas (c. 750–1480)
(c) The Mallas of the three kingdoms (1480–1768)
(d) The Gurkhas (from 1768 onwards).

The names of Licchavi and Malla are well-known from Buddhist literature and Indian history. The Licchavis of Vaiśālī, a town north of the Ganges not far from Patna, and the Mallas of Kuśinagara and Pāpā (Pāvā), neighbours of the Śākyas of Kapilavastu, were contemporaries of the Buddha. The Licchavis reappear many centuries later in Indian inscriptions and on coins. The initiator of one of the finest periods of Indian culture and the founder of the Gupta dynasty, Candragupta I (accession in 320 AD), was married to a Licchavi princess named Kumāradevī. The representation of this couple on gold coins would seem to suggest that by his marriage, the Gupta was able to extend his dominion far to the north. In an inscription by his successor Samudragupta, Nepal is also named as one of the tributary border states under Gupta rule. Thus it is very probable that the Guptas were linked to the Licchavis in Nepal. No such links have yet been established, however, as having existed between the Mallas of early Buddhist times and the Mallas in Nepal. But the closeness of connections with classical India is shown not only by the proud and ancient Indian names of the kings and their families, but also by inscriptions in stone which in the period from c. 400–750 AD were composed by Nepalese kings in Sanskrit, and written in lettering that is almost identical to Indian lettering of the time of the Gupta dynasty.

In the 7th century, Nepal came under the political influence of Tibet, whose king, Srong-btsan sgam-po, ruled from c. 620–649 AD, and in that time laid the foundations for a great Tibetan empire which, in the golden age of the following two centuries, included large sections of Central Asia and China, as well as the north-eastern regions of India. Nepal must have recognised the sovereignty of Tibet early on. The then king, Aṃśuvarman, a Thākuri and former minister who appears to have come to power through his marriage to a daughter of his Licchavi ruler, sent his daughter—evidently as a sign of his submission—to Lhasa, to the culturally still very backward, isolated Kingdom of Bod, where she was to become the bride of the King of Tibet. In 641 the Nepalese princess was joined by a Chinese princess who became the King's second wife. Her hand had at first been refused to a Tibetan delegation by the Emperor of China, but after Tibetan armies had marched on West China, he changed his mind. Both

women were devout Buddhists, and took religious statues with them to Tibet, where shrines were erected to house the sculptures. Through their superior culture, the ladies aroused the interest of the king and many others in their belief, hitherto unknown in Tibet, and in their customs, although in Srong-btsan sgam-po's time, the dominant religion in Tibet remained a primitive Animism and Shamanism known as Bon. Speaking of the Nepalese king Aṃśu-varman, our oft-quoted Chinese pilgrim Hsüan-tsang, in his description of conditions in Nepal in 637 AD, reports that the late king had distinguished himself through his knowledge, wisdom, and virtue; he had earned a wide reputation as the author of a text-book on phonetics and grammar. His succes-sor, from the Licchavi family, is also described as clever, upright, and a sincere Buddhist. The account of the people, however, is not so favourable. Evidently the pilgrim had been confronted by coarse mountain folk. Having described the country as cold and full of mountains and valleys, though at the same time favourable for the cultivation of corn and rich with flowers and fruits, he goes on to call the people ugly, coarse, deceitful, and by nature unsociable and ignorant. A sense of time or of justice, he says, was unknown to them; however, there were not a few skilful craftsmen. Apart from Buddhists, according to Hsüan-tsang, there were also heretics (Hindus). Buddhist monasteries and Hindu temples stood side by side. The number of monks living in Buddhist monasteries he gives as two thousand, including followers of Hīnayāna as well as Mahāyāna Buddhism; he was unable to establish the exact number of Brahmins.

Some scholars dispute Sylvain Lévi's assertion that Nepal remained depen-dent on Lhasa until the collapse of the Tibetan empire under gLang-dar-ma (842 AD), or at least until the end of the 8th century. It is difficult to be more precise, since the 9th and 10th centuries are historically an obscure period, owing to the lack of documents. These only begin again in the 11th century: from then on, there are dated manuscripts, with the name of the ruling king, which serve to supplement the information obtainable from the none too numerous inscriptions.

An important event in the 9th century is the establishment of a specifically Nepalese chronology with the year 879 AD counting as the year 1. The Malla rulers reckoned dates in accordance with this 'Nepalese Era', and the tradition still survives. It is not clear what event led to the inauguration of the Nepal Era as from the year 879. The designation of its starting-point as the year of the Śrī-Paśupati-bhaṭṭāraka in a genealogical table (vaṃśāvali) would seem to indi-cate that the inauguration was brought about by an event connected with the national shrine of the Paśupatināth. It is possible that an offering was made in that year in memory of the liberation of the country from Tibetan rule.

There are abundant inscriptional sources of information from the end of the 14th century onwards; the period 1480–1768, which began with the division amongst his heirs of the Malla kingdom by King Jayayakṣamalla (d. 1480), and the subsequent independence of the kingdoms of Katmandu, Patan, and Bhatgaon is therefore well covered. For the 17th and 18th centuries, the number of historical documents is disconcertingly large. It is significant that at the begin-

ning of the Malla period the only language used in the documents is Sanskrit, but then the tendency arises to give technical data, such as the size of estates and suchlike, in Newari, the Tibeto-Birman language of the Mongolian Newars, who then formed the majority of the population of the Nepal valley. Even the writing on stone and copper-plate documents, called ancient Newari, reveals an independent, provincial style that is clearly different from Indian characters. All this indicates the growing cultural isolation of Nepal, which is certainly closely linked to the Islamic conquest of northern India in the 13th century, when the Muslims destroyed the spiritual centres of Buddhism, and repressed Hinduism. Nepal was then thrown back on her own resources. Occasionally the Muslim raiders did get as far as Nepal; one of these was the Sultan Shams-ud-din-Ilyās in 1346 AD, whose attack is recorded in an inscription on the great Stūpa of Svayambhūnāth near Katmandu: the inscription was written on the occasion of the restoration of the monument, which had been damaged by the Bengali Muslims. But Nepal was spared any lasting conquest, and was able to preserve its traditional culture, unlike the Himalayan valley of Kashmir to the west, which the Muslims succeeded in Islamising—a fact that has played a vital part in the religious and political disputes of our own time.

5. RECENT HISTORY

In early times what is now called Nepal consisted generally of some 20 kingdoms or more, and of these the Malla kingdoms in the valley of Katmandu, dominated by the Newar tribe, were the most populous and for centuries were the setting for most of Nepal's history. From the end of the 15th century, these Malla kingdoms were in a state of political disruption, after King Jayayakṣa-malla had divided his realm amongst his heirs. Within a narrow space, there were three miniature kingdoms constantly in a state of friction: Katmandu, its immediate neighbour Patan (Lalipattana, Lalitapura), and a few miles further east, Bhatgaon (Bhaktagrāma, Bhaktapura).

After nearly three hundred years, this situation was transformed in 1768, when power passed from the Newars to the present rulers, the Gurkhas, whose old home was the region round the town of Gurkha, between the valleys of Katmandu and Pokhra. In the first half of the 18th century, the leaders of these people were a Rājput family of Indian origin, which had fled from the Muslims through the Gandakī valley into the Nepalese highlands. Amongst them was the mighty Pṛthivī Nārāyaṇa Shāh who, after an initial failure to capture Nawakot, the geographic key to the valley of Katmandu, obtained more arms and ammunition from India, the homeland of his Rājput wife, advanced again into the Katmandu valley, and cut off the approach road. In 1767, through an act of treachery, he captured the fortified mountain town of Kirtipur. A brief diversion was caused by a small expeditionary force sent by the East India Company, which in response to a call for help from the Malla King Jaya Prakāśa of Katmandu, had advanced on Nepal in 1765, but they were forced to

withdraw. After this, resistance in the valley soon ended. In September 1768, Katmandu surrendered, and Patan and Bhatgaon soon followed suit. The Gurkha regions and the Malla kingdoms thus merged into a single state, with Katmandu as its capital, and the rule of the Gurkhas was extended over the whole of present-day Nepal. Though the Newari language continued to be used by a large section of the population in the valley, the official language became that of the Gurkhas, an Indo-Aryan idiom.

At the beginning of the 19th century, friction arose between Nepal and the East India Company, which had become the leading power in North India, and this led to war in 1814/15. In 1816 Nepal had to cede border regions to the British, and to allow the permanent presence of a British resident at the Court. Until the end of the Second World War, Nepal's external relations remained loosely under the control of the British, who did not, however, interfere in internal affairs or oppose the Nepalese desire for isolation, the result of their mistrust of foreign influences. In 1845 there was a *coup d'état*. The king was reduced to being a figurehead and Jang Bahadur, of the Rānā family, set himself up as leader, with the title of Mahārājah. In 1850 he visited England, where he was greatly honoured, and he became a true friend of the British, which showed itself particularly in June 1857 during the Indian Mutiny. In return for the outstanding services to the British of a force of Gurkhas, some of the border regions that had been taken from Nepal in 1816 were returned. From then on the courageous, tenacious Gurkha soldiers have served the British well through two world wars right up to the present day. They are recruited mainly from the Magar and Gurung clans, in the Gurkha province, and together with their modern weapons they always carry their traditional long knife, the kukri. The military spirit of their rulers at the turn of the century is evinced by the huge Tundikhel parade ground in the main street of the modern part of Katmandu.

After India became independent in 1947 and British rule, together with that of the Indian Mahārājahs, came to an end, it was not long before Nepal came under the influence of events in her neighbour country. Movements towards reform were supported from Delhi. Until then, power had remained with the hereditary Prime Minister who came from the all-powerful Rānā family, but the king—Tribhuvan Bir Bikram Jung Bahadur—who had been a mere figurehead, realised that the time had come to make a move. In 1951, the Rānā family were 'deposed', the country was opened up to modern inventions and influences, and a form of constitutional monarchy was set up. Even this, however, did not provide a satisfactory solution to the country's problems, and since 1955, King Mahendra Bir Bikram Shah Deva, son of the former king, has ruled directly with changing cabinets.

6. RELIGION: HINDUISM AND BUDDHISM

In the field of religion the influence of Indian culture, as is clearly shown by the use of Sanskrit and Indian characters in Nepalese inscriptions, is all-embracing. The leading members of society in the Katmandu valley, through their constant contact with Indian immigrants, who included nobles, priests, ascetics and merchants, had been converted to Indian religions even before the birth of Christ. Buddhism as well as the various branches of Hinduism all had their followers. As has already been seen, Hsüan-tsang in the 7th century mentions the fact that Buddhist monasteries and Hindu temples were to be found standing side by side. Characteristic of the friendly relations between the different faiths was the fact that King Aṃśuvarman, whose daughter introduced Buddhism into Tibet, was, like most Nepalese rulers in ancient times, a worshipper of the great Hindu god Śiva.

Hinduism is known to have arisen in the Ganges valley in the second half of the first millennium BC, as a synthesis of the religious ideas of the Aryan conquerors of India with those of the earlier inhabitants. Its main figures are the great gods Viṣṇu and Śiva, around each of whom is grouped a circle of dependants. The gods of the previous Vedic age receded into the background— the heroic god Indra (Plates 36, 82), the fire-god Agni, the guardian of oaths and promises Varuṇa, etc. They were not abolished, but simply relegated to a secondary position. An exception was the sun-god Sūrya, to whom temples (such as the one at Konarak) and statues were dedicated under the influence of Iranian sun-worship. There are a number of Indian kings who have designated themselves in inscriptions as sun-worshippers (ādityabhakta), and in Nepal too there must have been sun-worship. The oldest stone sculpture illustrated in our plates (Plate 9) may represent a sun-god, and an image of Sūrya dated 1065 AD, from the reign of the Nepalese king Pradyumna, is shown in Plate 14.

Viṣṇu, one of the principal Hindu gods, is only a secondary figure in the Vedas—sometimes an attendant on the god Indra. His heroic deed, often mentioned and ever admired in the hymns, was the three giant steps with which he is said to have encompassed the entire world—earth, air, and sky. Later he is called 'he who took the three giant steps' (trivikrama). In Hindu times the ancient myth was transferred to one of Viṣṇu's incarnations or 'descents' (avatāra), which became necessary whenever powerful demons endangered the gods or brought evil to the world. Incarnated as a dwarf (vāmana), Viṣṇu outwitted the presumptuous potentate Bali by getting him to promise him as much space as he, Viṣṇu, could cover in three steps. No sooner had the request been granted than the dwarf grew into a towering giant, and in two steps covered the whole universe; with the third, he placed his foot on the head of the cheated Bali and trod him down into the Underworld. Impressive stone carvings of this deed are to be found in Nepal (Fig. VI) and in India.

Ten incarnations are usually attributed to Viṣṇu, ascending the evolutionary ladder from beast to man. The ten are reproduced on two book covers in Plates 67 and 70a. The first incarnation is that of a fish; this is followed by a tortoise

and then a boar. On his fourth descent, Viṣṇu has already attained to the higher regions of life. He is not yet completely human, but is a hybrid creature with a man's body and a lion's head—the man-lion (*narasiṃha*). The otherwise important incarnation of Viṣṇu as the flute-playing pastoral god Kṛṣṇa is represented in our plates only as a secondary figure on a mirror-handle (Plate 65), and that of the heroic archer Rāma is not shown separately in any of our illustrations. Instead Rāma's evil adversary, the ten-headed demon and lord of Laṅkā (Ceylon), is to be seen in a wood-carving (Plate 57), his sword drawn, riding his war-chariot into battle. The poet Kālidāsa has described the divine majesty of the god Viṣṇu in the depths of the ocean, stretched out upon the world-snake Ananta or Śeṣa, sleeping the sleep of concentration (*yoganidrā*), while the gods, threatened by demons, appear before him to call on him for help. The idea of Viṣṇu resting upon the snake (*anantaśayana*) has been given a very particular form of expression in Nepal. Massive stone sculptures of the god lying on the giant snake are placed in the middle of artificial pools, as at Bālāju (Fig. VIII) some miles north-west of Katmandu, and Nīlkantha, to the north.

In images Viṣṇu is often seen from the front, with four arms, and a diadem on his head, standing or seated in calm serenity, as in Plate 16. As weapons to show his might, the god holds a discus and a club in his upper hands, whilst in his lower he has a conch and, as an attribute of his goodness, a lotus. At his sides stand his first wife, Lakṣmī, the goddess of beauty and fortune, and the mythical bird Garuḍa, his mount (*vāhana*) (Fig. X) in human form except for its beak and wings. The bird is often represented on its own in human form, in the attitude of a worshipper before Viṣṇu temples (Figs. IX and XXVIII, on a column).

The appearance of women and mounts or other dependants and family-members of a god is a typical feature of Indian images, as is the superhuman multiplicity of arms or heads, a means of illustrating the qualities and powers of the gods, which far exceed all earthly measures. What this many-headedness can mean, may be shown by two examples of Viṣṇu images. In the first (Plate 19), four manifestations or forms (*vyūha*) of the god are grouped round a central column, the face of each figure being turned towards a cardinal point— i.e. north, south, east or west. They are Vāsudeva (= Kṛṣṇa), his elder brother Saṃkarṣaṇa (= Balarāma), his eldest son Pradyumna (of Rukmiṇī), and his grandson Aniruddha, a son of Pradyumna. The bringing together of these members of his family in a single complex symbolises the 'union' of the noble qualities of knowledge, honour, fertility, strength, virility and majesty. There is a similar union of different divine manifestations in the central figure of a brightly coloured book cover (Plate 70b). The dark blue figure of Viṣṇu, with its ten arms, has four additional heads, including those of a boar and a lion. The two human heads are those of the gods Brahma and Śiva, whose creative and destructive powers are thus linked in this miniature with those of

Fig. VI Viṣṇu's three giant paces during incarnation as dwarf. Licchavi Period (400–750 AD). Bas-relief at Changu Nārāyaṇa (in the area of Nārāyaṇa Temple in Campakagrāma).

Fig. VII Viṣṇu's incarnation as Balarāma. Lower section of bas-relief of multi-headed Viṣṇu. Licchavi Period (400–750 AD), Changu Nārāyaṇa.

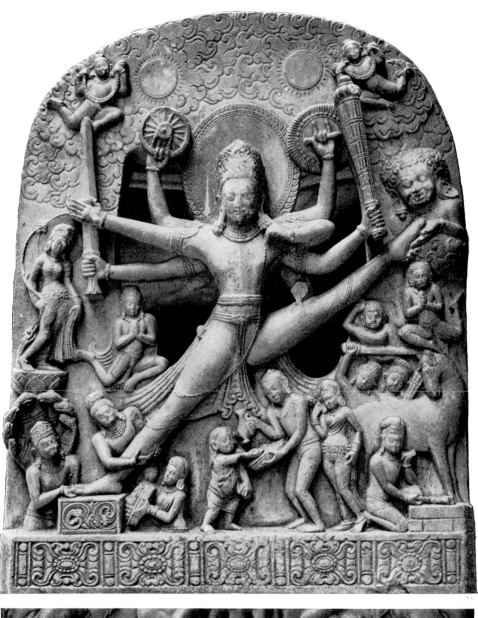
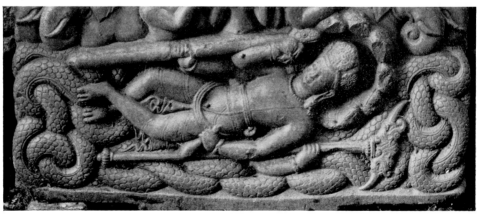

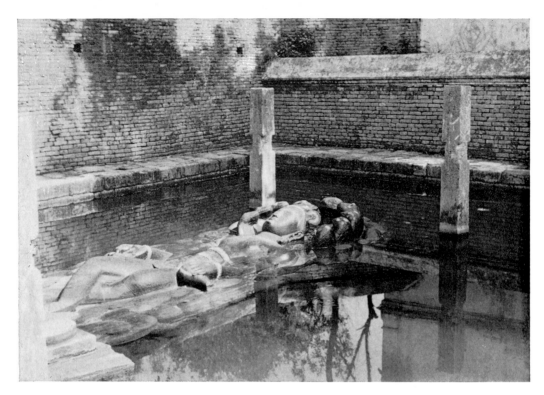

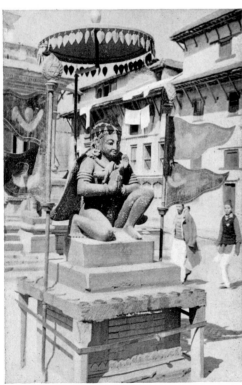

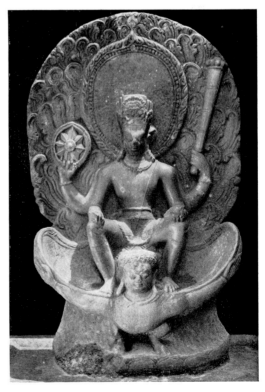

Viṣṇu the Preserver. The additional faces of his incarnations as a boar and as man-lion serve to draw attention to two important aspects of the god's complex nature as well as to the immanence of their qualities in him.

The circle of gods grouped round the second of the principal gods of Hinduism, Śiva, is even more important for Nepal than that of Viṣṇu, for Śiva is the god of the Nepalese national shrine, the famous Temple of Paśupatināth near Deo Pattan (Fig. XIII). Śiva 'The Gracious', as he is euphemistically called, was known in the Vedas as Rudra, a dreaded figure of destructive power. This destructive power, however, is also productive and creative, which is symbolised by the Liṅga, or Phallus (Fig. XI). It is in this symbolic form that Śiva is worshipped in the Temple of Paśupatināth, where one of his terrible weapons, the trident, stands in full view as a grim warning (Fig. XIV). This dreaded god likes to withdraw into the solitude of woods and mountains in order to concentrate his mind after the fashion of the yogin. With a hide round his waist and a snake round his neck he sits like an ascetic, ashes smeared over his body. He is 'Lord of the Animal World' (*paśupati*), as attested by the name of the Temple, and is generally 'Lord of all Creatures' (*bhūtapati*).

Under the name Maheśvara ('The Great Lord') Śiva is often to be seen with his wife Umā, embracing her tenderly as she sits on his left thigh (Plates 12, 21, 52, 65). The oldest and finest of these scenes shows the couple in a mountain cave in the Himalayas, where both Śiva and Umā, who is also known as Pārvatī, 'Mountain-Daughter', have their home. In these representations, Śiva's wife and female complement (*śakti*) is a submissive wife. She is also to be found as a benevolent universal mother and protectress of all living creatures, and is then known as Umā, Devī, or Pārvatī. There is, however, another more violent side to her character, which is indicated by such names as Durgā 'The Unapproachable', Kālī 'The Black', and Caṇḍī 'The Wild'. As Durgā Mahiṣamardinī she uses the trident to destroy a demon embodied in a water-buffalo (*mahiṣa*). This scene, described in the Devīmāhātmya, is vividly portrayed in stone (Plate 18) and wood (Plate 54), of which the livelier is that in wood in which the ten-armed goddess has placed her right foot on her mount, the lion, and is fighting with the part-human, part-animal buffalo demon. Her lower left hand is holding up the relatively small body of the buffalo by its tail, whilst her lower right hand thrusts the trident into the human body of the demon, which seems to grow out of the neck of the buffalo and is in the act of drawing a sword. The arms, which whirl round the body of the goddess and are holding all kinds of weapons, reveal her irresistible and terrifying power. The victory of the goddess over the buffalo demon is celebrated every autumn in Nepal, with a festival that lasts several days and is called 'Durgā worship' (*durgāpūjā*). The climax of this is the

Fig. VIII Viṣṇu in sleep of concentration, over-life-size image in pool at Bālāju, about 1650 (donated by King Pratāpamalla). Cf. Fig. XXX.

Fig. IX Viṣṇu's mount, the bird Garuḍa, in human form, in front of small Nārāyaṇa (= Viṣṇu) Temple in Patan.

Fig. X Viṣṇu on his mount, the bird Garuḍa, Licchavi Period (400–750 AD), Changu Nārāyaṇa.

public slaughter of a large number of buffaloes, which are led one after another into a temple courtyard and beheaded with a kukri.

The strange idea of portraying a god as a dancer probably arose in connection with Śiva, whose worshippers tried to express his cosmic powers in dance rhythms. From this example, the dancing pose was extended to other gods. Śiva, however, always remained the 'King of Dancers' (*naṭarājan*). The most famous images (in bronze) of the god dancing hail from South India and are known all over the world. The North Indian and Nepalese 'Lord of the Dance', Narteśvara or Nṛtyeśvara (Plate 23), is the same god. His dances and those of his dependants are discussed below (see page 30).

Buddhism, in the objects shown in our illustrations, is for the most part shown at a very advanced stage of its development, with the historic Buddha Śākyamuni having receded into the background. Only in one illustration do we see the Master, dressed in simple monk's clothing, but with the attributes of 'a great man' (Plate 37). There are also two fine and impressive large reliefs depicting legendary events from the life of the historic Buddha: one shows the miraculous birth in the Lumbinī Grove (Plate 13, see also page 13), the other (Plate 10) is a fragment of a large relief showing the temptation of the Buddha by Māra, the Evil One, the Master's great adversary, who tries to hinder him in the struggle for Enlightenment by attacking him with demonic hordes, and when this has failed, by getting his seductive daughters to offer themselves to him. All the other sculptures and paintings are inspired by later religious ideas. In them we find Buddhas with the names of Dīpankara, Amitābha, and Akṣobhya. Dīpankara, the 'Light Maker', is one of the forerunners of the historic Buddha, who are believed to have appeared during earlier stages of a drama, without beginning and without end, of worlds arising and passing away. Dīpankara (Plate 40) is one of the earliest of these. Inspired by his majesty, a young Brahmin, who in a later birth became the historic Buddha, on meeting him resolved to aspire to the rank of Buddha, which he only reached, however, after a long succession of rebirths. The written sources speak of a large number of earthly predecessors of the Buddha, and in the course of time these were increased. In Mahāyāna Buddhism, the religion of the 'Great Vehicle', the concept of the Buddha is further developed: according to this belief, the body of a Buddha that has appeared on earth and undergone the fate of man, is a mere reflection of a more perfect ideal in a paradisal world, a so-called Dhyāni Buddha, that is a Buddha that can only be experienced through deep concentration or mystic vision. The body of a human Buddha is in fact the magical creation or transformation (*nirmāṇakāya*) of a heavenly or supernatural body called *saṃbhogakāya*, meaning a body of communal joy; this name derives from the fact that this kind of Buddha's heavenly existence in the so-called 'Buddha Fields' is shared by other heavenly beings. These are on their way to becoming Buddhas and have been born in the paradise of the Dhyāni Buddhas and see their magnificence. According to this teaching, therefore, all Buddhas that have appeared on earth as men and teachers (Mānuṣi Buddhas) have heavenly counterparts. Most important of the Dhyāni Buddhas are the counterparts

Fig. XI Liṅga (phallus—symbol of Śiva) with four projecting heads (aspects of the god). In a street near Temple of Bhuvaneśvara in Deo Pattan.

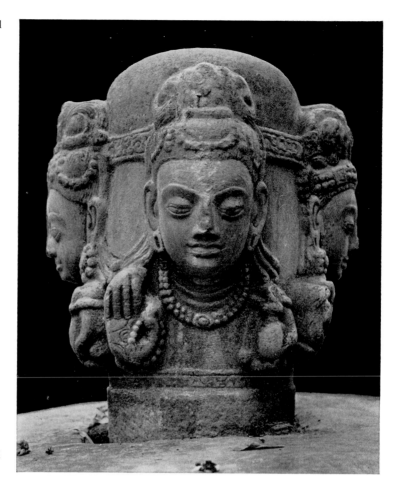

Fig. XII Part of ornamental fountain at Sundari Chowk in Patan. Gaṇeśa with elephant heads (left), and eight-headed Śiva (right).

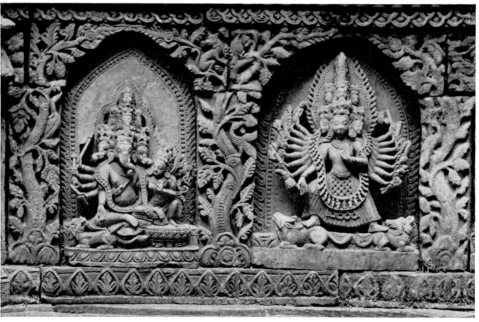

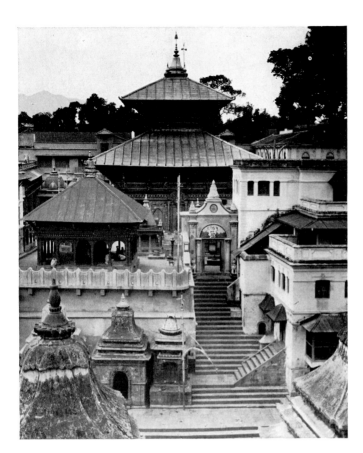

Fig. XIII Entrance to Temple of Paśupatināth. View from bank of Bagmatī.

Fig. XIV View over chapel roofs in the foreground on to courtyard of Paśupatināth Temple with gilt stone sculpture of the bull Nandin.

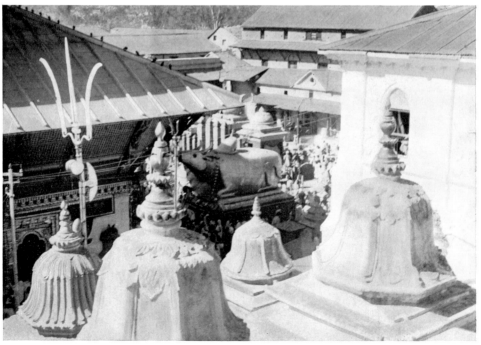

of the last four earthly Buddhas and a fifth that is to come, called Maitreya. The point about these earthly Buddhas is that they belong to the present cycle of the world's existence, called the Bhadrakalpa or Blessed Age, and they therefore take precedence in the consciousness of the believer. (They are shown in the top row of deities in Plate 76.)

Enthroned beside the Dhyāni Buddhas in their worlds are so-called Bodhisattvas, 'Beings of Enlightenment', who are potential Buddhas or Buddhas designate. These blessed beings have come within reach of their goal, the rank of a Buddha, having travelled the way that leads through the ten stages (*bhūmi*) of supreme virtue and perfection; they have, however, abstained from taking the final step to deliverance and extinction in order to stand by those who have remained behind on earth, their former companions in suffering, to help them in their troubles and to guide them along the right path. These Bodhisattvas (Plate 34) thus have the function of helpers to those who belong to this branch of the Buddhist religion—like the saints in western churches.

To each Dhyāni Buddha is attached a Bodhisattva, who is regarded as his emanation; many of these figures appear under several names or in different forms. The system is far from inflexible. Wide popularity is enjoyed by the group of five earthly Buddhas that belong to the present age (as already mentioned), together with the corresponding Dhyāni Buddhas and Bodhisattvas.

Mānuṣi Buddhas	Dhyāni Buddhas	Bodhisattvas
Krakucchanda	Vairocana	Samantabhadra
Kanakamuni	Akṣobhya	Vajrapāṇi
Kāśyapa	Ratnasambhava	Ratnapāṇi
Gautama	Amitābha	Padmapāṇi-Avalokiteśvara

and the Buddha to come:

Maitreya	Amoghasiddhi	Viśvapāṇi

Each of the Dhyāni Buddhas is depicted in a pose that is characteristic of him: Vairocana is preaching (*dharmacakra*), Akṣobhya is touching the earth (*bhūsparśa*), Ratnasambhava is giving (*varada*), Amitābha is meditating (*dhyāna, samādhi*), and Amoghasiddhi is protecting (*abhaya*). The gesture of Akṣobhya, 'The Imperturbable' (Plate 38), i.e. touching the earth, is the same as that with which the historic Buddha, on defeating Māra, called upon the earth-goddess to be a witness to his virtues in former births. Each Dhyāni Buddha is also given a specific region or portion of heaven. Thus Vairocana (see Plate 69) has the middle, Akṣobhya the east, Ratnasambhava the south, Amitābha the west, and Amoghasiddhi (see Plate 69) the north. The Dhyāni Buddha Amitābha, who has been related to the historic Buddha, is lord of a paradise in the western region of heaven that is of the highest bliss, and is called Sukhāvatī, 'Land of Happiness'. Amitābha means 'of immeasurable brightness' or 'of immeasurable

light'. This Dhyāni Buddha is a god of compassion, of the brightest light and limitless life.

7. RELIGION: TANTRISM AND VAJRAYĀNA

In the second half of the first millennium Nepal came under the influence of a strange religious movement that incorporated ideas of sinister spiritual power, magic forces, necromancy, and a great variety of symbols. Named after its holy scriptures, the Tantra or 'Warps', it is known as Tantrism. Before the Islamic conquest of North India (13th century) it was to be found above all in Bihar and Bengal, and it was a mixture of Hinduism, especially of Śiva worship, and Buddhism, bringing about a kind of syncretism between the two religions. This mixture is to be found even today in Nepal, where Buddhists visit Hindu temples, and vice versa. In the Buddhist parts of ancient India, the monasteries and religious training colleges of Nālandā, Vikramaśīlā, and Otantapurī in eastern North India were all promoters of Tantrism.

A look at some of the illustrations connected with the god Śiva will help to clarify the main elements of Tantrism. For instance the 'Lord of the Dance' (Plate 23, see also above page 26) shows the five-headed fourteen-armed god Śiva, dancing on the back of his mount, the bull Nandin, to the obvious delight of the latter. We find gods and their dependants dancing joyfully in various other plates—for instance in Plate 58, Śiva's elephant-headed son Gaṇeśa, the remover of obstacles and patron of learning who appears to get a great deal of pleasure from his dance. On the base of the wood-carving in Plate 61 we find Śiva dancing, and beside him are his mount Nandin, this time in human form, and his dependant Bhṛṅgin, who are beating drums for the god's dance. We find Bhṛṅgin again, dancing and holding a drum in front of his body, in an ivory carving in Plate 66. All these sculptures are relatively temperate and cheerful, but there are others which bring to the fore a more grisly side of Śiva and his dances. A wood-carving (Plate 59), presenting Śiva in all his forms (viśvarūpa), reveals several frightening features. Not only does Śiva have a larger number of heads (17), arms (34), and legs (8), but there are also other features that arouse disquiet: the daemonic face on his belly, a daemonic head with bristling hair in the second row of heads, the garland round his shoulders with human heads dangling from it, the small curled-up snakes that serve as ear-rings, the two large snakes rearing up on either side of him, and the flames (the nimbus) flaring up behind his heads. The basic features of violence, blood-thirstiness, rage, and madness occur frequently in images of Bhairava, 'The Terrible', and other guises of Śiva not represented here.

Tantrism maintains that it is possible to make use of the powers of these terrible gods if one is initiated into certain magic practices. The expert is then able to conjure up deities at will and to ally himself to their powers. Some idea of the procedures involved may be given by a summary of the instructions for the summoning of a Buddhist goddess of salvation, a Tārā (Plate 53). Accord-

Fig. XV Bodhisattva Maitreya, with vial in left hand. Silver, Nepal Museum, Katmandu.

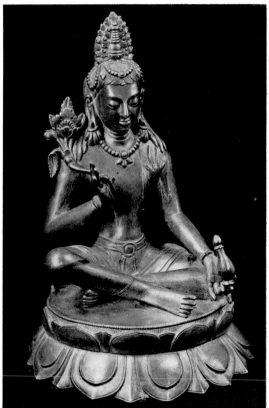

Fig. XVI Standing Tārā, stone, holding stem of lotus in left hand. Nepal Museum, Katmandu.

Fig. XVII Bodhisattva Padmapāṇi, standing. Stone, near Ghaṭa-vihāra, in Kathe Simbhu Street, Katmandu.

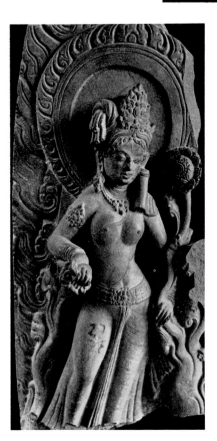

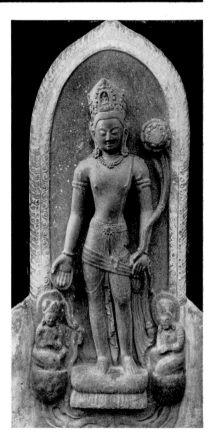

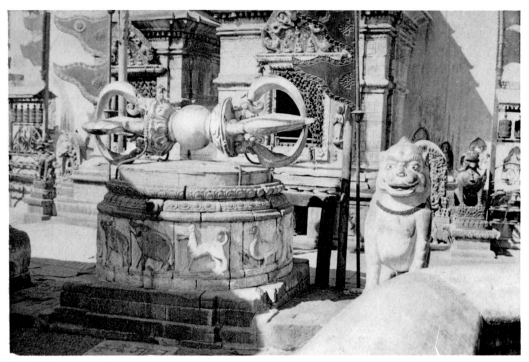

Fig. XVIII Large gilded *vajra* (thunderbolt, magic dagger) on terrace of Svayambhūnāth Stūpa near Katmandu, at top of ascent.

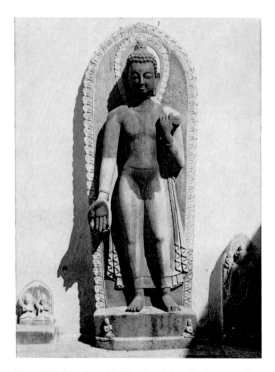

Fig. XIX Standing Buddha in niche. On terrace of Svayambhūnāth Stūpa near Katmandu, 9th or 10th century.

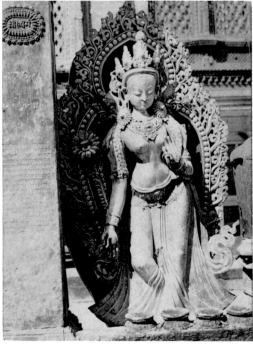

Fig. XX Tārā, Buddhist 'helper to salvation', on terrace of Svayambhūnāth Stūpa near Katmandu.

ing to the Sādhanamālā, the adept begins by visualising a bright round disc with a blue lotus blossom in it. On this, written in yellow, he sees the syllable Tāṃ, a mystic syllable (*bīja* = a 'germ' or seed) of magic power representing the goddess whom he wishes to summon. If the sorcerer meditates sufficiently on the syllable, then it will emit radiant beams of light which illuminate the heavens and attract countless Buddhas and Bodhisattvas to take up their positions in the atmosphere above. The sorcerer makes them an offering of flowers and sweet-smelling essences, followed by a confession of sins and a number of solemn vows. He then concludes by praying that all merits which he may obtain from his worship of the Buddhas and from his other activities should benefit his future enlightenment. After he has made all the gods disappear again by pronouncing the words Oṃ Āḥ Muḥ, he turns his attention to the actual conjuring up of his chosen goddess. He awakens in himself a feeling of brotherly sympathy with all beings, and penetrates into the reality underlying the external world and its relation to the Absolute. 'Oṃ'—so runs the formula—'in accordance with their true nature all things are pure, and so too am I.' Then he asks himself how the world of suffering and sin has come about, and he recognises the fact that the original purity has been lost through a disturbance caused by the differentiation between 'I' and 'Thou', between the subject and the object. This difference, he realises, must be eradicated by means of meditation on the emptiness of all phenomena and the re-establishment of the unity between 'I' and 'Thou'. After he has achieved this realisation, he visualises his goddess Tārā, in accordance with a detailed description (*dhyāna*) given in the text, and then spends a long period of time in meditation. Then a miracle occurs: from the imagined picture of the goddess, or rather of her 'germ', the syllable Tāṃ, there come rays of light which illuminate the world, and these rays in the upper atmosphere light up an ideal original Tārā, 'The Redeemer'—an eternal Tārā. As he did earlier for the assembled Buddhas in the skies, the sorcerer makes an offering of flowers to the eternal Tārā, worships her and with his hands makes a special gesture (*mudrā*) also prescribed in detail, and thus he greets the deity. He then conjures up a magic spell that symbolises the deity, and realises the oneness of his vision with the mystic incantation Oṃ Tāre Tuttāre ture svāhā, the 'mighty King of magic spells, revered by all, and honoured even by the Buddhas'. The meditation ends by his identifying himself with the deity.

Characteristic features of Tantrism—as can be seen from this example—are mystic syllables (*bīja*), magic spells (*mantra*), significant gestures, ponderings on the oneness of everything, meditation on the profound connections between microcosm and macrocosm. The contemplation of images, and the absorption into them, is of great importance. The magic practised can serve to give one possession of miraculous powers, such as invincibility in battle, the ability to uncover buried treasure, the power to go everywhere unseen, suddenly to become invisible, to transform metal into gold, to walk in the air, to appear anywhere in the world, and to visit the Underworld. Some of those who have achieved 'perfection' in these arts (called *siddha*) are to be seen as secondary

figures in the paintings illustrated. The knowledge and practices which the adept makes his own are secret, and can only be transmitted personally by the master to his pupil, who under his supervision penetrates step by step into the mysteries after repeated solemn consecrations. In return for this the pupil must always show obedience and the utmost reverence to his teacher, who alone can perform and therefore teach the rites correctly.

In the extremely lively painting of the dancing Śiva, reproduced in Plate 79, we find another essential element of Tantrism. Here the god is shown dancing together with his wife and female counterpart (śakti), in the enjoyment of intense pleasure (mahāsukha). The couple are accompanied by a number of small, naked, female deities dancing at the sides of the picture. Here we find a strong emphasis laid on the female element and on sensuality, and this, together with the enjoyment of displays of violence, is peculiar to Tantrism.

From the invocation of the Tārā described above, it is clear that monistic ideas are predominant in this religious movement. The adept was obliged to bring about a process of unification with the deity and thus to effect an identification of the external world with the Absolute. Such thought processes can eventually take on a sensual slant, as has happened in the Christian conception of divine love, and a school of the 'left hand' was enticed to connect the idea of unification with erotic conceptions and thoroughly earthly practices, lapsing into a moral relativism. A thousand or so years earlier, the author of an Upaniṣad had compared the spirit in deep sleep to a man who 'embraced by a beloved woman, has no consciousness of what is outward or what is inward'. In a similar sense, this movement sees in the sacred enjoyment of love an elevation above the individual, a dissolution of the opposition between 'I' and 'Thou', the establishment of a blissful identification between man and woman, and the foretaste of a merging into the Absolute. The external world—so the argument may be continued—is ruled by two polar forces, the male and the female principles, the unification of which is a realisation of the All-Oneness and leads to an awareness of the bliss of the Absolute. The actions and processes of sacred love-making, which take on a mystic significance, are given religious connotations and a religious holiness. The adept enters into a union with a girl, who for this purpose has been specially consecrated with all kinds of rites by a Master and receives the name of Vidyā, 'Knowledge'. In the enjoyment of love, which is not merely for the purpose of satisfying animal desires, the salvation-seeker then merges with 'Knowledge' the Vidyā, though the texts do not omit to stipulate that the Vidyā should be beautiful and loved by the sorcerer. Her age should be preferably between twelve and sixteen—the age at which married life begins or began for the Indian girl. A slightly repellent, though beautiful embodiment of such a Vidyā is to be seen in the bronze figure of a fairy (sprite) of the class possessed of knowledge or spells (vidyādharī) in Plate 41, who is floating in the air, her dancing leg raised high (ūrdhvatāṇḍava).

The Buddhist variety of Tantrism is frequently given the name Vajrayāna, 'diamond vehicle', after the Vajra, 'magic dagger' or 'thunderbolt', which represents indestructibility in the form of a symbolical 'diamond' (Fig. XVIII). It

34

ing to the Sādhanamālā, the adept begins by visualising a bright round disc with a blue lotus blossom in it. On this, written in yellow, he sees the syllable Tāṃ, a mystic syllable (*bīja* = a 'germ' or seed) of magic power representing the goddess whom he wishes to summon. If the sorcerer meditates sufficiently on the syllable, then it will emit radiant beams of light which illuminate the heavens and attract countless Buddhas and Bodhisattvas to take up their positions in the atmosphere above. The sorcerer makes them an offering of flowers and sweet-smelling essences, followed by a confession of sins and a number of solemn vows. He then concludes by praying that all merits which he may obtain from his worship of the Buddhas and from his other activities should benefit his future enlightenment. After he has made all the gods disappear again by pronouncing the words Oṃ Āḥ Muḥ, he turns his attention to the actual conjuring up of his chosen goddess. He awakens in himself a feeling of brotherly sympathy with all beings, and penetrates into the reality underlying the external world and its relation to the Absolute. 'Oṃ'—so runs the formula—'in accordance with their true nature all things are pure, and so too am I.' Then he asks himself how the world of suffering and sin has come about, and he recognises the fact that the original purity has been lost through a disturbance caused by the differentiation between 'I' and 'Thou', between the subject and the object. This difference, he realises, must be eradicated by means of meditation on the emptiness of all phenomena and the re-establishment of the unity between 'I' and 'Thou'. After he has achieved this realisation, he visualises his goddess Tārā, in accordance with a detailed description (*dhyāna*) given in the text, and then spends a long period of time in meditation. Then a miracle occurs: from the imagined picture of the goddess, or rather of her 'germ', the syllable Tāṃ, there come rays of light which illuminate the world, and these rays in the upper atmosphere light up an ideal original Tārā, 'The Redeemer'—an eternal Tārā. As he did earlier for the assembled Buddhas in the skies, the sorcerer makes an offering of flowers to the eternal Tārā, worships her and with his hands makes a special gesture (*mudrā*) also prescribed in detail, and thus he greets the deity. He then conjures up a magic spell that symbolises the deity, and realises the oneness of his vision with the mystic incantation Oṃ Tāre Tuttāre ture svāhā, the 'mighty King of magic spells, revered by all, and honoured even by the Buddhas'. The meditation ends by his identifying himself with the deity.

Characteristic features of Tantrism—as can be seen from this example—are mystic syllables (*bīja*), magic spells (*mantra*), significant gestures, ponderings on the oneness of everything, meditation on the profound connections between microcosm and macrocosm. The contemplation of images, and the absorption into them, is of great importance. The magic practised can serve to give one possession of miraculous powers, such as invincibility in battle, the ability to uncover buried treasure, the power to go everywhere unseen, suddenly to become invisible, to transform metal into gold, to walk in the air, to appear anywhere in the world, and to visit the Underworld. Some of those who have achieved 'perfection' in these arts (called *siddha*) are to be seen as secondary

figures in the paintings illustrated. The knowledge and practices which the adept makes his own are secret, and can only be transmitted personally by the master to his pupil, who under his supervision penetrates step by step into the mysteries after repeated solemn consecrations. In return for this the pupil must always show obedience and the utmost reverence to his teacher, who alone can perform and therefore teach the rites correctly.

In the extremely lively painting of the dancing Śiva, reproduced in Plate 79, we find another essential element of Tantrism. Here the god is shown dancing together with his wife and female counterpart (*śakti*), in the enjoyment of intense pleasure (*mahāsukha*). The couple are accompanied by a number of small, naked, female deities dancing at the sides of the picture. Here we find a strong emphasis laid on the female element and on sensuality, and this, together with the enjoyment of displays of violence, is peculiar to Tantrism.

From the invocation of the Tārā described above, it is clear that monistic ideas are predominant in this religious movement. The adept was obliged to bring about a process of unification with the deity and thus to effect an identification of the external world with the Absolute. Such thought processes can eventually take on a sensual slant, as has happened in the Christian conception of divine love, and a school of the 'left hand' was enticed to connect the idea of unification with erotic conceptions and thoroughly earthly practices, lapsing into a moral relativism. A thousand or so years earlier, the author of an Upaniṣad had compared the spirit in deep sleep to a man who 'embraced by a beloved woman, has no consciousness of what is outward or what is inward'. In a similar sense, this movement sees in the sacred enjoyment of love an elevation above the individual, a dissolution of the opposition between 'I' and 'Thou', the establishment of a blissful identification between man and woman, and the foretaste of a merging into the Absolute. The external world—so the argument may be continued—is ruled by two polar forces, the male and the female principles, the unification of which is a realisation of the All-Oneness and leads to an awareness of the bliss of the Absolute. The actions and processes of sacred love-making, which take on a mystic significance, are given religious connotations and a religious holiness. The adept enters into a union with a girl, who for this purpose has been specially consecrated with all kinds of rites by a Master and receives the name of Vidyā, 'Knowledge'. In the enjoyment of love, which is not merely for the purpose of satisfying animal desires, the salvation-seeker then merges with 'Knowledge' the Vidyā, though the texts do not omit to stipulate that the Vidyā should be beautiful and loved by the sorcerer. Her age should be preferably between twelve and sixteen—the age at which married life begins or began for the Indian girl. A slightly repellent, though beautiful embodiment of such a Vidyā is to be seen in the bronze figure of a fairy (sprite) of the class possessed of knowledge or spells (*vidyādharī*) in Plate 41, who is floating in the air, her dancing leg raised high (*ūrdhvatāṇḍava*).

The Buddhist variety of Tantrism is frequently given the name Vajrayāna, 'diamond vehicle', after the Vajra, 'magic dagger' or 'thunderbolt', which represents indestructibility in the form of a symbolical 'diamond' (Fig. XVIII). It

34

often occurs as an attribute or weapon on Buddhist images from Nepal, and goes together with other weapons such as the razor and the khaṭvāṅga club. The word Vajra is also used for the emptiness or nothingness (*śūnyatā*) which in Vajrayāna is regarded as the Absolute. In connection with the sacred enjoyment of love, the symbolism goes still further; various names take on at one and the same time a religious and an erotic meaning. For instance, the phallus is called Vajra, 'Thunderbolt' or Maṇi, 'Jewel', and the female organ is Padma, i.e. lotus. In this sense, Vajrayāna can become a way to salvation by means of the sacred enjoyment of love.

As love-making thus receives an indirect sanctification and becomes an expression of salvation, it is scarcely surprising that the conception of the Buddha should also undergo some changes to reflect experiences of love. Like the Hindu gods, Buddhas and Bodhisattvas are allowed female complements which act as their śaktis or female powers. The Dhyāni Buddha Vajrasattva, 'He whose Essence is the Vajra (Diamond)'—he is counted as the sixth paradisal Buddha in Vajrayāna and is often regarded as the Primordial Buddha—is sometimes represented in union with his śakti (as in Plate 77, top centre). Theorists call this representation of a Buddha, Mahāsukhakāya, 'Body of the Great Pleasure'. Nirvāṇa became equated with the orgasm (*mahāsukha*). Many of the Buddhist protective deities are depicted in a close embrace with their śaktis, in a state of extreme excitement. An example is the 17-headed, 74-handed Mahāsaṃvara in Plate 81, who is shown in sexual union with his śakti: a vision of unlimited force, that seems ready to explode the whole universe. Even the picture of his śakti, Vajravārāhī, on her own in Plate 78, dancing with a cranium full of blood in her hands, is rather ghoulish.

Many followers of the older forms of Buddhism would doubtless turn away in disgust if it were suggested to them that such things were in conformity with the teachings of the Master. Indeed the original teachings seem here to have been virtually turned upside down, for we know that the Buddha forbade his monks to indulge in any sexual intercourse, and regarded the temptations of sensuality as amongst the greatest dangers on the road to salvation. There is much in Tantrism that we too might find repulsive, but it would be wrong to interpret the eroticism and mysticism as mere blasphemy. In his book *Buddhistische Mysterien* (Stuttgart 1940, p. 158), H. v. Glasenapp quite rightly emphasises that these things should not be seen solely as records of a period of depravity, created by immoral priests for the gratification of their lusts. 'For behind all these teachings and rituals, though they do not fit well into their Buddhist framework, there stands an ancient popular religion, the belief in great Mother Goddesses and in the sanctity of the act of procreation. The ideas and pictorial representations of Buddhist Shaktism are as inoffensive for anyone who has grown up with them as the Linga cult in India, which is condemned as immoral by Europeans who do not know it, although the Hindus, when they worship the holy Phallus stone, do not associate any lascivious ideas with it at all.'

8. ARCHITECTURE

Before the country was opened up to the outside world in 1950, the predominantly religious architecture of the Nepal Valley remained entirely medieval in character, especially in the capitals of the ancient kingdoms of Patan and Bhatgaon. Modern palaces in Katmandu, built for the rulers alongside the old city in accordance with plans by French architects, did not lead to any significant changes. The style of the architecture carried on medieval tradition.

There are many signs of a centuries-old Buddhism to be found all over the Nepal Valley in the form of Stūpas, or relic-mounds. The largest and most famous of them are situated on hills outside the towns, where they can be seen from far and wide. Fig. XXI shows an example of such a building in which some special features of Nepalese architecture are easily recognisable. This is the Cārumatī Stūpa in Chabahil, to the east of Katmandu, said to have been erected by Cārumatī, a daughter of the Indian king Aśoka (see page 12). A nearby monastery is also attributed to her. The Cārumatī Stūpa consists of a huge, hemispherical dome on a circular foundation, a very ancient form of the massive structure generally known as the 'egg', that is similar to Indian examples (like the great Stūpa of Sāñchī) dating from the third century BC up to the beginning of the Christian era. On this 'egg' is a rectangular plinth, from which rises a tapering spire of great height. This part of the building is a development of the relatively small canopies on the ancient Indian Stūpas and is a much later addition. Its thirteen steps are meant to symbolise superimposed worlds or stations along the path to Enlightenment. Right at the very top one can see a proper canopy in the old style. On the walls of the plinth—and this is a feature peculiar to Nepal—are painted four gigantic pairs of eyes, with the suggestion of noses beneath. These are said to represent the wisdom of the Buddha, manifested on all sides, or his all-seeing eyes. Originally this decoration was probably intended to protect the building from the 'evil eye' and the machinations of evil spirits.

Fig. XXII shows another canopy with the four pairs of eyes painted on the plinth against a golden ground, but here the steps of the canopy are round, and on all four sides directly above the socle there is a three-cornered, ornamental gilded plaque on which the five Dhyāni Buddhas are represented. The Stūpa of which this spire is a part is the Svayambhūnāth, which is the most venerated of all by the Nepalese. All pilgrimages begin with a visit here. The Svayambhūnāth stands to the west of Katmandu, on top of a hill overlooking the city, and is reached by a steep path with several hundred steps. The huge white dome, hemispherical in form, is of plastered brick, like all the larger Stūpas in Nepal, and may perhaps incorporate the actual top of the hill itself. Around the Stūpa is a broad terrace with all kinds of constructions. The ritual passage followed by the Buddhists, like a processional way in European centres of pilgrimage, leads past shining gold altars and chapels with cult images built on to the dome and at times actually connected to it (Fig. XXIII), past genii and deities, lamps, candlesticks, and the figures of various donors. In the same place there are also

monastery buildings, smaller temples, statues, and a host of votive Stūpas, which in principle repeat the form of the main Stūpa, but in more recent times have been given a bell-shaped form curving downwards and outwards, on a rather higher foundation. This bell shape (Fig. XXIV) marks an essential difference between the Nepalese votive Stūpa and that to be found in Tibet or in the neighbouring Sikkim and the Indian Darjeeling (where they are known as Chorten). There the 'egg' tapers inwards at the bottom, like a bottle. Votive Stūpas are to be found on the way to, and in the neighbourhood of, places of pilgrimage, and at temples and monasteries; they can be compared to the votive altars and crucifixes by the wayside in the Catholic regions of the West, and are usually decorated with the image of one Dhyāni Buddha on each of the four sides. The development of the shape and decoration of the Stūpa could be studied in Nepal over a period of some two thousand years, but the large, older edifices are still so much the central point of religious activity that excavations and scientific study of their exact dates are for the time being out of the question.

Another famous place of pilgrimage for Buddhists is the Stūpa of Bodhnāth (Fig. XXV), which is even larger than the Svayambhūnāth, and indeed is one of the most massive constructions of its kind in Asia. It is situated in the plain to the east of Katmandu. Here there are not so many decorative accessories, but in niches all round the Stūpa there are 108 large prayer-wheels, which are turned with great fervour by the many Tibetan pilgrims and Nepalese Bhutiyas who go there. Three terraces run all round the Stūpa at different heights, and on festive occasions thousands of bright streamers flutter round the dome, suspended from cords that come down on all sides from the very top of the Stūpa. Oil lamps or candles are lighted in niches or on the terraces, and the over-all effect is deeply religious as well as being very colourful.

When one stands in the square in front of the former palace of the Malla Kings in Patan (Fig. XXXI) one feels that one is back in the Middle Ages; one cannot help being struck by the richness of the decorations and the wealth of forms in the religious and secular buildings around it. Here and there are columns surmounted by figures, one of which is to be seen in the foreground of our illustration; from the top, King Yoganarendramalla gazes upon the palace which he built in about 1700. Next to him is the tiny, seated figure of his wife. If one looks at the sides of the square, one can understand the reports of Chinese pilgrims from ancient India, who talked of squares crowded with multi-storeyed monasteries and golden-topped temples. Here some of this has been preserved, and here too is a confirmation of what was written in the Chinese annals of the T'ang era, concerning the residence of the Nepalese king in the 7th century AD: 'In the middle of the palace stood a seven-storeyed tower covered with copper plates. The balustrades, screens, columns, and beams, and all the interior fittings were inlaid with beautiful stones and even with jewels. On each of the four corners of the tower was a copper gargoyle that opened out into gilded dragons' heads. Piped water spouted out of the mouths of these monsters, and flowed down from the top of the tower like a fountain.' The observer is struck even today by the many-roofed buildings he sees everywhere,

as described in the old report—those 'Pagoda style' edifices which, at first sight, make one think of Chinese influences. The suggestion of Chinese models is misleading, for on the contrary the 'Pagoda style' travelled from India through Nepal and Tibet to China and Japan, as has been shown, amongst others, by Percy Brown in his book *Indian Architecture*. In it he traces the roots and history of Indian temple towers from the standpoint of the architect, and has found towers whose form is related to those of Nepal in various parts of India—such as Gujarat, Malabar, southern Kanara, and eastern Orissa; he also shows how Chinese pagodas derive as well from the tower forms of early Indian times. The Nepalese temple, based on a rectangular or square ground-plan, has a similarly shaped interior repeated in several storeys, one above the other; this is a continuation of an Indian tower form dating from pre-medieval times, and it may have been specially cultivated by Buddhists, although discontinued in India as a result of extermination of the Buddhists by the Muslims. With its superimposed, one-roomed storeys, in which one must imagine altars with Hindu or Buddhist idols, the Nepalese temple has generally departed from the usual medieval Indian forms in which the tower-topped place of worship was connected to an entrance hall and sometimes also to colonnades.

Stone-faced temples are rare in Nepal and are generally modern. Each of the squares in front of the palaces at Bhatgaon and Patan contains a stone building of this kind, and although neither of them has any large halls or porticoes, there is a striking resemblance to the steeples of medieval North Indian stone temples. One difference, however, is that the lower parts of the buildings are more open and airy. The construction of the Kṛṣṇa Mandir at Patan (Fig. XXXI, in the background to the left) reminds one of Indian secular architecture, such as the five-storeyed Panchmahal in Fatehpur Sikri.

Apart from these few stone edifices, Hindu as well as Buddhist temples are usually built with a combination of wood and brick in the Pagoda style. The framework of buttresses, posts, binders and joists, abutments and beam-heads is made from the resistant wood of the Himalayas, and the oldest surviving buildings of this kind may date as far back as the end of the 14th century. The combination of wood and brick is clearly to be seen in an impressive, five-storeyed temple, the Nyatapola, in Bhatgaon (Fig. XXVI, in colour), in which the whole roof structure of pillars and buttresses is made of wood, whilst the walls are built with baked bricks. The podium which tapers in a series of steps is also made of bricks, and contains a staircase which, like the terraces of the Bodhnāth Stūpa, is overlaid with stucco. The flight is guarded at the bottom by figures of two wrestlers, followed by a succession of animals, each creature being considered to be ten times stronger than the one below.

In secular architecture the bright red bricks are often left unfaced. Masonry of this kind is to be seen in the royal palaces of Katmandu, Patan and Bhatgaon (Fig. XXIX). Here one can see bricks of different forms used to denote the various storeys and also for other kinds of decoration. Brick-making is an ancient art, as is shown by the archaeological finds from the tarai illustrated in Plate 8: occasionally very large individual ones were carefully selected and then beautifully

Fig. XXI Cārumatī Stūpa at Chabahil.

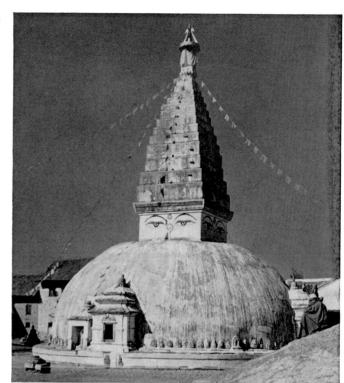

Fig. XXII Spire (13-storeyed construction topped by canopy) of Svayambhūnāth Stūpa near Katmandu.

Fig. XXIII Chapels at Svayambhūnāth Stūpa near Katmandu.

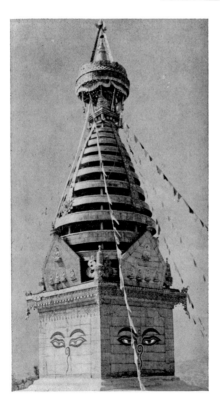

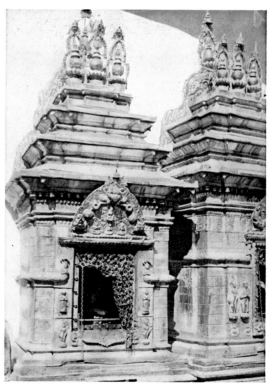

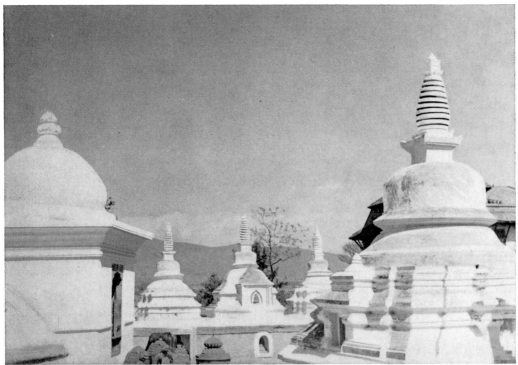

Fig. XXIV Subsidiary stūpas of northern 'Aśoka' Stūpa, Patan.

Fig. XXV Stūpa of Bodhnāth, near Katmandu.

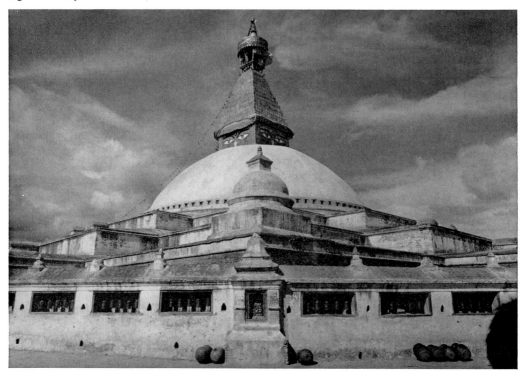

decorated. In Patan there is a Buddhist temple built entirely of such moulded bricks, and there is an Indian counterpart in the material used for the 18th century Jor-Bangla Temple at Vishnupur (see Percy Brown, op. cit., Fig. CXVIII).

Alongside the rich wooden carvings and the ornamental bricks, there is also metal in the form of brass, copper, and bronze, that has been cast, embossed and hammered, and so encrusted on to the buildings that it becomes a striking feature of Nepalese architectural decoration. The gilded copper and the brass on many projecting temple roofs are quite dazzling in the sunshine. Individual architectural features such as door lintels, mouldings, and grilles are made of gilded sheet metal or of wood with a metal coating. A fine example of this is the gold portal in the Palace of Bhatgaon (Fig. XXVII). Something similar can be seen in the chapels at Svayambhūnāth illustrated in Fig. XXIII.

The Newaris have shown great skill in their use and control of the abundant water available in their country. Washing, for the purification and expiation of sins, is as vital to the Nepalese as it is to the Indian, and so it is scarcely surprising that in this field too there should be similarities with the water supply systems used in ancient India. In India we know of large stone cisterns deep in the earth where water was stored, so that it could not evaporate; we know too of the hot springs in Rajgir, the waters of which were certainly artificially collected and carefully stored even in the time of the Buddha. Nepal, like India, has built bathing places on its rivers, where the Hindus can carry out their ritual ablutions on stone steps—as at the Paśupatināth Temple on the banks of the Bagmatī, and elsewhere. In addition, the water from mountain streams is collected in stone channels and directed to places in the centre of heavily populated towns, where the water flows unceasingly and people are constantly to be found bathing or washing their clothes. Such places have stone floors, and are often decorated with sculptures. The water flows into stone basins or gushes out of wells specially constructed to hold it. The decoration of these installations also shows similarities to Indian prototypes. A particularly beautiful example of this kind of construction, now situated in a well-looked-after public park, is the white marble fountain of Bālāju (Fig. XXX). Here the clear silvery water from various springs is dammed up behind a wall, and is released, as it were, along a broad front through twenty-two adjacent spouts in the shape of Makaras, or sea-monsters (Plate 17). In other places, spring water is directed along narrow canals into artificial pools connected with places of worship, for instance at Nīlakantha, where an image of Viṣṇu lying on the world-snake is placed in the clear water of a square pool with stone sides (cf. Fig. VIII).

9. ARTISTIC STYLES

Nepalese art can be divided into six stylistic periods that follow the dynastic phases of Nepal's history. These are:

I The pre-Licchavi period (before 400 AD)
II The Licchavi period (5th–8th century)

The pre-Licchavi period is represented in this book by seven terra-cotta figures (Plates 1-7) excavated in the tarai, the homeland of the Buddha in the Himalayan foothills (see above, page 11). The oldest Nepalese stone sculpture yet discovered dates from the beginning of the Licchavi period, and is shown in Plate 9; experts on Nepalese art believe that this is an image of a Kirāta king, that is, a prince of the ruling house prior to the Licchavis. Little research has, however, been carried out so far on this period of Nepalese history.

A considerable number of sculptures from the Licchavi period have survived. Examples from this classical period of Nepalese art include the representation of Māra's attack on the Buddha (Plate 10), and the image of the goddess Sarasvatī (Plate 11). Also from this period are some of the sculptures illustrating the section on the religions of Nepal (Figs. VI, VII, X and XI). There are also two sculptures corresponding to the magnificent relief illustrated in Fig. VI of Viṣṇu taking the three giant paces; they are less well preserved and, from the inscriptions, date from the 5th century AD. These works are comparable with similar works from India, carried out during the golden age of Indian art associated with the name of the Gupta Dynasty. These Nepalese sculptures are indeed closely related to their Indian counterparts, but the faces of the persons represented reflect a native ideal of beauty that seems to have inspired the artists at work in Nepal; it is this feature which gives a special character to works which might otherwise have seemed no different from the Indian creations of that period.

Two further illustrations show works from the end of the Licchavi period or from the age of transition between the Licchavis and the Mallas: the god Śiva with his wife in a cave in the holy mountain of Kailāsa (Plate 12), and the birth of the prince who later became the Buddha in the Lumbinī Grove (Plate 13)—two of the most beautiful creations of Nepalese art. Further examples of this period are the Buddhist statues of a Tārā and a Bodhisattva reproduced in Figs. XVI and XVII. By Indian standards these stem from the early Middle Ages rather than the Classical period. Closely related to them are Indian works from the beginning of the Pāla age, named after an Indian dynasty that ruled from the middle of the 8th until the middle of the 12th century in the neighbouring North Indian lands of Bihar and Bengal.

The early Malla period (11th–14th century) is rather more extensively illustrated in this book, and amongst these works are several that can be exactly dated by means of their inscriptions. From the year 1065 there is the stone relief with the stately figure of the sun-god Sūrya holding a lotus in either hand (Plate 14). Here, and in two manuscripts dated 1220 and 1247, one can clearly see the links with Indian art of the Pāla and Sena periods. Plate 67 reproduces the

Fig. XXVI Nyatapola Temple, Bhatgaon, built in 1703 by King Bhūpatīndramalla (reigned 1694–1722).

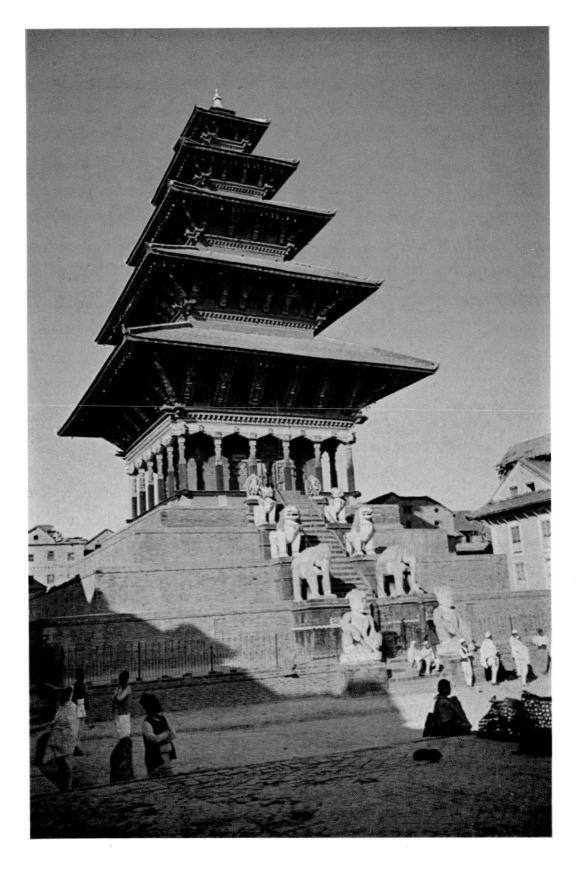

cover of the earlier of these two manuscripts, with a depiction of the ten incarnations of the god Viṣṇu; several palm leaves of the other manuscript (a Buddhist one) are decorated with very fine miniatures of Buddhas and dependent female deities (Plate 69). The stone sculpture of Avalokiteśvara (Plate 15) and the precious bronzes in Plates 31–34 are also ascribed to this period.

Apart from the twenty or so pieces already mentioned, the majority of the objects illustrated stem from the late Malla period, which coincides with the development of the three Malla kingdoms of Katmandu, Patan (Lalitpur) and Bhatgaon (Bhaktapur), towards the end of the 15th century.

After the extermination of the Buddhists and the destruction of Pāla and Sena art in India during the 13th century, the offspring of this style of art survived and flourished on the soil of Nepal (Fig. XIX). Nepal had by now been thrown back upon its own resources, and its art took on an unmistakable character of its own. The country was no longer a mere stopping-place for traffic between India and Tibet, but it had become the starting-point and the goal of cultural and scientific exchanges with Tibet and East Asia. In Lhasa there were colonies of Newaris, whose work in metal and wood was greatly prized.

In tracing the development of late Malla art, a definite starting point is offered by the Viṣṇu stele (Plate 16) inscribed with the date 1417 AD. This figure displays certain stylistic peculiarities which are continued throughout a whole group of sculptures in stone and wood.

It seems to be typical of the 15th and 16th centuries that the figures are rather squat and powerful-looking, whilst the faces are Mongolian—as can be seen from the wood-carvings in Plates 47, 49, 51, and 53, or the bronze in Plate 37. In the next stylistic phase (around the 17th century), the naturalness of movement apparent in such figures as those illustrated by Plates 47 and 55, seems to be disappearing. There is a certain stiffness about the sculptures of the chief deities (Plates 18, 20, 21, 23, 52), and they seem to be conforming to a fixed, often repetitive norm. The artist was allowed little latitude for imagination or personal expression. This school-like conformity does not, however, prevent individual works from achieving a charm of their own (Plate 61). The elaborate ivory figure of the dancing Bhṛṅgin (Plate 66) is almost baroque in character, and the absence of the arms seems to emphasise the vigour of this apparition and its movements. Its face, with its daemonic grin, should be compared with the crude though nonetheless impressive head of the goddess Cāmuṇḍā, in baked clay (Plate 28). Close to these in time (17th–18th century) are sculptures such as the Vidyādharī hovering in the air (Plate 41), the dancing Gaṇeśa (Plate 58), Śiva in all his forms (Plate 59) and the door lintel (Plate 64), along with the clay figures in Plates 29 and 30. A beautifully balanced work of art, very much in the Indian tradition, is the ivory mirror handle (Plate 65) dating from 1733. The carvings on the spinning-wheel (Plate 63) of about 1750, and the painting of the casket (Plate 68) are also richly decorated. The human figures on the latter—if one compares them with miniatures from the Western Himalayas—would seem to suggest the early 18th century.

The lid of the casket is covered with peonies, and this decoration of large

3—N * •

rosettes plays a similar role in Central Asian and Tibeto-Chinese art to that of the lotus in Indian art. This clear link between Nepal and these eastern regions can also be seen in other features: the Buddha Śākyamuni in Plate 37, for instance, is dressed in a robe that conceals his body, in contrast to the transparent garment worn by the Dhyāni Buddha Akṣobhya (Plate 38); the flowing lines of this robe are strongly reminiscent of the graceful forms of dress depicted in Buddha figures from eastern Asia.

The influences of central and eastern Asia are clearly shown in the paintings reproduced in our illustrations. The 'hanging' picture, which is so common in Nepal (Sanskrit: *ṭaṅkā* or *paṭa;* Newari: *paubhā*), is more typical of central and eastern Asia than of India, and is frequently to be found in Tibet. It consists of a painting on specially prepared cotton cloth (Plates 73-79) which is 'framed' with bands of more or less costly silk. Wooden rollers are attached to the material at the top and bottom, so that the picture can be rolled up and easily stored to be brought out on those special occasions when it is to be exhibited. Some of these pictures are bequests to temples and monasteries, and others are kept as objects of private worship in a niche in a room set aside for a family deity. Quite often they bear inscriptions explaining the reason for the picture's creation and indicating a date (see the descriptions of Plates 73, 75, 77, 79). The image of the god Śiva, in all his emanations, united with his śakti (Plate 79), was painted in 1659 on the instructions of a famous king, Pratāpamalla of Katmandu, who reigned from 1639 to 1664, and is of outstanding quality. Sometimes the donors are unobtrusively portrayed in the lower section of the painting, wearing contemporary national dress. The 'hanging' picture of 1823 (Plate 77) depicts the paradisal world of the Dhyāni Buddha Amitābha. The composition has exact analogies in Tibetan pictures, and it follows east Asian models.

One curiosity of Nepalese art, represented in this book by three illustrations, is paintings on paper. Such pictures came into use among the upper classes around the year 1800, as replacements for 'hanging' pictures. At that time, some Nepalese dignitaries had obtained permission to import glass, and people who had come into contact with the domestic culture of European families now had their devotional pictures painted on paper, and fitted them with glass and frames and hung them up on the walls. The fashion did not last long. Plate 82 is a reproduction of such a painting on paper in an unusually broad format. Its subject is a display of dancing and music in the heaven of the King of the Gods, Indra, executed in the form of an Indian-style court festival, and the dress and accessories are a guide to the dating of the picture. In an independent group below we can also see the god Śiva, with his wife Durgā and his son Gaṇeśa.

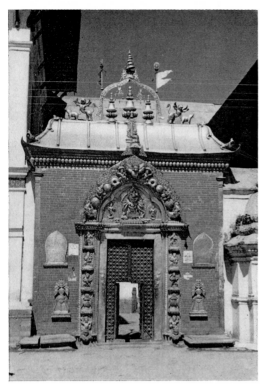

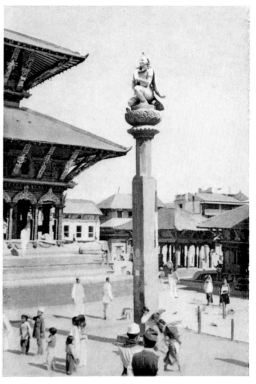

Fig. XXVII Main portal (in gilded metal) of Palace in Bhatgaon, built in 18th century by King Ranjitmalla.

Fig. XXVIII Pillar topped with Garuḍa figure in front of Kṛṣṇa Temple at Patan, built by King Siddhinarasiṃhamalla (reigned from 1620).

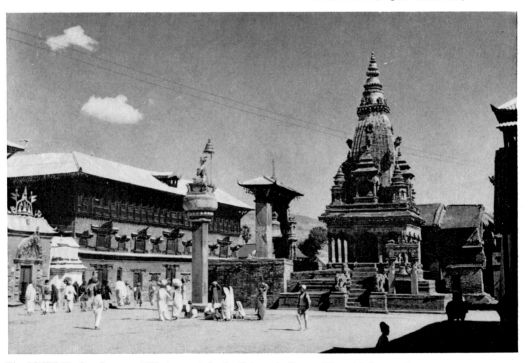

Fig. XXIX Durbar Square at Bhatgaon; left, the Palace; in front, pillar with figure of builder, King Bhūpatīndramalla (about 1700); right, stone Temple of Vatsaladevī.

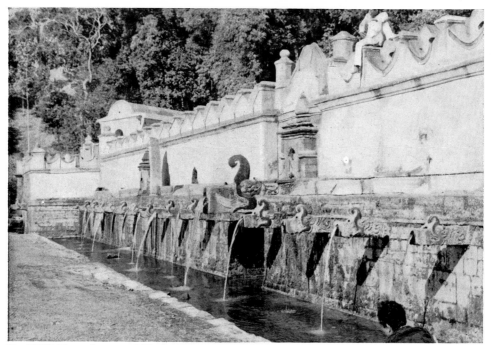

Fig. XXX Fountain: row of 22 pipes, at Bālāju, north of Katmandu; built by King
Pratāpamalla, about 1650; cf. Fig. VIII.

Fig. XXXI Durbar Square in Patan. In foreground, pillar with figure of King
Yoganarendramalla (reigned from 1698).

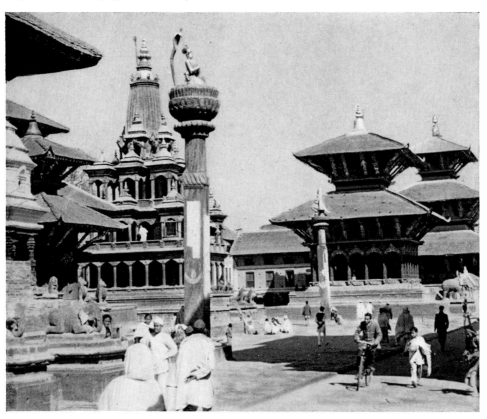

PLATES

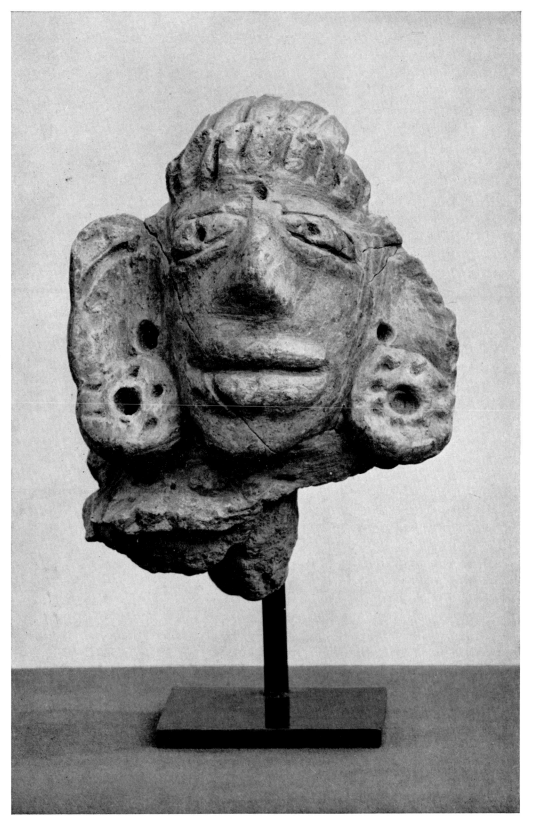

1 Woman's head. 3rd century BC. Baked clay hand moulded; yellowish pink on grey core.
Height 12 cm., breadth 9·5 cm. Find from 1964–65 excavation in Banjarahi (near Lumbinī
Grove, Buddha's birthplace), in District of Bhairawa. Department of Archaeology,
Katmandu.

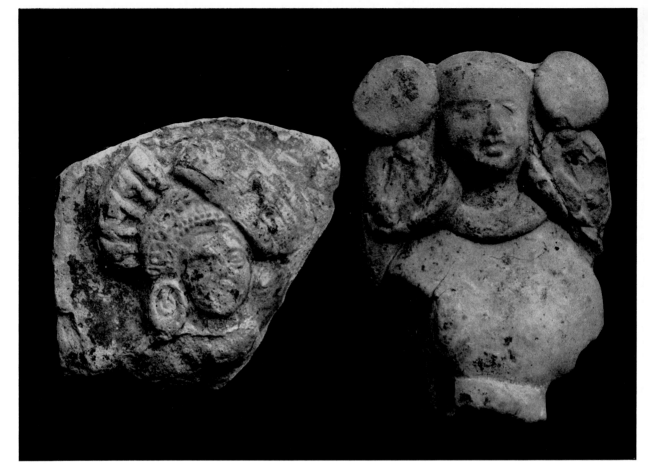

2 and 3

Woman's head in bas-relief. Fragment of a plaque. 2nd–1st century BC. Baked grey clay, impressed with aid of a mould and covered with layer of yellowish pink plaster; brownish red lacquering. Height 6·5 cm., breadth 7·4 cm.

Bust of woman, with heavy ornaments on head and ears. 2nd–1st century BC. Baked clay, pinkish red; head ornaments hand-moulded and added separately. Height 8·6 cm., breadth 6·5 cm.

6

Damaged terra-cotta figure of ram. Offering? 2nd–1st century BC. Baked clay, pinkish red. Height 6·4 cm., breadth 9 cm.

4 and 5 Left and right thighs of female figure—folds of robe between. Fragment from a bas-relief. 1st century BC or AD. Baked pinkish red clay. Height 6·5 cm., breadth 6 cm.
Lower part of female body with wide girdle. Fragment of bas-relief. 1st century BC or AD. Baked clay, pinkish red. Height 9·8 cm., breadth 6·5 cm.

7

2–7 are finds from 1962–63 excavation in Tiraulakot-Kapilavastu (home town of Buddha), in District of Taulihawā. Department of Archaeology, Katmandu.

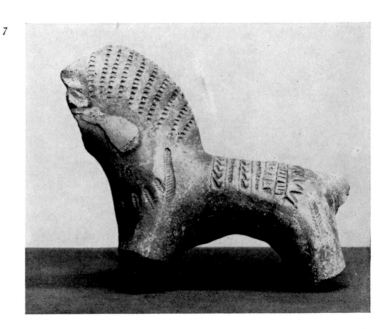

Damaged terra-cotta figure of horse. Offering? 2nd–1st century BC. Baked clay, pinkish red; heavy reddish brown lacquering, polished (?). Height 11 cm., breadth 14·7 cm.

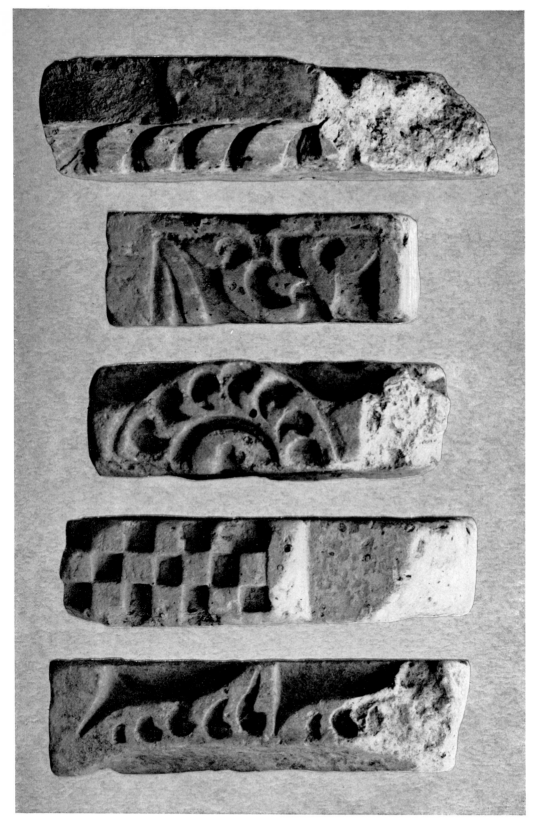

Five ornamental bricks from a temple. Medieval. Height 5–5·5 cm., length 15–21·3 cm., breadth 14·3–19 cm. Heavy yellow baked brick. Lori Kudān, District of Taulihawā. 1962–63 excavation. Department of Archaeology, Katmandu.

8

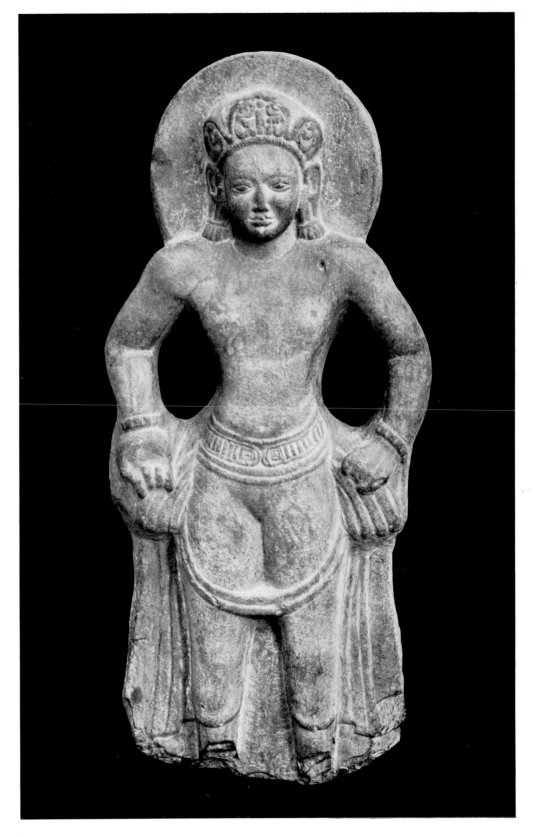

9 Statue of a prince or god. 4th–5th century AD. Grey limestone. Height 40 cm., breadth
18·8 cm. According to Kramrisch, from 'Gorakshanath Monastery, Mrigasthali, Pashupati,
Nepal'. Bir Library, Katmandu.

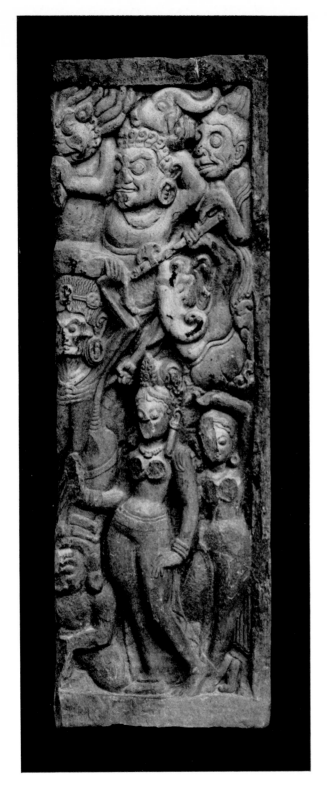

10

Fragment from Māra's attack on the prince who later became the Buddha during his struggle for Enlightenment—attempted seduction by Māra's daughters. 6th century AD. Height 75 cm., breadth 26 cm. Dark grey, partly faded limestone. Archaeological Garden, Lalitpur.

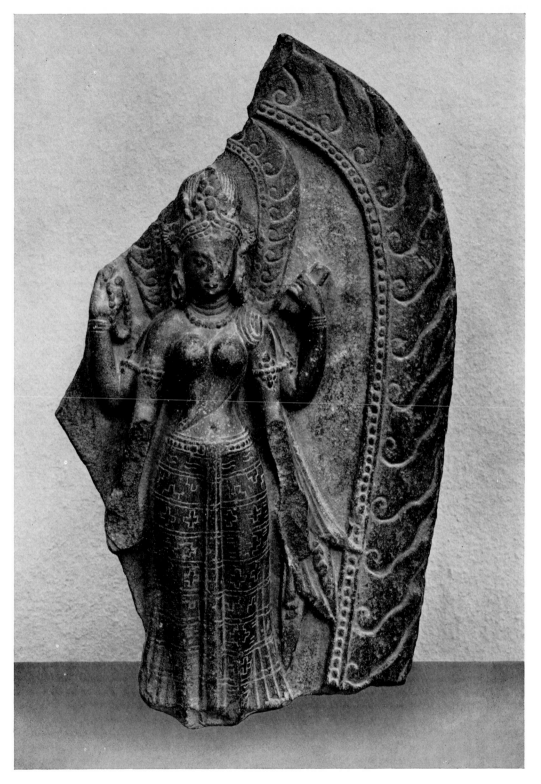

11

Stele with relief of Sarasvatī, goddess of learning and the arts. 7th century AD. Greenish grey limestone. Height 65 cm., breadth 37 cm. National Art Gallery, Bhaktapur.

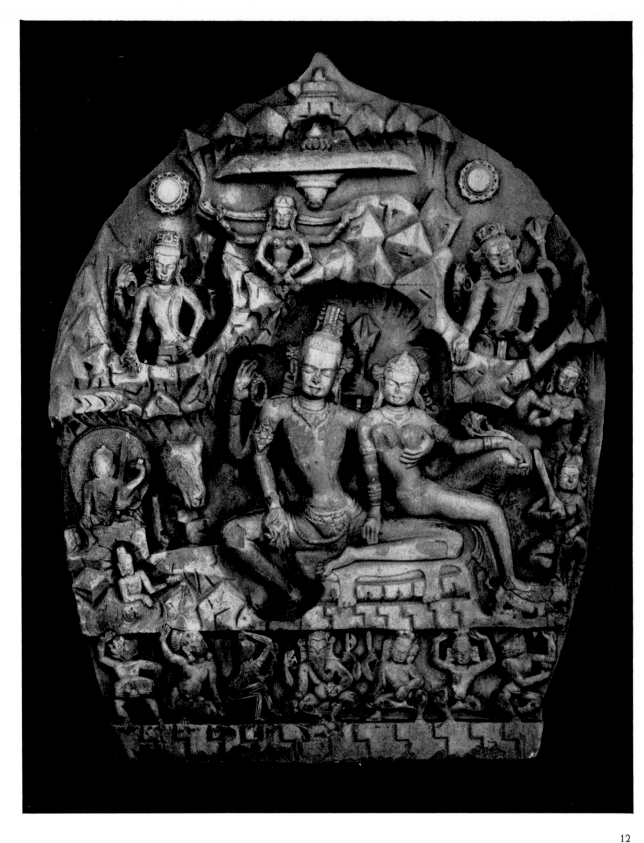

12

God Śiva in happy union with wife Umā (*umāsahita maheśvara*) in Himalayan mountain-
cave on Kailāsa, surrounded by members of family. 8th–9th century AD. Greenish grey
limestone. Height 100 cm., breadth 80 cm. Archaeological Garden, Lalitpur.

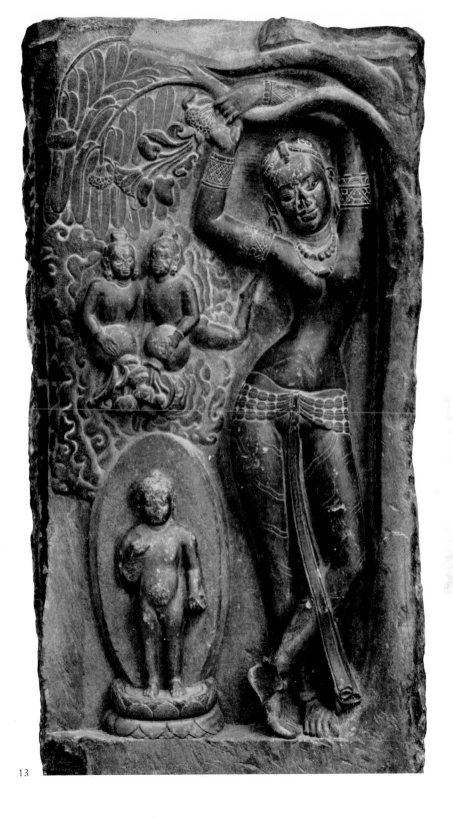

13

Birth of Prince Siddhārtha of Śākya tribe of Kapilavastu; later the Buddha Gautama. 9th
century. Blue-grey limestone, brightly polished. Height 84 cm., breadth 33 cm. Sundara
Fountain, Deo Pattan, Nepal. Archaeological Garden, Lalitpur.

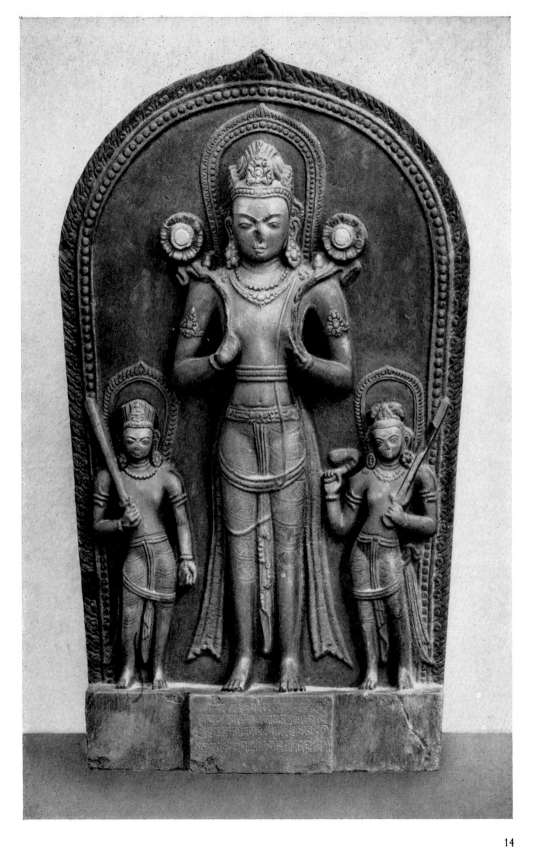

Sūrya, the Sun-God, with two dependants. 1065 (inscription). Stele with relief in grey-black limestone. Height 73 cm., breadth 47 cm. Archaeological Garden, Lalitpur.

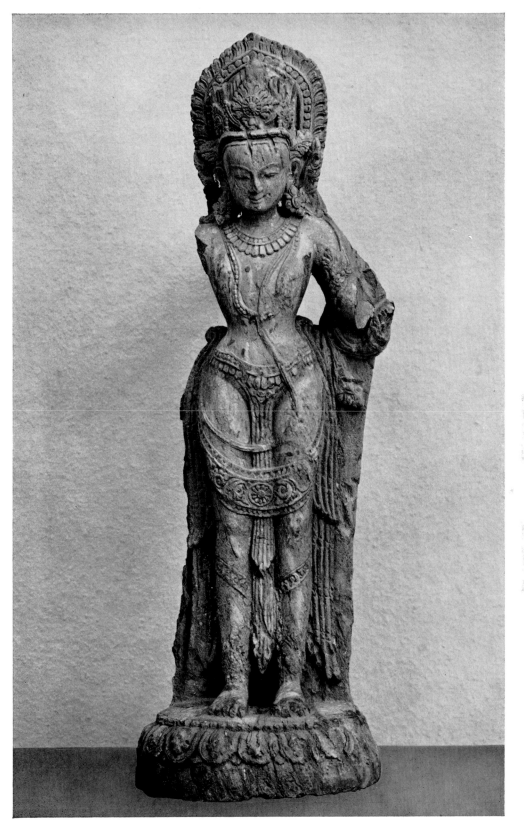

15

Slender male deity without attributes, sometimes called Avalokiteśvara. 13th–14th century.
Statue of greenish grey limestone. Height 60·5 cm., breadth 20 cm. Archaeological Garden,
Lalitpur.

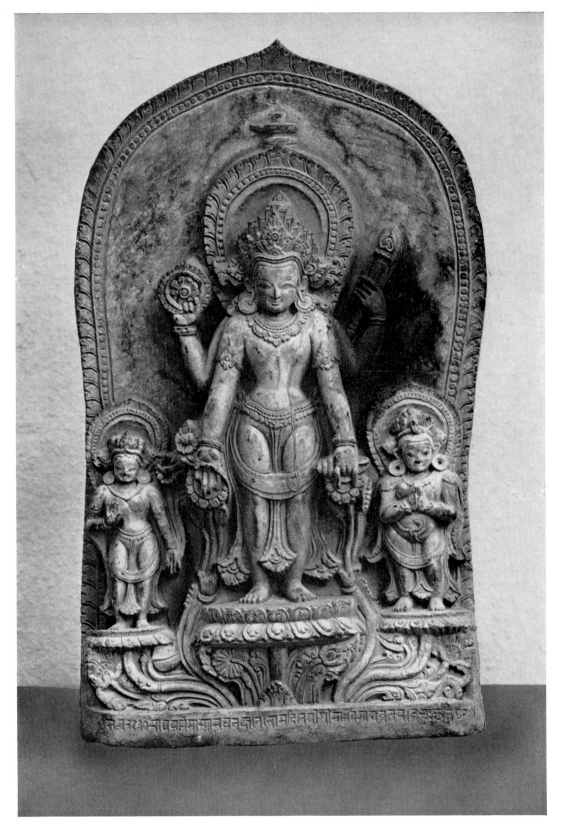

God Viṣṇu, with Lakṣmī and Garuḍa. Nepalese Era 537 = 1417 (inscription). Stele in grey
limestone. Height 49 cm., breadth 30 cm. Archaeological Garden, Lalitpur.

17

Head of sea-monster (*makara*). Decoration on water-pipe. 17th century. Grey limestone. Height 9·7 cm., breadth 36 cm., thickness about 10 cm. Archaeological Garden, Lalitpur.

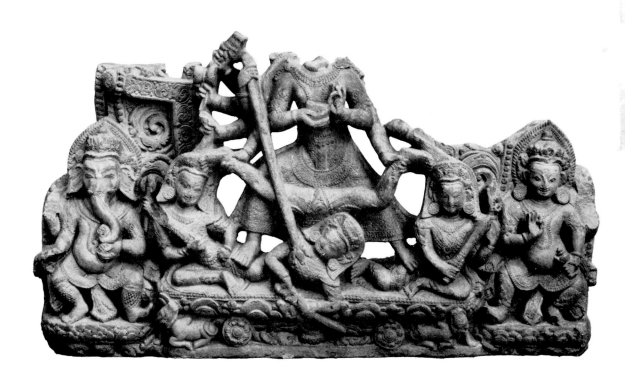

18

Śiva's wife Durgā killing demon Mahiṣa (*mahiṣāsura-mardinī*). 17th–18th century. Relief in grey limestone. Height 45 cm., breadth 81 cm. Bhaktapur Museum, Bhaktapur.

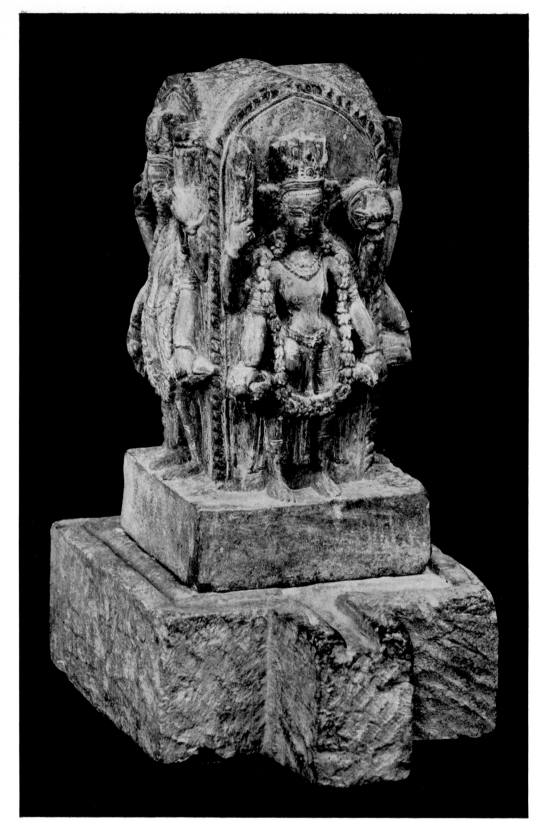

God Viṣṇu in four manifestations (*caturvyūha viṣṇu*) as relief on four sides of truncated
pillar. 18th century. Blackened limestone. Height 28·2 cm., breadth 15 cm. (without socle).
Archaeological Garden, Lalitpur.

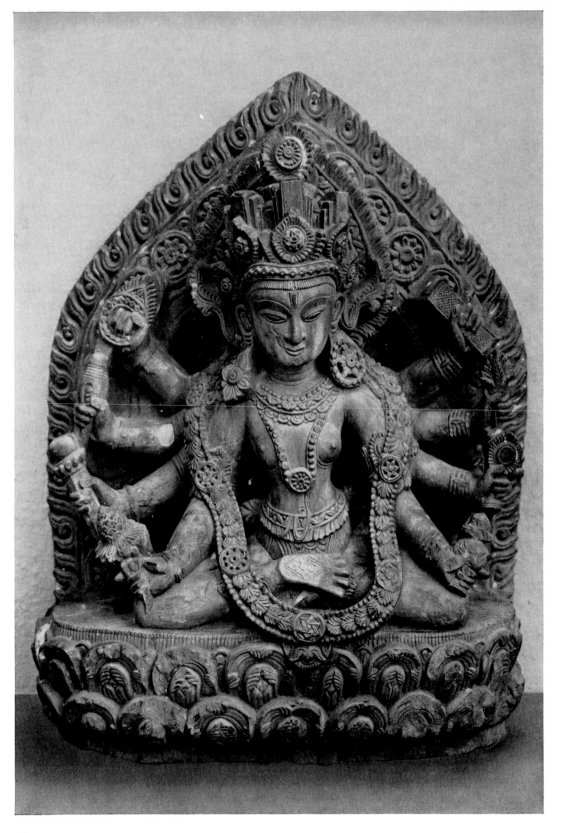

20 Androgynous figure of god Nārāyaṇa-Viṣṇu (right half of body) with wife Lakṣmī (left half). 17th century. Grey limestone. Height 41 cm., breadth 32 cm. National Art Gallery, Bhaktapur.

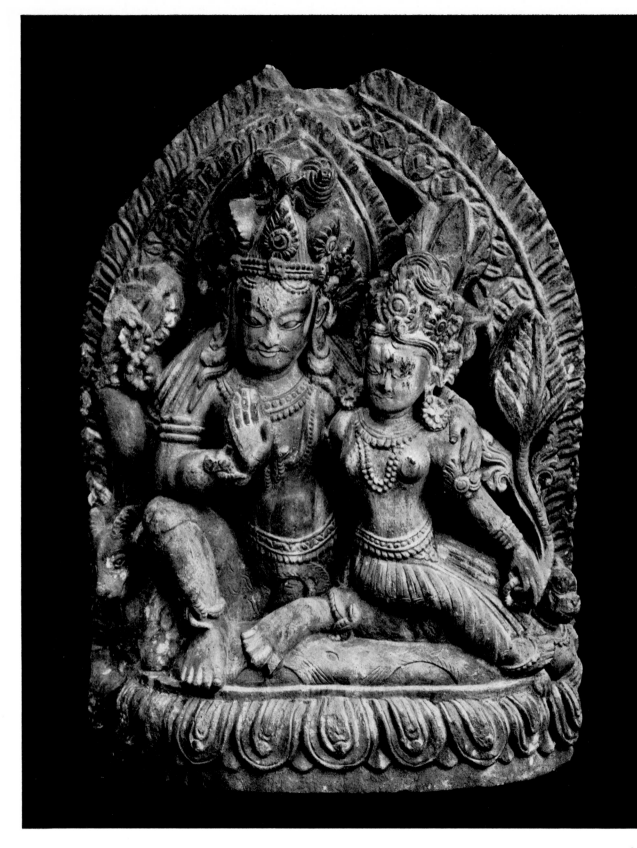

Śiva in happy union with wife Umā (*umāsahita maheśvara*). 17th–18th century. Dark grey limestone. Height 34·5 cm., breadth 26·5 cm. National Art Gallery, Bhaktapur.

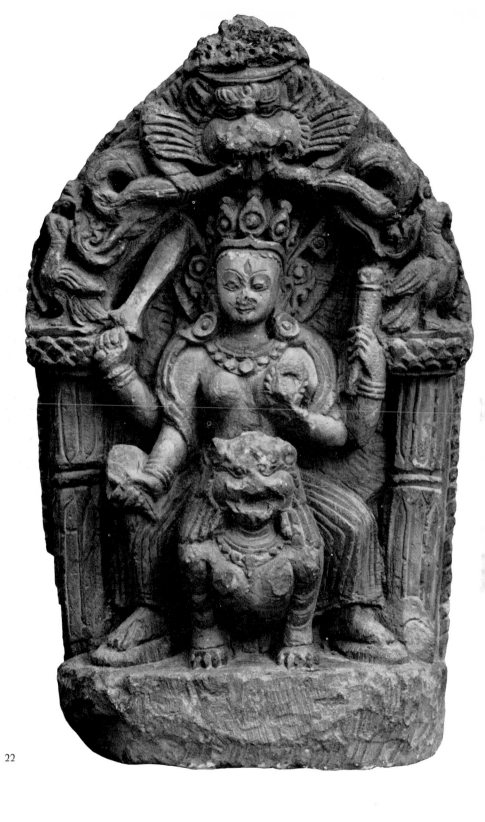

22

Durgā, Śiva's wife, four-armed, riding her mount, the lion. 18th century. Grey limestone. Height 61 cm., breadth 39 cm. Archaeological Garden, Lalitpur.

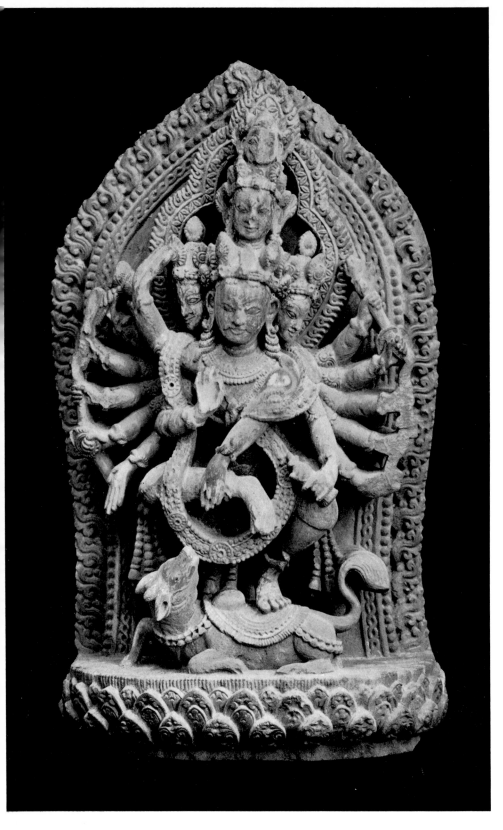

23

Śiva as God of the Dance (*nṛtyeśvara*) with five heads and fourteen arms, on mount, the bull Nandin. 17th century. High relief on fretted grey limestone stele. Height 36·5 cm., breadth 22·3 cm. National Art Gallery, Bhaktapur.

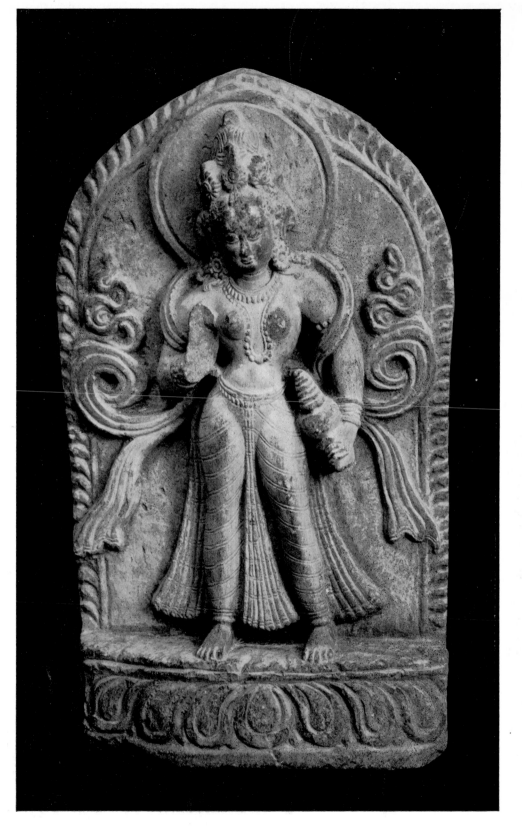

24

Viṣṇu's wife Lakṣmī, goddess of fortune and beauty. 17th century. High relief on small grey-green limestone stele. Height 22 cm., breadth 13·8 cm. Archaeological Garden, Lalitpur.

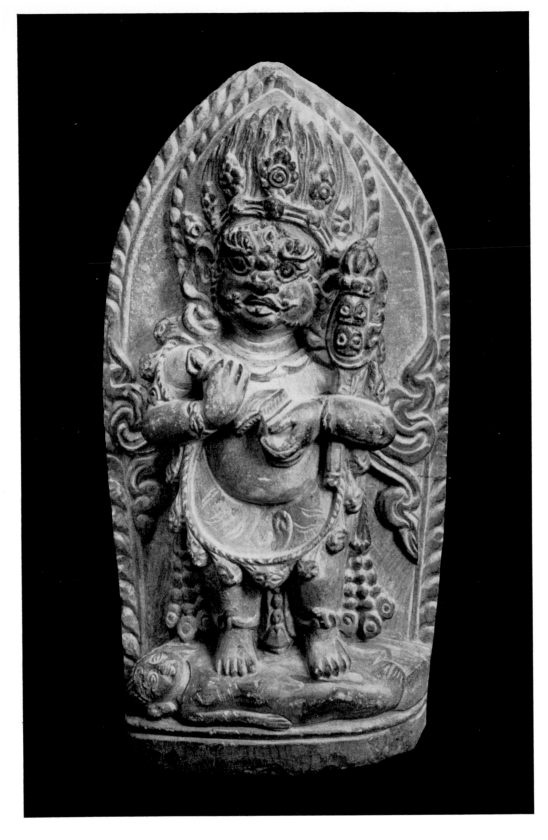

25

Mahākāla, 'The Great Black One', late Buddhist protective deity. 17th century. High relief on small grey limestone stele. Height 20·5 cm., breadth 11·2 cm. Archaeological Garden, Lalitpur.

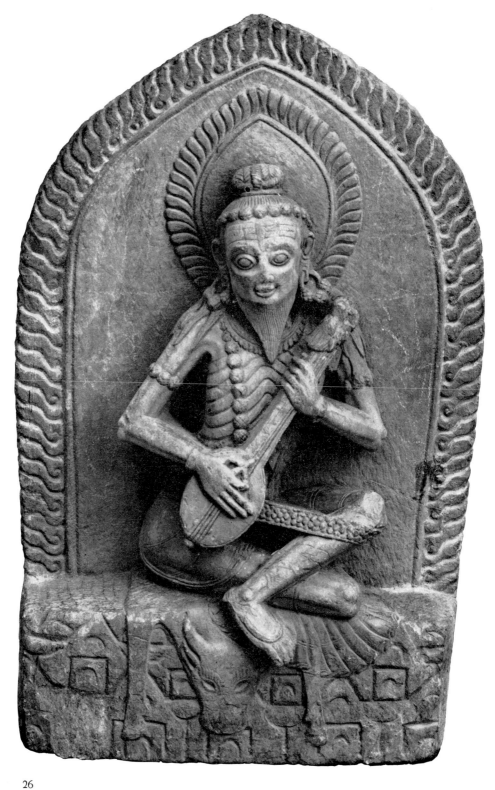

26

Nārada, lord of heavenly musicians, depicted as emaciated penitent. 15th–16th century. High relief on yellowish grey limestone stele. Height 46 cm., breadth 30·5 cm. Archaeological Garden, Lalitpur.

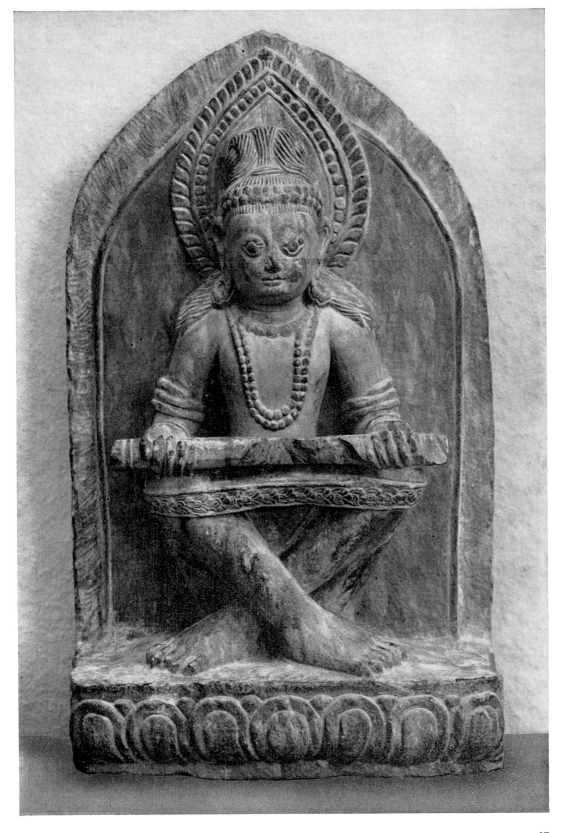

A holy one 'endowed with perfection' (*siddha*) doing exercises. 17th century. High relief on light grey limestone stele. Height 44 cm., breadth 27·5 cm. Archaeological Garden, Lalitpur.

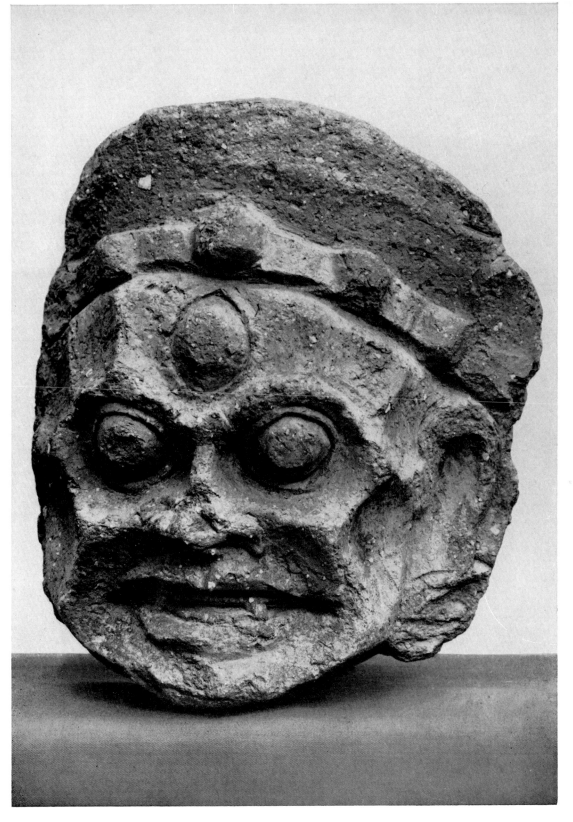

Head of goddess Cāmuṇḍā. 18th century. Baked red clay. Height 29·7 cm., breadth 26 cm. Bhaktapur Museum, Bhaktapur.

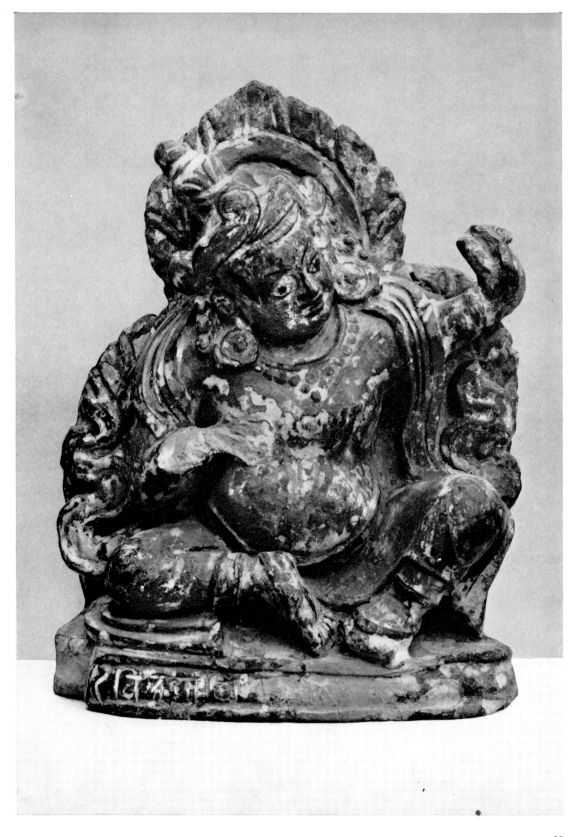

29

Virūpākṣa, 'strange eyed', an aspect of the god Bhairava. 18th century. Baked red clay,
burnt black and spotted (sintered). Height 24 cm., breadth 19·5 cm. Nepal Museum,
Katmandu.

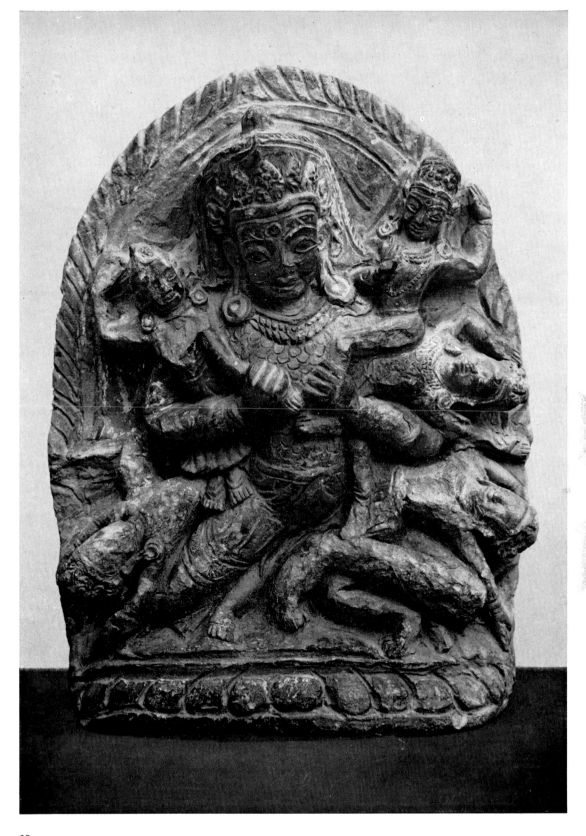

Bhīma (= Bhīmasena), one of the heroes of the Epic Mahābhārata, destroying five adversaries at one blow. 18th century. Small stele of red clay. Height 26 cm., breadth 20·5 cm. Nepal Museum, Katmandu.

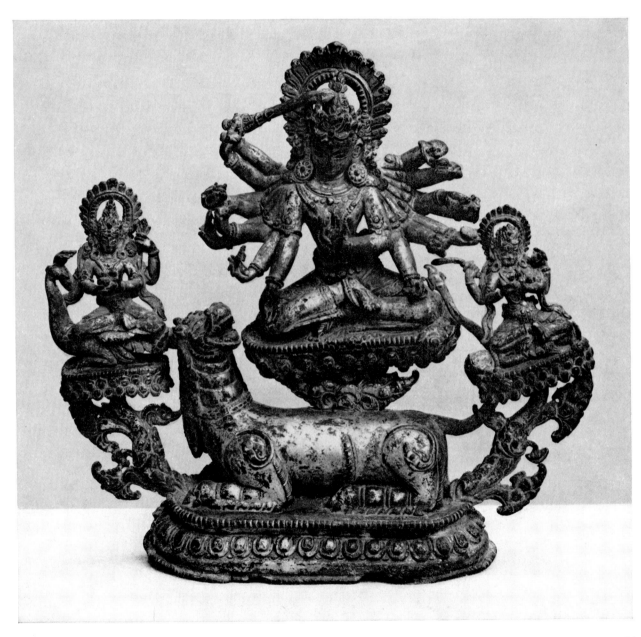

Mahālakṣmī, Viṣṇu's female complement (*śakti*), on roaring lion, together with two other
mother deities. 13th century. Bronze cast with gilded surface. Height 17 cm., breadth 18 cm.
Nepal Museum, Katmandu.

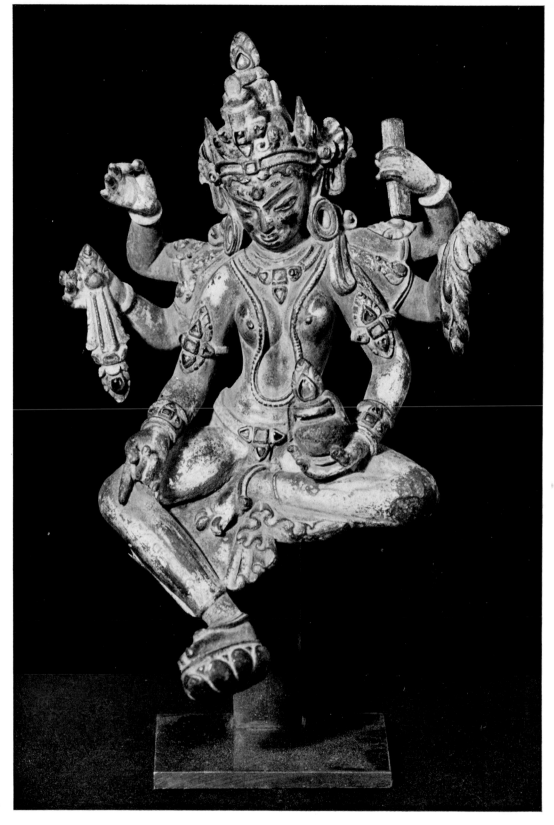

'Rich in Treasures' (*vasundharā, vasudhārā*), wife of Jambhala, god of wealth. 13th–14th century. Bronze cast with gilded surface, crown and ornaments inlaid with jewels. Height 16 cm., breadth 10·8 cm. Nepal Museum, Katmandu.

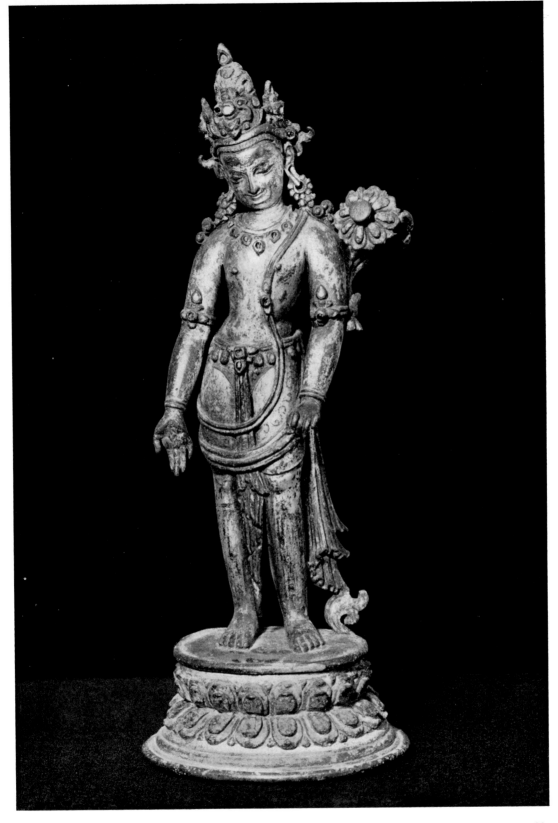

Padmapāṇi-Avalokiteśvara, saviour deity of Mahāyāna Buddhism, distinguished by lotus flower in left hand. 13th–14th century. Bronze cast, gilded surface, jewels inlaid in crown and other ornaments. Height 19·2 cm., breadth 7·5 cm. Nepal Museum, Katmandu.

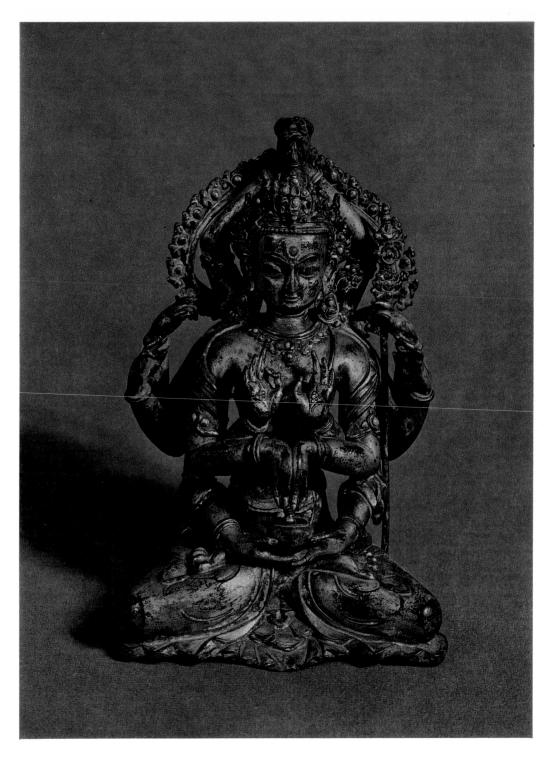

34

Bodhisattva Nāmasaṃgīti, emanation of Dhyāni-Buddha Vairocana. 14th century. Bronze cast, gilded surface, precious stones (turquoise) inlaid in crown and ornaments. Height 18·5 cm., breadth 12 cm. Nepal Museum, Katmandu.

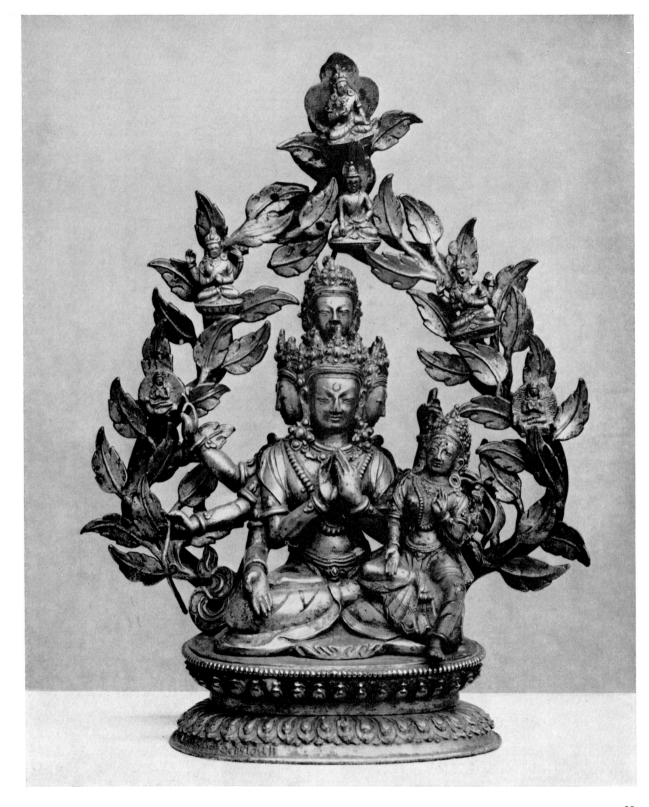

Lokeśvara, 'Lord of the Universe', Buddhist deity, a form of Avalokiteśvara, four-headed,
with female complement (*śakti*). 1806. A Newari inscription on back gives date as 926 in
Nepalese Era, and also names of donors. Gilded bronze; figures in main group and socle
cast; garland of leaves (mandorla) chased, with small figures fitted in individually. Height
29 cm., breadth 23 cm. Nepal Museum, Katmandu.

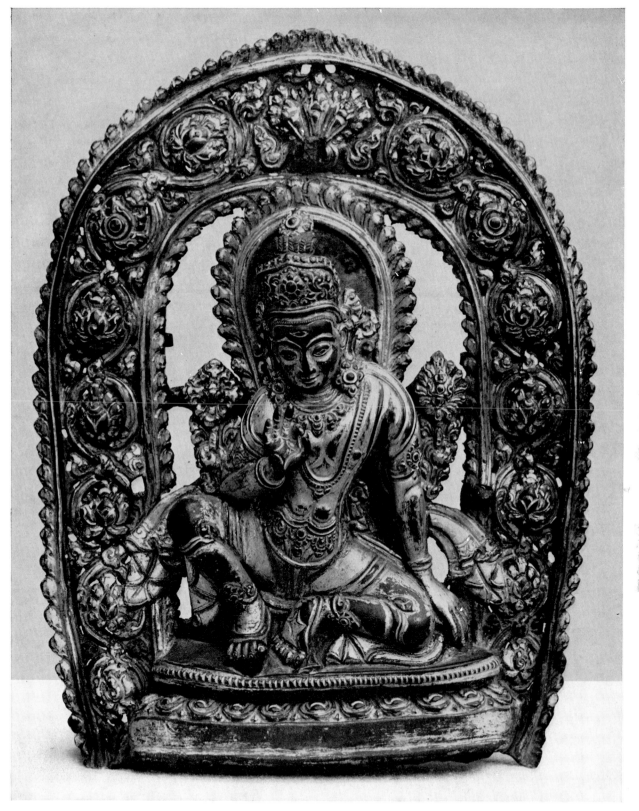

36

Indra, king of the gods, three-eyed, making gesture of explanation (*vyākaraṇamudrā*). 16th century. Bronze, with gilded surface; aureole (mandorla) made separately of copper gilt. Height 18 cm., breadth 14 cm. Nepal Museum, Katmandu.

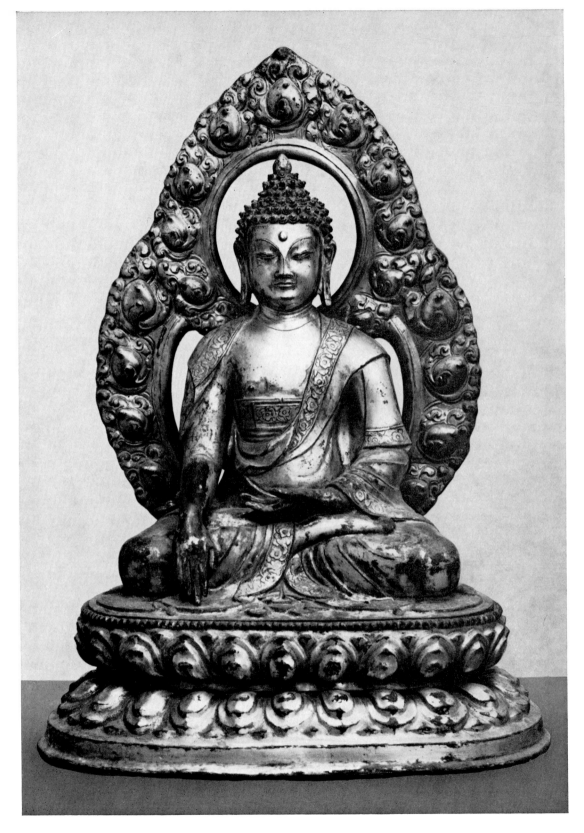

Buddha Śākyamuni, making gesture of touching the earth. 15th century. Bronze cast with gilded surface. Aureole (nimbus and mandorla) chased and detachable. Height 34·5 cm., breadth 26·2 cm. Nepal Museum, Katmandu.

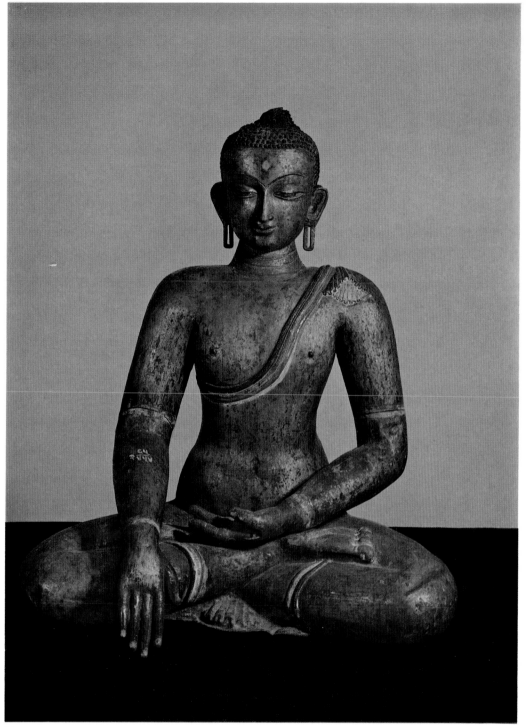

38

Image of Dhyāni-Buddha Akṣobhya making gesture of touching the earth. 15th–16th century. Chased bronze, gilded and partly painted over. The forearms and hands have been joined on separately. Height 76 cm., breadth 66 cm. Nepal Museum, Katmandu.

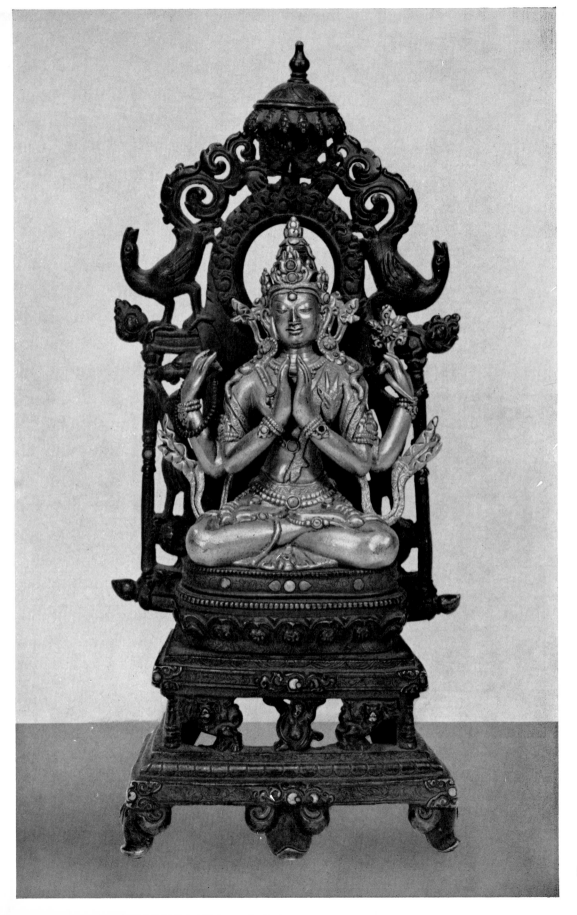

39

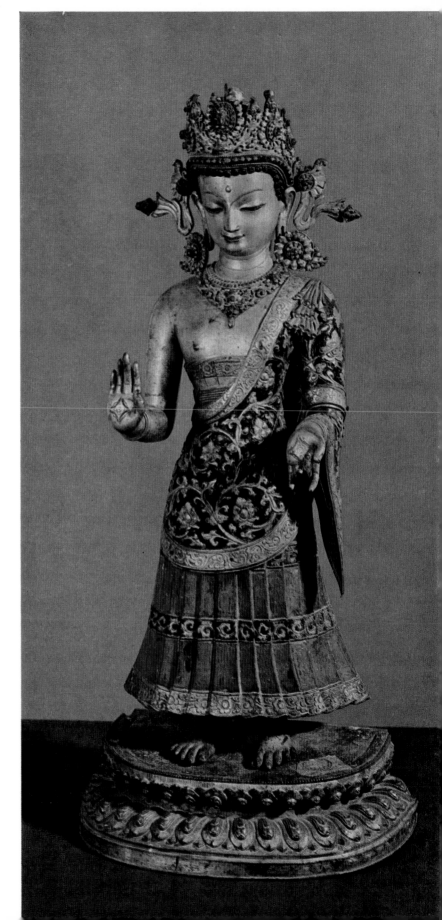

Ṣaḍakṣarī Lokeśvara, a form of the
Bodhisattva Avalokiteśvara, on throne
with ornamental back beneath canopy.
18th–19th century. Bronze cast,
encrusted with precious stones. Figure
gilded. Height 25 cm., breadth 11·1
cm. Museum für Indische Kunst,
Berlin (I 9930).

Buddha Dīpaṅkara, a predecessor of
historic Buddha, standing on lotus,
making gesture of protection
(*abhayamudrā*). 17th century. Bronze,
chased and gilded. Decorations on
clothing inlaid with black lacquer;
bottom of robe painted red. Inlaid
jewels and semi-precious stones
(turquoise, garnet, white sapphire) in
crown and ornaments. Height 71 cm.,
breadth 34·5 cm. Nepal Museum,
Katmandu.

40

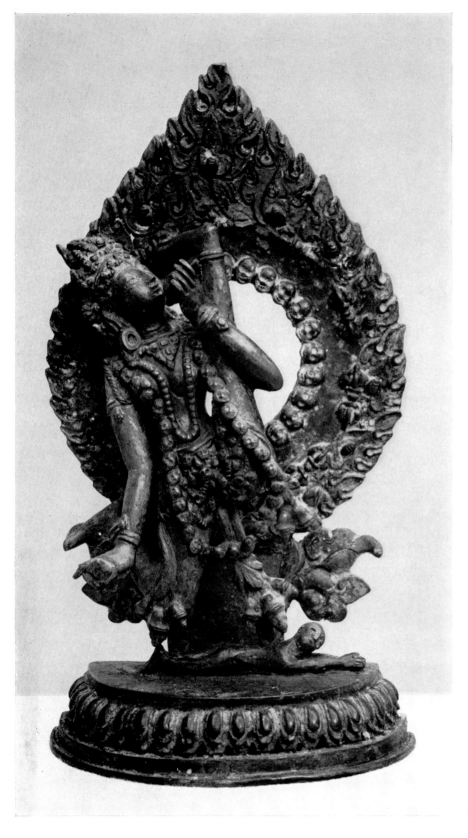

'Sorceress' (*vidyādharī*), a yoginī flying through the air. 17th century. Plinth and figure made of cast brass; aureole (mandorla) made separately of copper. Height 21 cm., breadth 20 cm. Nepal Museum, Katmandu.

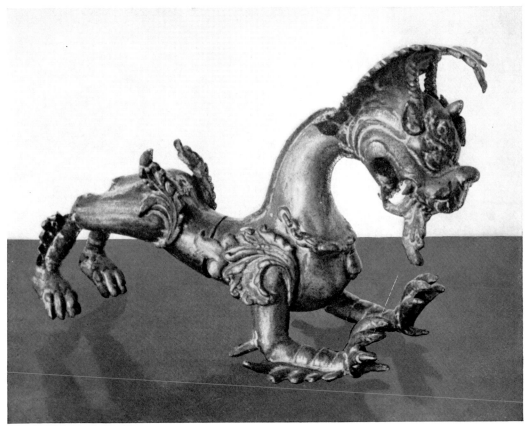

42

Lion-like mythical creature, winged and horned. 18th century. Bronze cast. Height 20 cm., length 29 cm., breadth 14 cm. On permanent loan to Museum für Indische Kunst, Berlin.

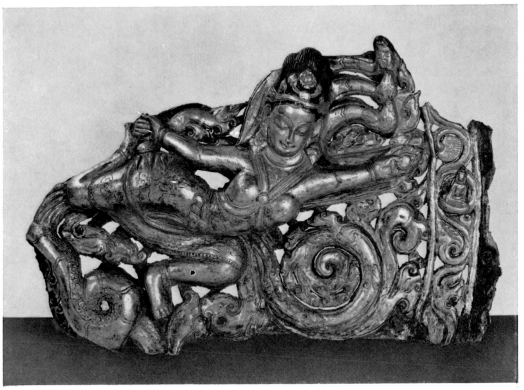

43

Snake goddess (Nāgī) amid ornamental plants. 16th–17th century. Copper plate, chased and gilded. Height 21 cm., breadth 33 cm. Museum für Indische Kunst, Berlin (I 9931).

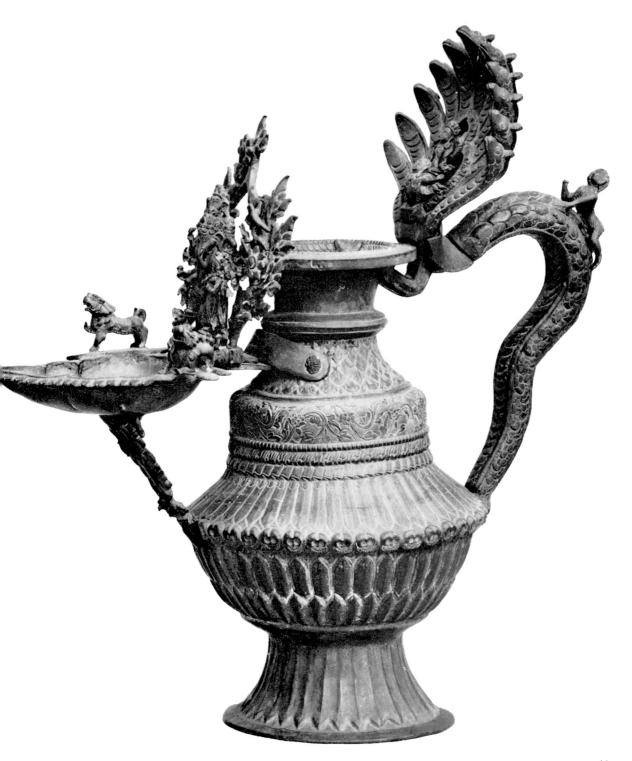

Cultic lamp (*sukuṇḍa*). Early 19th century. Bronze cast, assembled in individual parts.
Height 41 cm., breadth 19·5 cm., total width 42 cm. Nepal Museum, Katmandu.

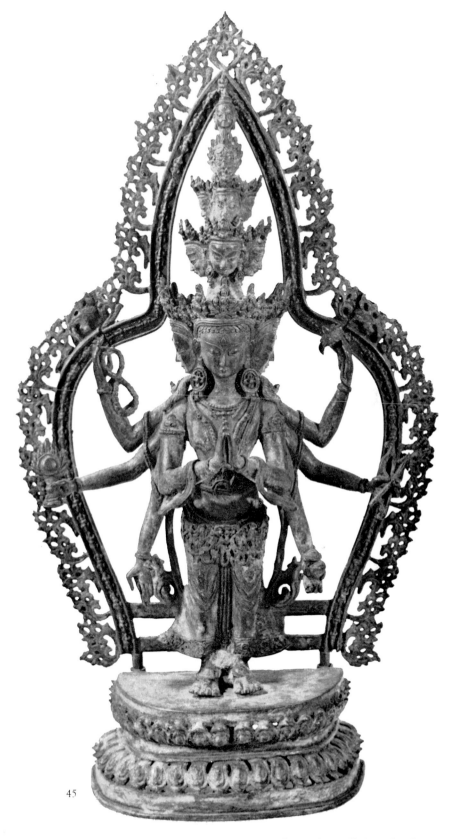

45

Bodhisattva Avalokiteśvara, eleven heads and eight arms, standing on lotus plinth, enclosed in open-work mandorla. 19th–20th century. Bronze cast. Height 53 cm., breadth 30 cm. Museum für Indische Kunst, Berlin (I 9995 a–c).

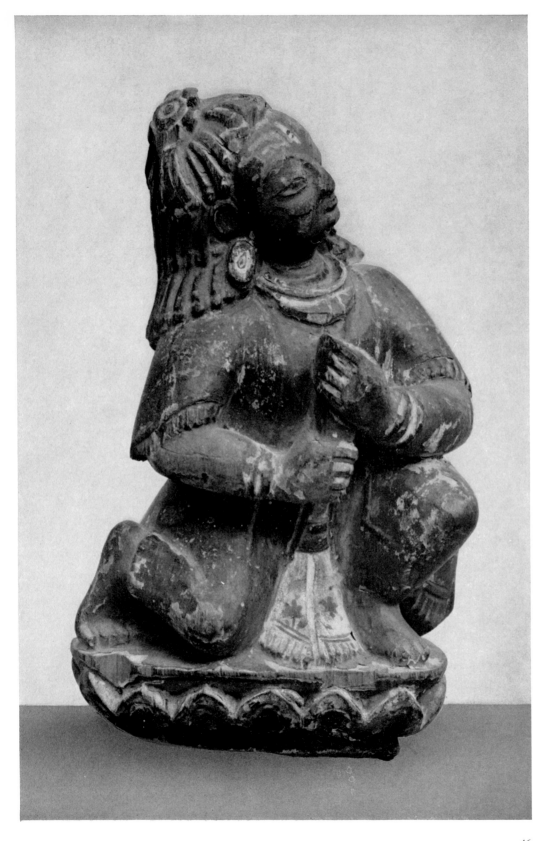

The bird Garuḍa, mount and attendant on god Viṣṇu, represented in human form,
kneeling. 17th–18th century. Small sculpture, carved in wood, covered over in plaster, and
painted. Height 15 cm., breadth 9·5 cm. Bhaktapur Museum, Bhaktapur.

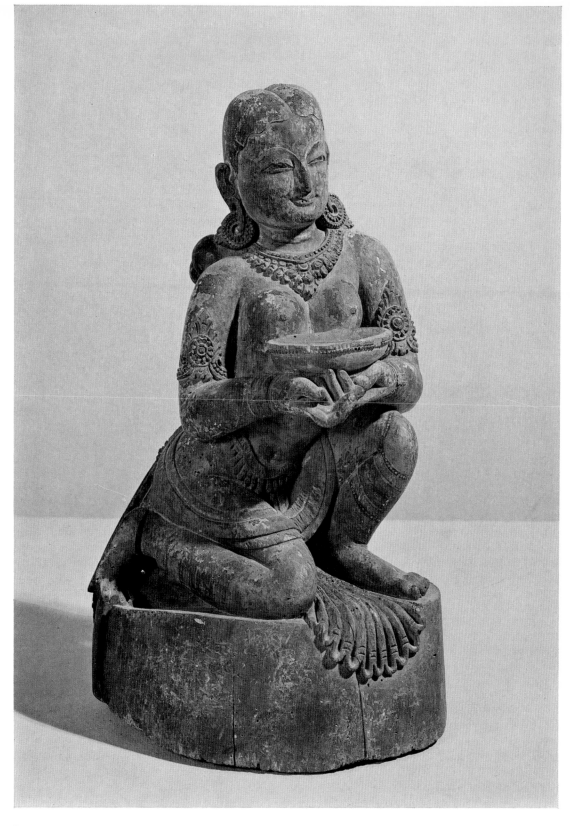

47

Female donor kneeling with bowl containing gift. 15th century. Carved wood tinted dark brown; traces of bright paint. Height 69 cm., breadth 40 cm. Bhaktapur Museum, Bhaktapur.

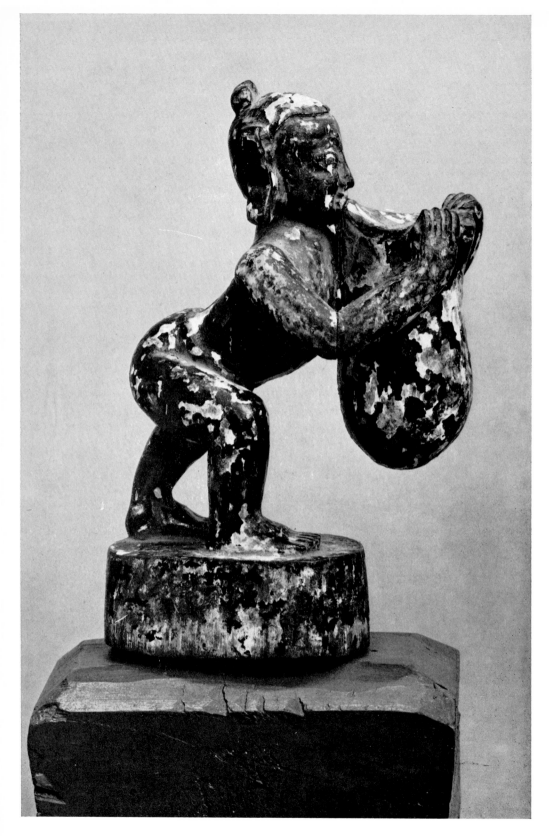

Gnome-like being (*yakṣa*) holding open a sack and asking for a gift. 17th century. Small, dark brown wood-carving, covered with plaster and painted over. Height 17 cm., breadth 11·5 cm. Bhaktapur Museum, Bhaktapur.

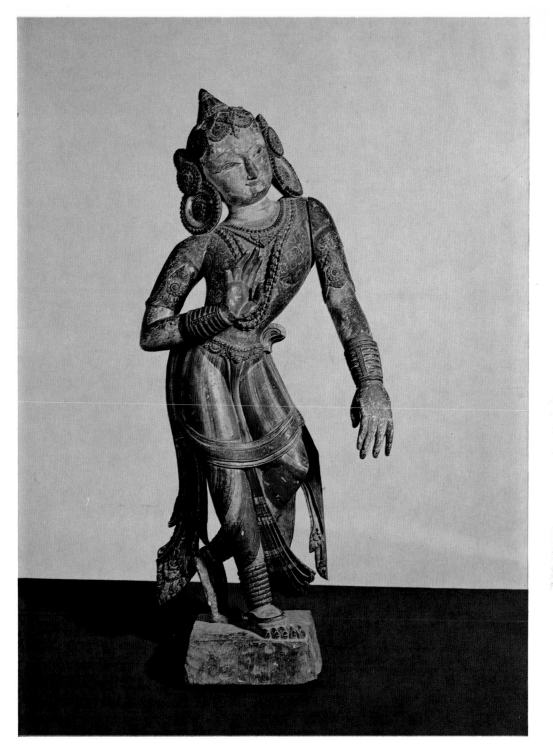

49

Dancing girl (*nṛtyadevī*) dressed as queen. 15th century. Animated figure carved from a single piece of wood, apart from left arm which has been joined on separately, and painted over. Height 85·5 cm., breadth 36 cm. Bhaktapur Museum, Bhaktapur.

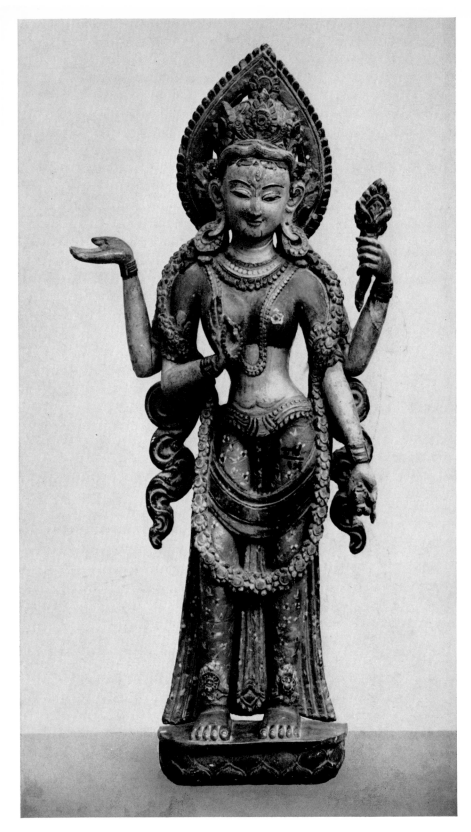

50

Bhṛkuṭī Tārā, i.e. the Tārā with frowning eyebrows (*bhṛkuṭī*); emanation of Dhyāni-Buddha Amitābha. 18th century. Wood-carving covered with plaster, painted in bright colours (red, blue, green, yellow, brown) which have been touched up; partly gilded. Height 84·5 cm., breadth 39 cm. Bhaktapur Museum, Bhaktapur.

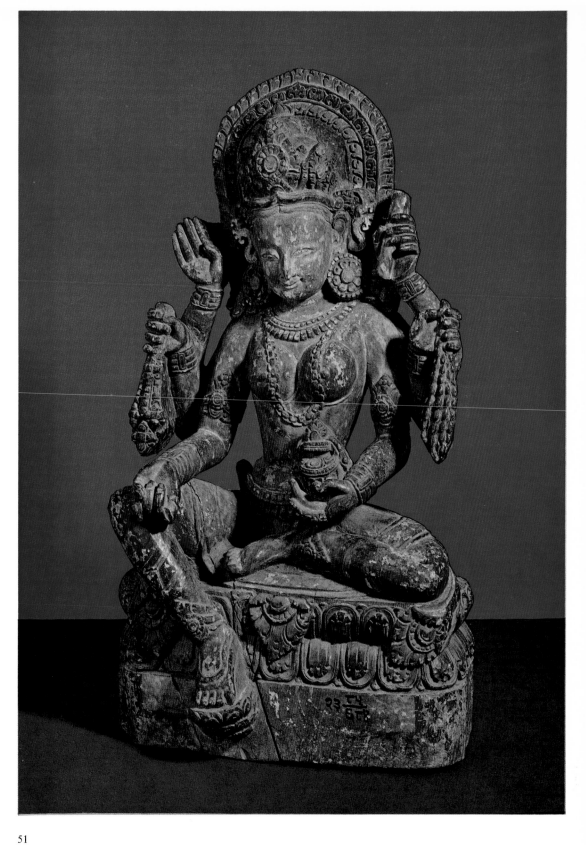

'Rich in Treasures' (*vasundharā*, *vasudhārā*), wife of Jambhala, god of wealth. 15th–16th century. Painted wood-carving. Height 71 cm., breadth 37·5 cm. Bhaktapur Museum, Bhaktapur.

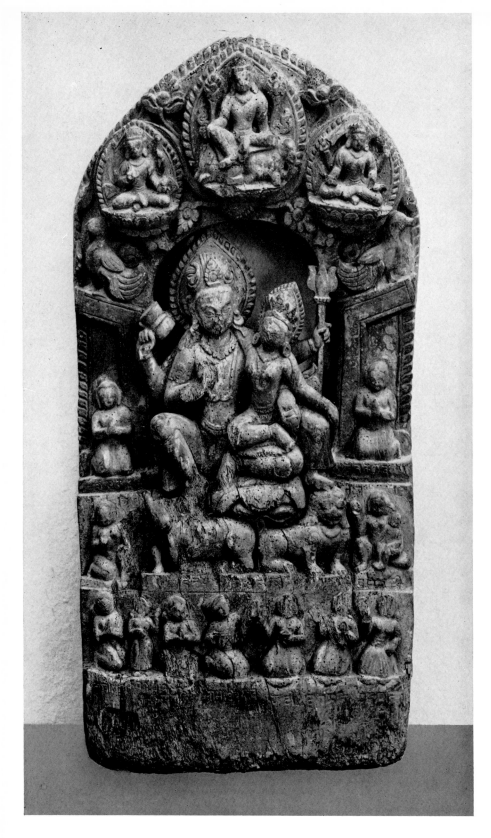

Śiva with wife Umā, in happy union (*umāsahita maheśvara*). 17th–18th century. Wood-carving. Height 67 cm., breadth 34 cm. Archaeological Garden, Lalitpur.

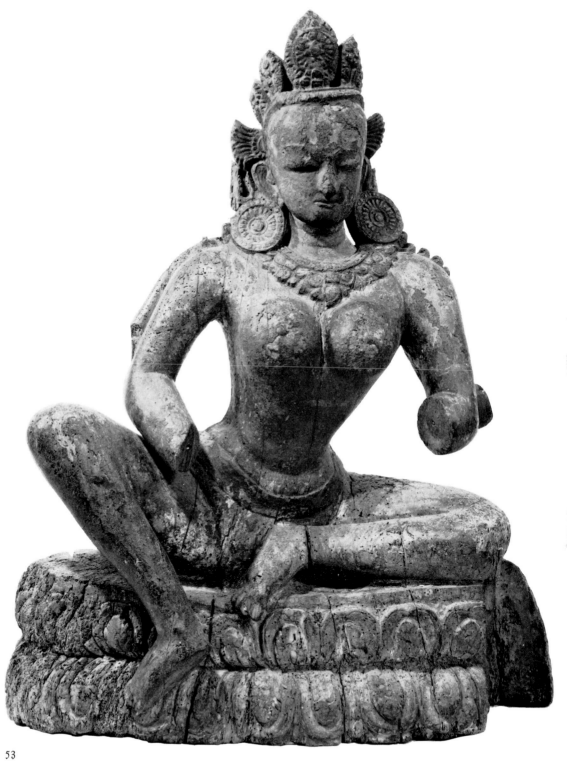

Tārā, Buddhist 'helper to salvation', seated on lotus. 15th–16th century. Wood-carving. Height 72 cm., breadth 58 cm. Museum für Indische Kunst, Berlin (I 10026).

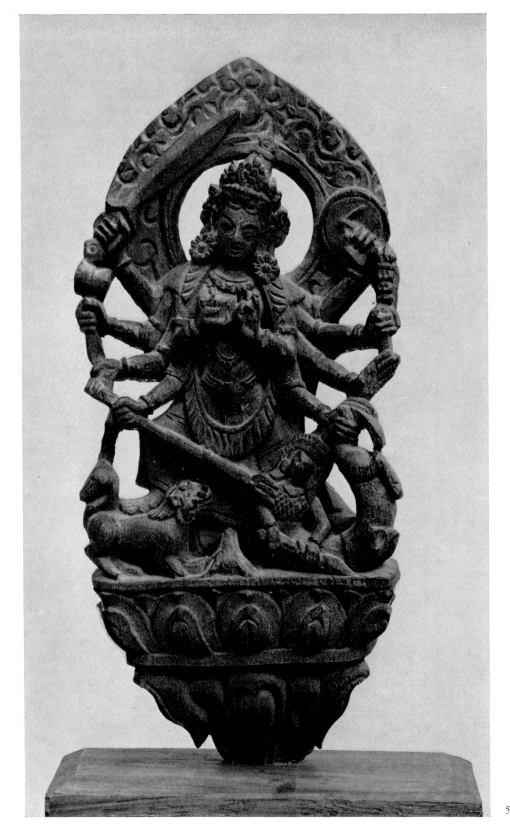

Śiva's wife Durgā killing the demon Mahiṣa (*mahiṣāsuramardinī*). 17th century. Wood, paint worn off. Height 32 cm., breadth 15 cm. Bhaktapur Museum, Bhaktapur.

54

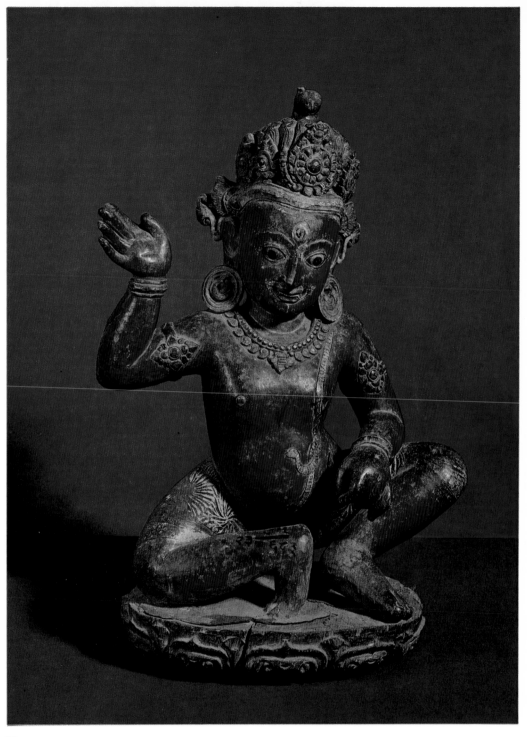

Hayagrīva, 'Horse-Neck', dependant of Buddhist deities, also servant to god of death Yama (*yama-kiṅkara*). 16th century. Wood-carving covered with brightly painted plaster. Height 56·5 cm., breadth 38 cm. Bhaktapur Museum, Bhaktapur.

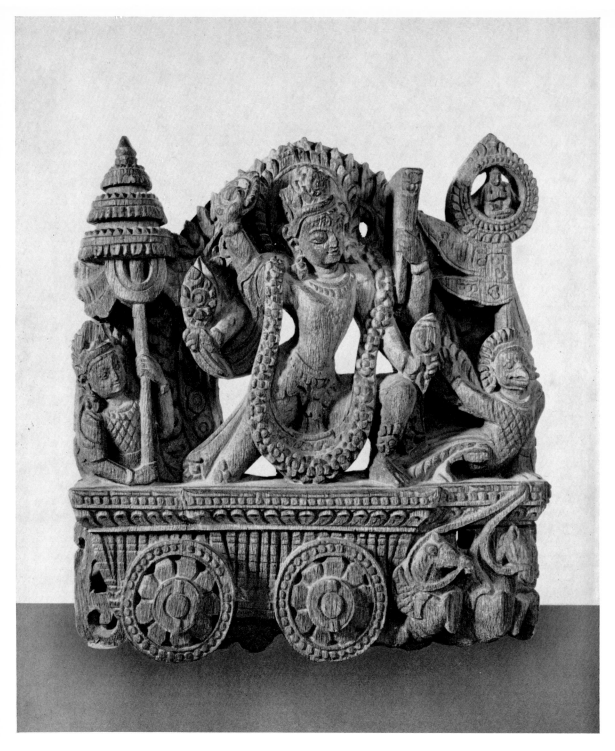

56

God Viṣṇu in warlike pose on war-chariot; right, the bird Garuḍa with Viṣṇu's standard;
left, canopy-bearer. 17th century. Wood-carving. Height 26 cm., breadth 24 cm. Museum
für Indische Kunst, Berlin (I 10002).

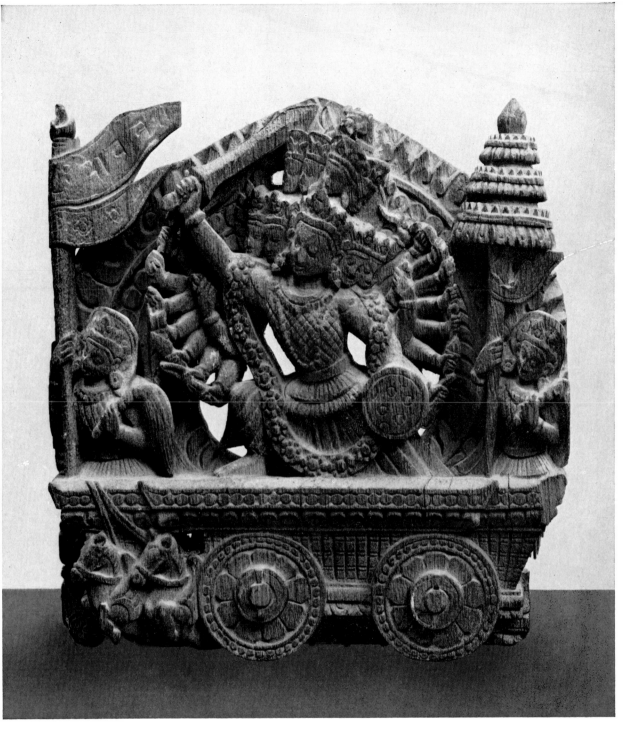

Rāvaṇa, the ten-headed demon from the heroic epic Rāmāyaṇa, storming into battle on his war-chariot. 17th century. Wood-carving. Height 26 cm., breadth 24·5 cm. Bhaktapur Museum, Bhaktapur.

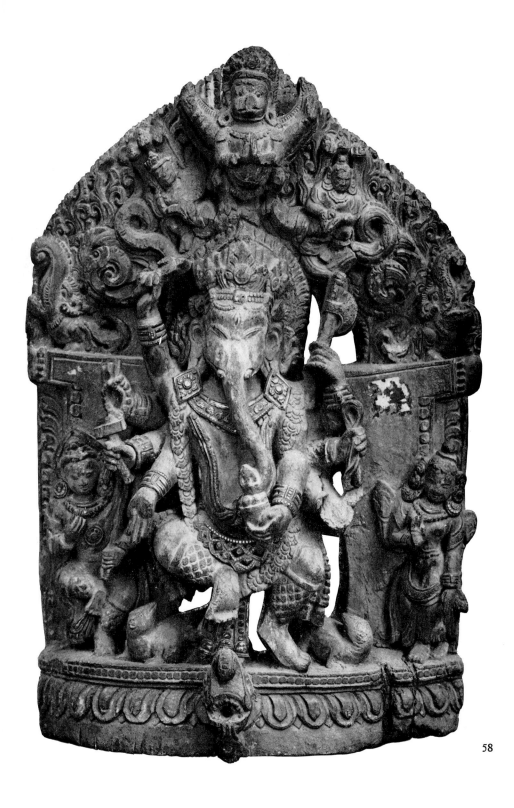

58

Śiva's elephant-headed son Gaṇeśa, dancing. 17th century. Wooden stele with traces of paint. Height 62·5 cm., breadth 43·5 cm. Bhaktapur Museum, Bhaktapur.

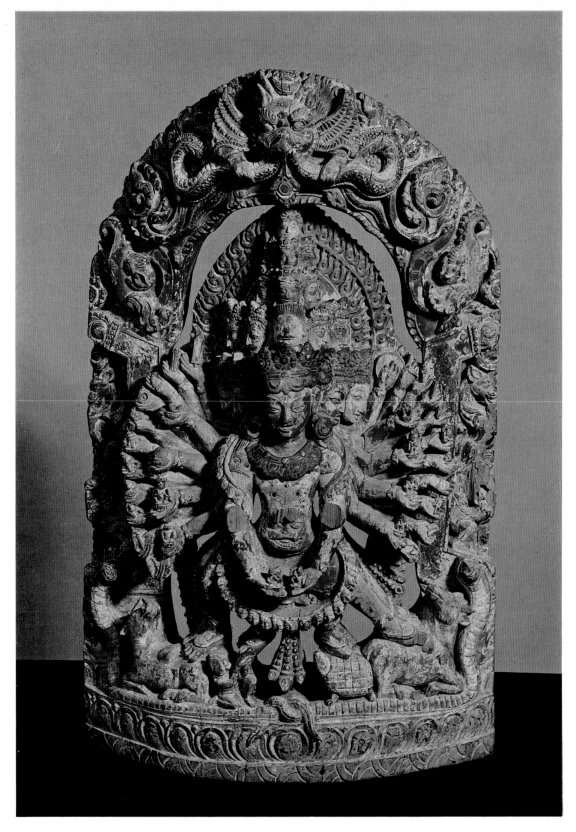

59

Śiva in all forms (*viśvarūpa*), dancing. 17th century. Wood-carving covered with plaster and painted over. Height 82·5 cm., breadth 52·5 cm. Bhaktapur Museum, Bhaktapur.

60

Pot (*kalaśa*) with five-tiered top. Wall decoration, or for window or door intended to bring good luck. 16th century. Rectangular wooden plaque. Height 33 cm., breadth 19·8 cm. Bhaktapur Museum, Bhaktapur.

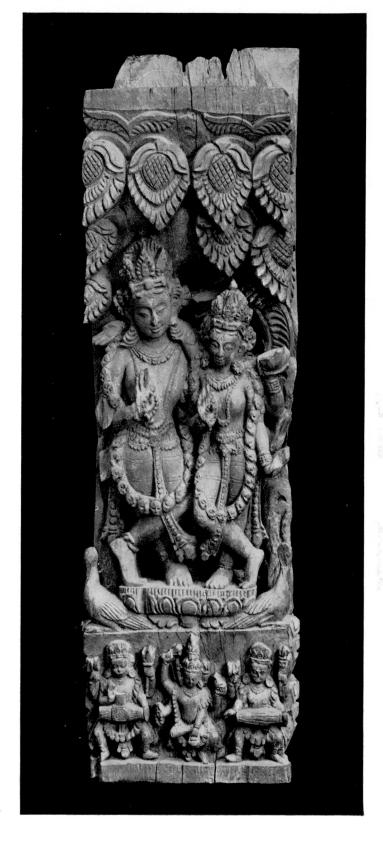

61

Śiva in happy union with wife Pārvatī (= Umā). 16th–17th century. High relief carved in wood. Height 69·5 cm., breadth 22 cm. Bhaktapur Museum, Bhaktapur.

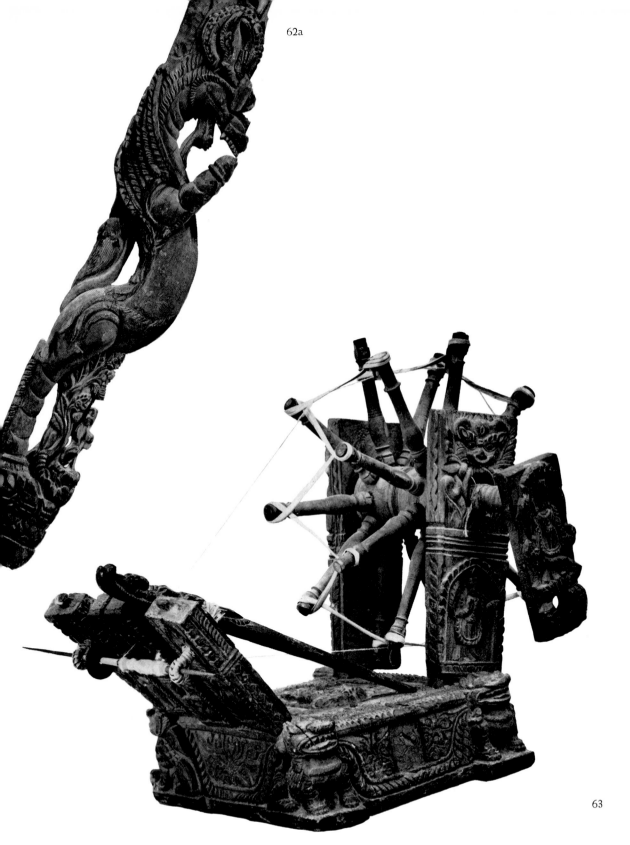

Spinning-wheel (*cakra*), wedding-present for a bride. 18th century. Framework of carved wood. Height 37·5 cm., length 51·5 cm. (between widest points), breadth 31 cm. Nepal Museum, Katmandu.

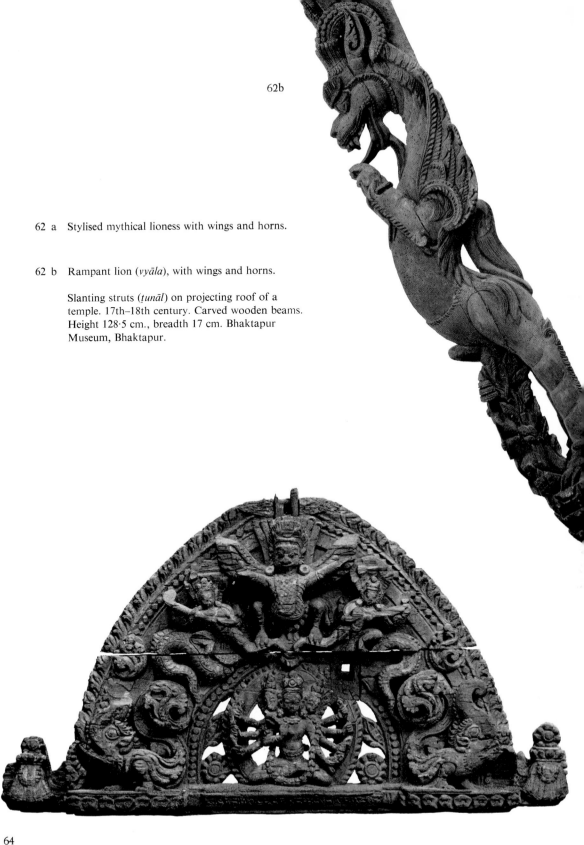

62 a Stylised mythical lioness with wings and horns.

62 b Rampant lion (*vyāla*), with wings and horns.

Slanting struts (*ṭunāl*) on projecting roof of a
temple. 17th–18th century. Carved wooden beams.
Height 128·5 cm., breadth 17 cm. Bhaktapur
Museum, Bhaktapur.

64

Semi-circular pediment (tympanum) with figure of a Bodhisattva and mythical creatures.
17th–18th century. Wood-carving. Height 32 cm., breadth 72·5 cm. Lalitpur Museum,
Lalitpur.

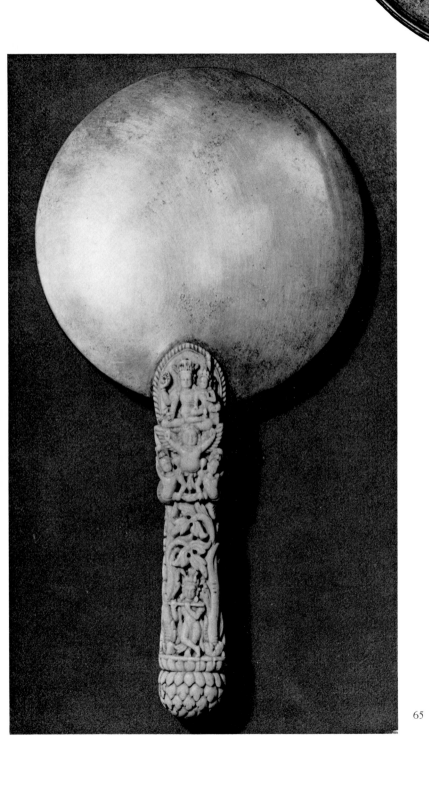

65

Round mirror with elaborately carved ivory handle. 1733. Top part (mirror) polished bell metal, front convex, back concave; handle made of rounded section of ivory carved on all sides. Handle: height 16·5 cm., breadth 3·5 cm. Diameter of metal disc, 15·7 cm. Nepal Museum, Katmandu.

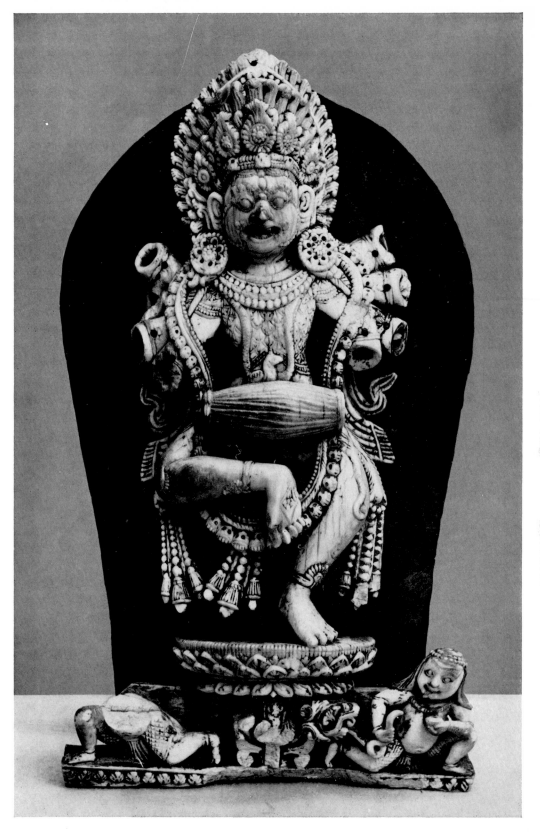

66

Bhṛṅgin, attendant on Śiva, dancing and beating drum. 16th–17th century. Ivory. Body made of one piece; once had eight arms, separately made, which were attached with pegs but are now missing. Height 24 cm., breadth 14 cm. Nepal Museum, Katmandu.

Inside of manuscript cover showing ten incarnations of god Viṣṇu. Painted wood, with two eyelets for binding string. AD 1220. Height 10 cm., breadth 52 cm. Bir Library, Katmandu.

Ornamental casket or toilet box (peṭāro) for woman. 15th century (?). Oval with steeply inclined lid of cane-plaiting, covered with cloth and painted plaster (also lacquered?). Iron hinges and clasps. Height 19 cm., breadth 16·5 cm., length 25 cm. National Art Gallery, Bhaktapur.

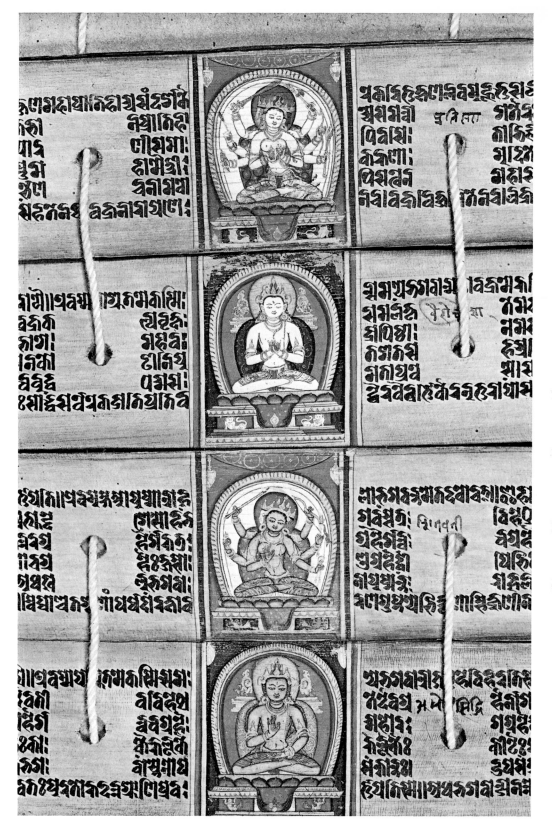

Manuscript of Buddhist Sanskrit text (*Pañcarakṣā*), containing miniatures of Dhyāni-Buddhas and female Buddhist deities. 1274. Height 5·5 cm., breadth 33 cm. Bir Library, Katmandu.

Inside of manuscript cover with painting of Viṣṇu and wife, together with ten incarnations of god. Late 18th century. Painted wood. Height 11·7 cm., breadth 45·2 cm. National Art Gallery, Bhaktapur.

70a

Seven scenes from a Buddhist legend (Viśvantara-Jātaka). Painting on cloth, part of a frieze several yards long, dated *samvat* 958 = 1837. Height 38 cm., breadth 74·5 cm. Museum für Indische Kunst, Berlin (I 10024).

71

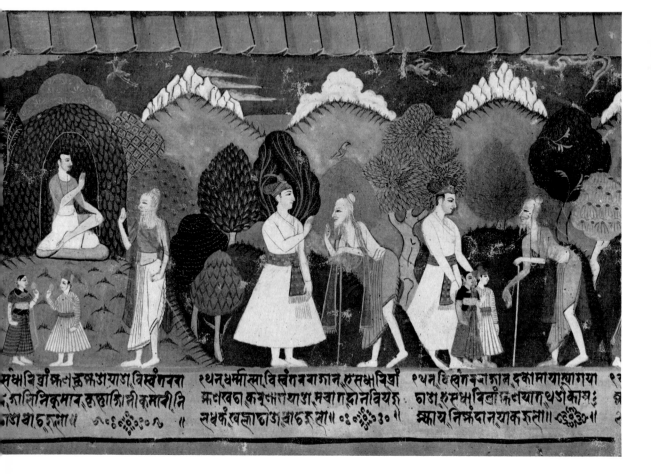

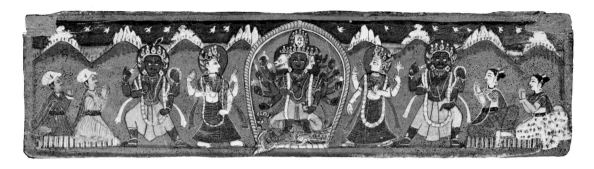

70b

Inside of second cover of same manuscript, with painting of multi-headed, multi-armed Viṣṇu figure, together with dependants and donors. Painted wood. Height 11·8 cm., breadth 45·1 cm. National Art Gallery, Bhaktapur.

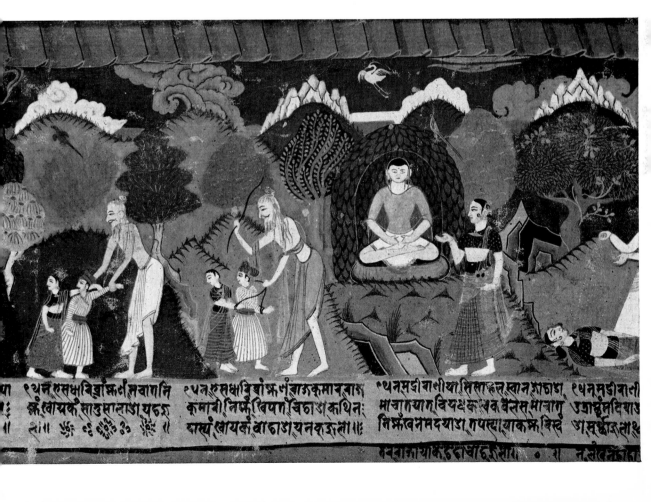

इ१ऽचतुष्पाणिं त्रिनेत्रधारि नायिकाडुम्बिलाडनर्थं एकादशविमुरुलक्ष्वयमगादिगीनेत्री॥

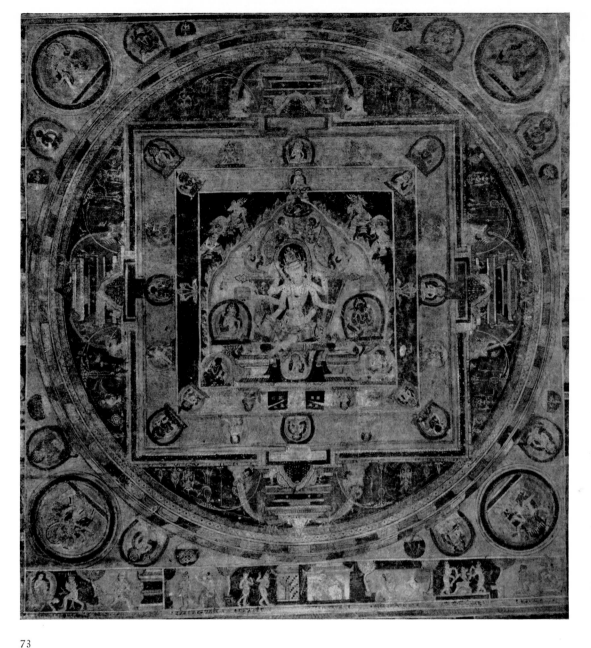

73

Section of a maṇḍala of Vasundharā or Vasudhārā. Painting on cloth, dated *samvat* 650 = 1529–30. Height 84 cm., breadth 75·5 cm. (section). Museum für Indische Kunst, Berlin (I 10010).

< Illustrations from a book about veterinary science, especially the treatment of horses, ascribed to an author named Śālihotra. 17th century. Folding book that can be put together in box-form, made of yellow Nepalese millboard and written in black Newari script. The edges of the leaves have a continuous border of green, blue, yellow, and white decorations on a red background. Height 4·5 cm., breadth 23 cm., thickness 7·5 cm. National Art Gallery, Bhaktapur.

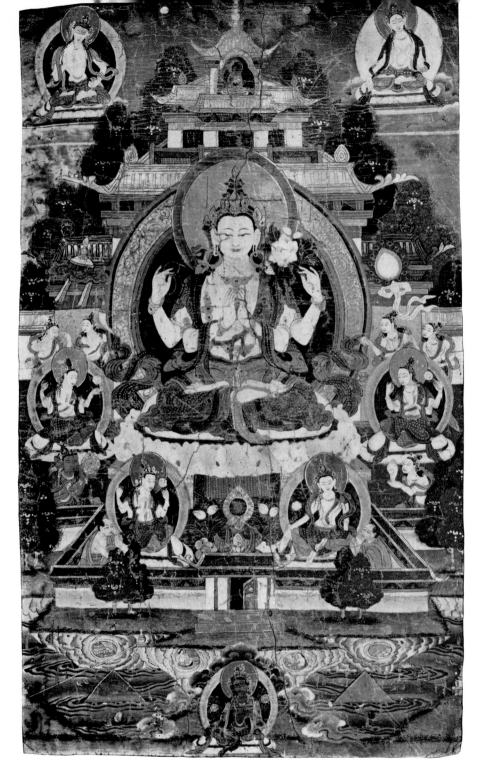

74

'Lord of the World' (Lokeśvara), a form of Avalokiteśvara, seated in Paradise of the West (Sukhāvatī). 17th century. Painting on cloth. Height 64·5 cm., breadth 40·5 cm. National Art Gallery, Bhaktapur.

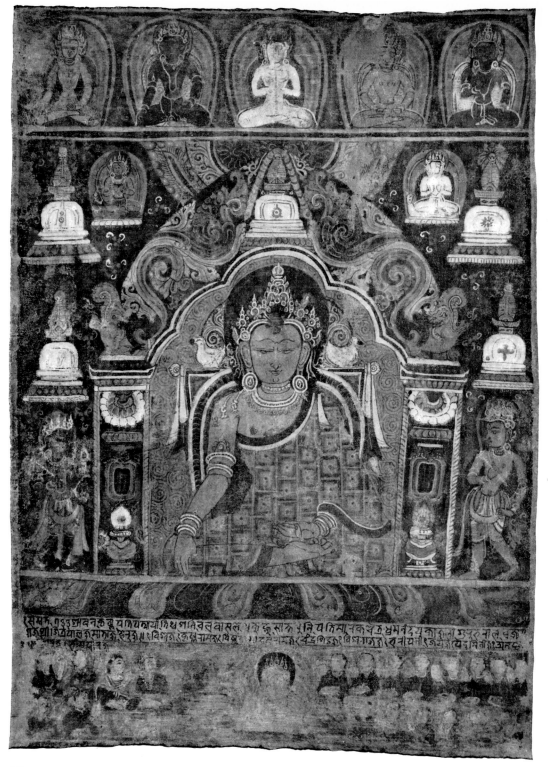

75

Crowned Buddha, surrounded by dependants and Stūpas. Painting on cloth, dated *samvat*
733 = 1612–13. Height 69·5 cm., breadth 51 cm. Museum für Indische Kunst, Berlin
(I 10009).

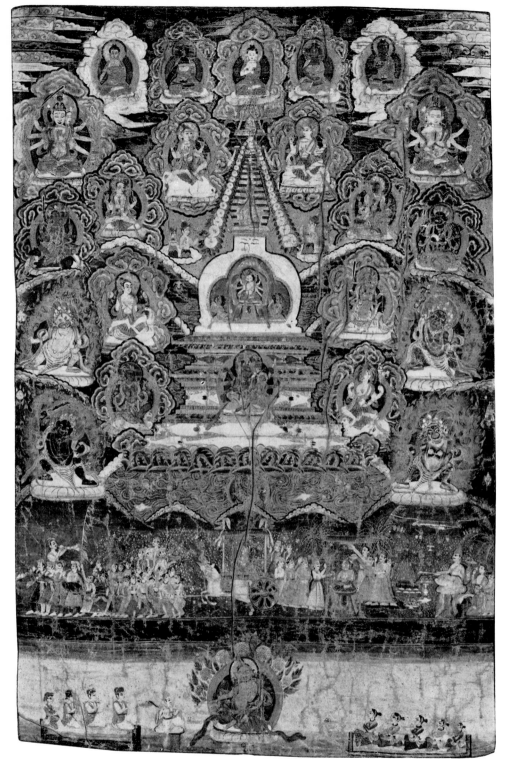

Depiction of Buddhist shrine (*caitya*) with goddess Uṣṇīṣavijayā as main deity, together
with Buddhas and attendant deities. 19th century. Painting on cloth. Height 73·5 cm.,
breadth 50 cm. Nepal Museum, Katmandu.

76

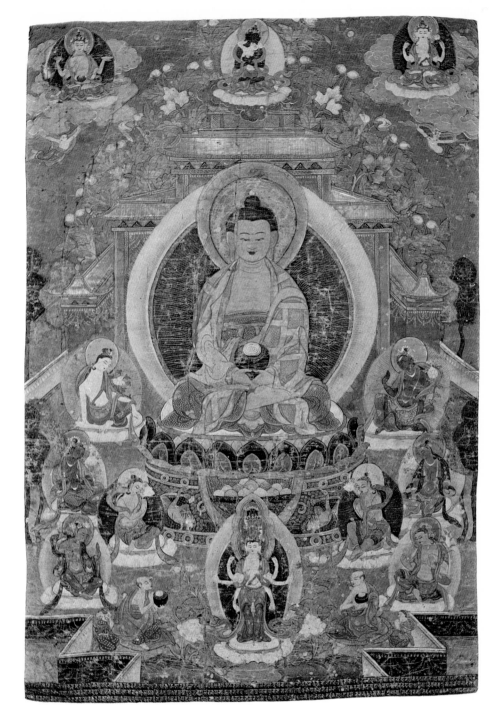

77

Dhyāni-Buddha Amitābha ('of immeasurable brightness') in his paradise Sukhāvatī. Dated 1823. Painting on cloth. Height 62·5 cm., breadth 43·5 cm. National Art Gallery, Bhaktapur.

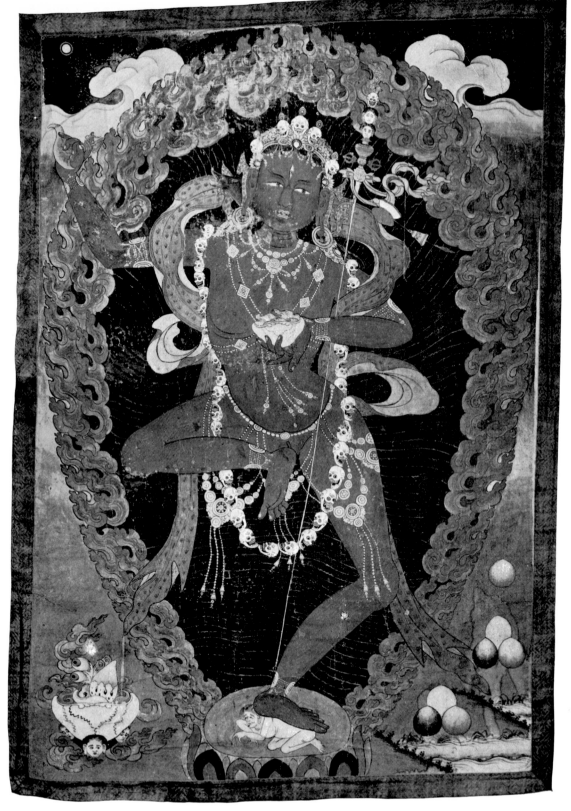

78

Vajravārāhī, a female embodiment of sensual passion. 18th–19th century. Painting on
cloth. Height 126·5 cm., breadth 89 cm. Nepal Museum, Katmandu.

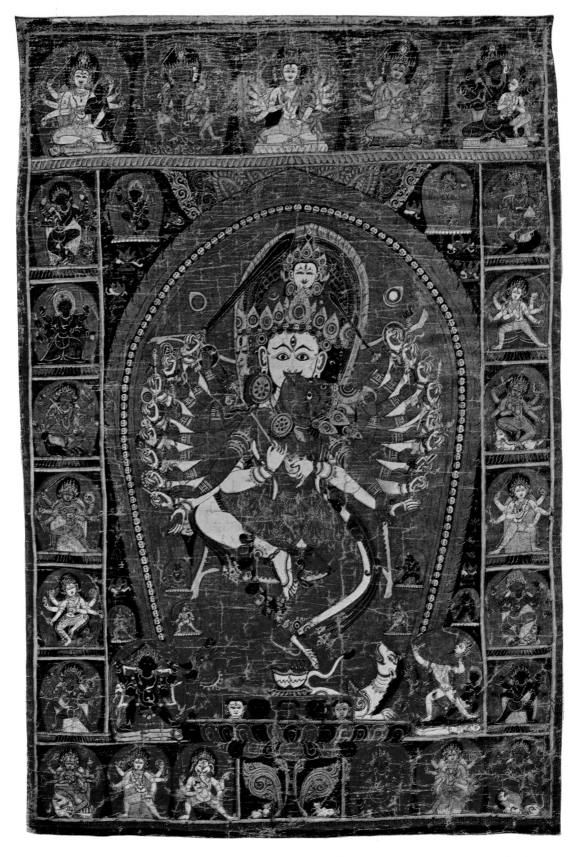

79 Nṛtyeśvara, 'Lord of the Dance'. Guise of Śiva, five-headed, with twenty arms, dancing together with his śakti. 1659. Painting on cloth. Height 94·5 cm., breadth 64·5 cm. National Art Gallery, Bhaktapur.

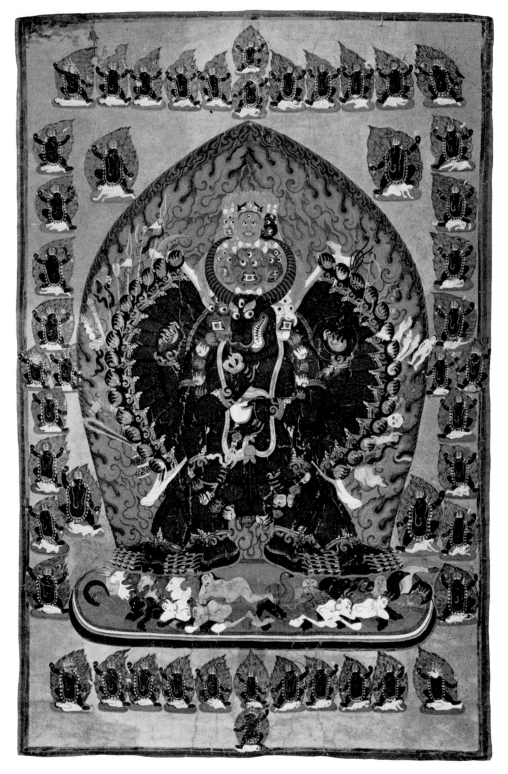

80

Buffalo-headed Saṃvara (*mahiṣa-saṃvara*), Buddhist guardian god, in the full expression of his powers. 19th century. Painting on paper. Height 139 cm., breadth 93 cm. National Art Gallery, Bhaktapur.

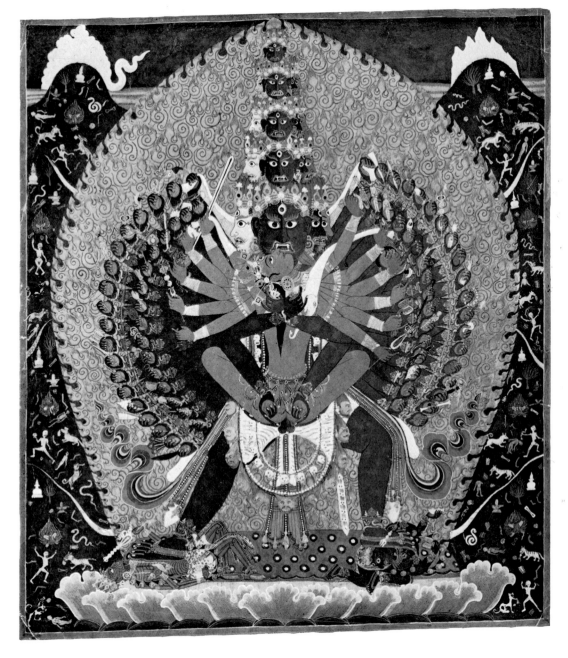

81

Buddhist protective god Mahāsaṃvara together with his female complement Vajravārāhī. 18th–19th century. Painting on paper. Height 65 cm., breadth 58 cm. National Art Gallery, Bhaktapur.

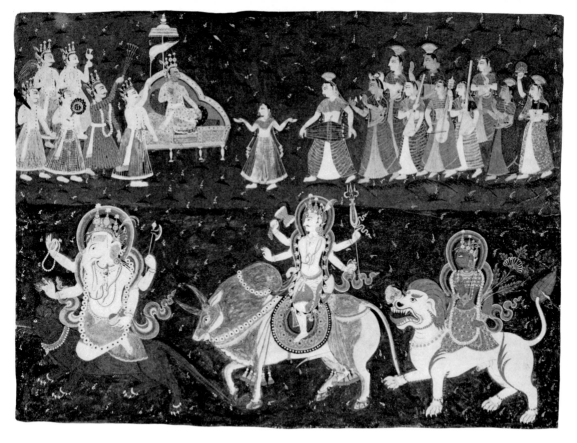

82

Indra, king of the gods, at a display of music and dancing in heaven, in presence of gods
Gaṇeśa, Śiva, and Pārvatī. 18th century. Painting on paper. Height 60·5 cm., breadth
78·5 cm. National Art Gallery, Bhaktapur.

Description of Plates

I ARCHAEOLOGICAL FINDS

1 Oval face modelled in clay. The holes in the ears, discs, and forehead may have held inlaid ornaments.

2 There are three strings of pearls round the forehead; on the left a head-dress bordered with rings or ribbons; on the right, immediately above the forehead, the hair is covered with a cloth or cap. Large round discs in the ears, and a high collar round the neck.

3 The hair is taken up at the sides and is decorated with protruding discs; the woman wears thick earrings that hang down to the shoulders, and a broad necklet.

4 Fragment of the lower half of a female body; the right leg bears the weight, the left knee is bent outwards in a dancing movement, and between are the folds of a robe.

5 The graceful lower half of a female body, with a three-tiered girdle round the waist. The legs are crossed, in the pose of a dancer, reminiscent of the figures of tree-goddesses on the gateways of the Stūpa at Sāñcī.

6 Badly damaged ram's head; the legs and tail have been broken off. Most of the colour has also been rubbed off. The body is decorated with an indented leaf pattern.

7 Head, legs, and tail of the horse have been broken off. Various parts of the body have been decorated before baking; a row of indentations in the neck represent the mane; lines, dots, and arrow-heads on the back are the saddle-cloth. There are impressed leaf-patterns on the breast and upper thighs.

II STONE SCULPTURES

9 As there are no attributes to indicate any specific deity, the statue is gener-
 ally regarded as the portrait of a king from the Kirāta tribe, i.e. dating from
 a period before documented history (the Licchavi Dynasty, after 400 AD).
 The socle and feet are missing, and there might also have been secondary
 figures on the socle that could have helped in identification. The frontal
 pose of the figure with legs apart, the plain nimbus, the squarish arms, and
 the position of the hands on a level with the hips, are all to be found in an
 early depiction of the Sun God (Sūrya) from Mathurā, though there the god
 is holding the tip of a garland in his hands, whereas this figure is obviously
 holding part of a robe (as can be seen clearly from the left hand). Compare
 the much later Sūrya figure in Plate 14. No definite identification of the
 statue is at present possible.
 Stella Kramrisch, *The Art of Nepal*, 1964, No. 1 and Page 23.

10 This is the right hand side of a large relief, most of which has been lost. The
 central figure was the Buddha, whose meditation had been disturbed and
 who was calling on the Earth Goddess to be his witness as Māra, Lord of
 the sensual world and the Buddhist devil, sought to prevent him from
 attaining Enlightenment. To this end Māra sent an army of his daemonic
 followers to attack the Buddha with terrible weapons, and when this
 proved unsuccessful he sent his beautiful daughters (the bottom half of the
 relief), who tried to seduce him and to win him back to the sensual world;
 this proved equally unsuccessful. The upper part depicts five monsters from
 Māra's army: one demon with a buffalo-head, one with the head of an
 elephant, two devils with grotesque faces—one with bristling hair—and an
 emaciated woman with pendulous breasts. This latter figure resembles
 depictions of the Goddess Cāmuṇḍā (see Plate 28), and the elephant-
 headed demon with an axe in his left hand is very much like the God
 Gaṇeśa (Plate 58).

11 The four-armed goddess stands upright (*samabhaṅga*) against the back-
 ground of a vertical, curved plaque which is framed by a broad decoration
 of flames (*prabhāvali* = garland of rays) and a paternoster. In her top right
 hand Sarasvatī holds a string of beads (*akṣamālā*), and in the opposite left
 hand, a manuscript (*grantha*), two of her usual attributes. It is uncertain
 whether or not she had a lyre (*vīṇā*) in her lower hands (an attribute
 signifying that she was goddess of the fine arts), as both these have been
 broken off. Stylistically the work is closely related to early sculptures from
 the period of the Indian Pāla Dynasty in Bihar and Bengal.

12 The god and goddess are seated on a flattened rock covered with a tiger-

126

skin, in a cave which is more or less horizontal at the sides but rises in an arch above their heads. All around them is the rugged stone of the sacred mountain Kailāsa, Śiva's home in the Himalayas; sitting or moving around in the cave are the family and dependants of the god. Śiva's hair is shaped in a *jaṭā*, that is, braided and piled high in the characteristic style of an ascetic (a crescent appears in it on the left and a skull on the right) and he is sitting in a rather relaxed pose (*lalitāsana*), with his right leg down and his left tucked up on the seat. He has four arms, the top right holding a string of beads (*akṣamālā*) and the top left a trident (*triśūla*). The hand of the front right or main arm is turned downwards in the gesture of giving (*varadamudrā*), while the left is under the left breast of his wife. Umā, who is nestling on her husband's left thigh on which she has her right hand, has her own left leg raised on the seat, while the lower part of her body is turned gracefully outwards, with her right foot hanging down and resting on the back of her tiny mount, the lion. She is holding a flower in her left hand. The bodies of the god and goddess are almost naked, but their ears, necks, arms and waists are hung with ornaments. From Śiva's shoulder falls the long cord of the 'twice-born'. On each side of the rocks above the two gods stands a four-armed guardian deity, carrying the attributes of Śiva; the lower left hands hold phials of balm, and the discs above their heads represent the sun and moon. Above Śiva's head is the goddess Gaṅgā, also four-armed; her upper arms are extended and with them she holds a folded cloth, while her lower hands are pouring the sacred water from her river down upon Śiva. A canopy (*chattra*) hangs over the central scene, and at the very top, above the highest blocks of stone, are Liṅga and Yoni, the symbols of conjugal unity. Halfway down the picture, to Śiva's right, lies his mount, the bull Nandin, with his head turned towards his master. Next to him is Śiva's son, the war-god Kārttikeya, a sword in his left hand; his left arm goes round the neck of his mount, a peacock, which is spreading its tail behind him, thus providing the god with a nimbus. In a hollow below is a figure holding a book in its left hand, and on the opposite side are two female followers, a servant with a fly-whisk and a guard with a sword.

In the lower regions of the mountain, the happy union of the divine couple is celebrated by gnomes and spirits, Śiva's so-called 'Gaṇas'. They are led by Śiva's second son, the elephant-headed Lord of the Gaṇas (Gaṇeśa), the bringer of good fortune and the patron of the arts (see Plate 58). He is represented with four arms and has his feet on the head of his mount, the rat, which is burrowing for treasure. Six little monster figures, some with animal heads and one with three heads, three arms and three legs, play music and dance; the one on the extreme left is a drummer.

13 This rectangular limestone relief shows the birth-scene in the Lumbinī Grove, as it is described in Buddhist texts. Queen Māyā, the mother of the Buddha, stands by an Aśoka tree in a dancer's pose, with her left leg

crossed over her right, and with her upraised hands she is clasping a branch of the tree, which brings forth blossoms and fruits at her touch. The birth takes place out of the right side of the mother, though this is not shown here. Instead, the future Buddha stands naked on a lotus near his mother, framed by an oval mandorla. His right hand is raised as if in pronouncement of the prophetic words with which he takes his first seven steps. In the sky above him—indicated by the clouds—are two deities. They are bathing the child with lotus-scented water, which they pour out of round pots. The fact that the two spirits are flying can be seen from the raised leg of the one on the right.

Stella Kramrisch, *The Art of Nepal*, 1964, No. 11, and Page 38 ff.

14 The slender figure of the god, towering over the secondary figures, is holding a long-stemmed lotus in each of his (damaged) hands, which are laid symmetrically against the left and right breast. This pose is typical of Sūrya images from the Indian Pāla age.

The whole composition is completely symmetrical, right down to the two secondary figures, who apart from the attributes in their hands are almost identical in appearance and posture. These are Sūrya's dependants Piṅgala and Daṇḍin. Piṅgala (left) has a pen and inkpot in his lowered left hand, while Daṇḍin (right) is holding a fly-whisk of hair from a yak's tail in his raised right hand. As guardian figures, they both carry swords in the other hand, and they stand in a graceful pose, with hips turned slightly inwards and their bodies forming a kind of triple curve (*tribhaṅga*). Ornaments and dress are somewhat simpler than those of the main figure, but of the same type.

An inscription on the socle at Sūrya's feet names the donor as Ratnākarasvāmin and the date as the 13th day of the light half of the month of Āṣāḍha in the year 185 of the Nepalese Era (= 1065 AD), in the reign of King Pradyumna, elsewhere known as Pradyumnakāmadeva, who ruled from *c*. 1061–1067.

Nepalese Art, 1966, III/16; Stella Kramrisch, *The Art of Nepal*, 1964, Page 45.

15 The slender, frontal figure of this male deity has lost its arms, apart from the stump of the top left arm, so that the attributes necessary for definite identification are missing. As it is also without the little Dhyāni Buddha Amitābha, which is frequently to be found in the headdress of Padmapāṇi-Avalokiteśvara, its identification as Avalokiteśvara is doubtful. The frontal pose is more typical of Sūrya and Viṣṇu than of Avalokiteśvara.

16 The main figure, the four-armed Viṣṇu, stands facing the front on a lotus. In his hands he is holding the attributes that are characteristic of him: top left, the discus; top right, the club; bottom left, the lotus; bottom right, the conch. The secondary figures are: (left) Lakṣmī, goddess of fortune,

Viṣṇu's wife, with a lotus stem in her left hand; (right) the human form of the mythical bird Garuḍa in an attitude of worship, his identity as a bird being indicated by a feather mantle round his shoulders.

It is worth noting the way in which the lotus socles of the three figures are connected: all three lotus blooms grow on stems coming out of a lotus pool, which is filled with stems and flowers. Two such stems, one on either side of Viṣṇu's socle, are very tall and end in blooms on which Viṣṇu's lower hands are resting.

One strange feature is the presence, at the top of Viṣṇu's nimbus, of Liṅga and Yoni, symbols from the sphere of the god Śiva. The date (1417) is contained in the inscription on the socle.

17 This stone was the end of an open U-shaped gutter, which caught the water from a fountain. The outlet is decorated with the head of a 'Makara'. Images of this scaly, fish-like creature can be shown to have decorated Indian buildings since at least the second century BC. The model for it was probably the Ganges dolphin, which has been extinct for many centuries, rather than the horny crocodile. Our illustration shows the jaws wide open, with small, pearl-shaped teeth and a long tongue; the rolled-up, trunk-like end of the top jaw has been broken off.

18 The upper part of this stone relief has been destroyed. The dominant figure is Durgā, Śiva's wife, who is to be found in more benevolent mood under the name of Umā in Plate 12 and elsewhere. Here she is presented in the form of a wrathful goddess of destruction. Her head and some of her arms have been broken off, but the rest of her body is intact. She stands in a triumphant pose, legs wide apart, each foot crushing the body of one of her enemies. With her spear she is killing her arch enemy, the demon (*asura*) Mahiṣa, 'Buffalo' (see introduction, p. 25). This straddle posture is typical of all Mahiṣāsuramardinī images (cf. Plate 54). The defeated demon, by nature a water-buffalo, is here depicted in human form: still clutching his sword, Mahiṣa lies between the two similar figures—his attendants—on whom the goddess is trampling; Durgā has seized his legs, is lifting him up, and is about to tear his body apart. In one of her hands, which probably numbered five on either side, the goddess is holding a drum in the shape of an hour-glass (*ḍamaru*) such as is also to be found in images of her husband Śiva (see Plate 52). This battle against the buffalo demons takes place on a raised, projecting part of the plinth, each corner of which is supported by a bull or Śiva's mount (one would have expected to find at least one lion, Durgā's mount, instead).

Dancing on a slightly lower section of the base on either side of the central group are Durgā's sons Gaṇeśa (left), the elephant-headed patron of the arts and god of wisdom, and Kārttikeya (right), the god of war. The whole length of the plinth is decorated with lotus blooms and leaves.

19 This group of figures (see introduction, p. 22) is arranged round a trun-
 cated column in a liṅga-like shape. On each side, facing east, south, north
 and west, stands a god in high relief against a flat background, enclosed in a
 mandorla in the shape of a lotus leaf. According to texts, Vāsudeva
 (characterised by discus and club) stands on the eastern side, Saṃkarṣaṇa
 (with plough and pestle) on the southern, Pradyumna (with bow and
 arrow) on the northern, and Aniruddha (with sword and shield) on the
 western. Vāsudeva's grandson Aniruddha, shown in this illustration, holds
 his shield in his top left hand, and his sword in his top right. The over-all
 composition is reminiscent of the stone liṅgas with four heads looking in
 four directions (*caturmukha liṅga*) of the Śiva Cult (see Fig. XI in the
 introduction).

20 The fact that the left female half of the Lakṣmī-Nārāyaṇa figure has a
 slightly fuller breast, is so unobtrusive that the uninitiated spectator will
 scarcely be aware of the androgynous character of the sculpture. Differences
 are only to be seen in the ear decorations—that of the goddess (on the
 figure's left) is more elaborate. The decisive factor is the attributes held by
 the hands. In the four hands of the figure's right male half are the attributes
 of the god Viṣṇu, from top to bottom: discus, conch, club, and lotus. On
 the other side, in the hands of Lakṣmī, the goddess of fortune, are: a book,
 symbol of knowledge, an ear of corn (abundance), a mirror and a receptacle
 for rouge (*sindūra-pātra*), signifying beauty-care (cf. Plate 24). The figure is
 seated in an ascetic pose (*vajraparyaṅka*). In execution this is a consummate
 work of art, which revels in intricate details. Particularly striking amongst
 the decorations of the body is the broad garland of flowers (*vanamālā*) hang-
 ing down from the shoulders with its ornamental medallions. Engraved in
 the forehead is a V, which is the distinguishing mark of the Viṣṇuites.

21 The god and goddess sit in a tender embrace on a tiger-skin spread over the
 plinth, which is decorated with lotus-leaves. Umā is on Śiva's left thigh.
 Crouching rather inconspicuously in the bottom left and right corners are
 their mounts: the bull behind Śiva, and the lion (very small) behind Umā.
 The figures stand out in high relief against the background of an oval
 plaque framed by a garland of flames and a geometrical pattern. Śiva has
 four arms; in his top right hand he is holding a string of beads (*akṣamālā*)
 and a lotus; his main right hand is raised in a gesture of protection
 (*abhayamudrā*); the hidden, top left hand holds the trident (*triśūla*); and the
 god has his main left arm round Umā's shoulder. The goddess is embracing
 her husband with her right arm, and in her left she is grasping a flower-stem.
 Both of them are wearing elaborate crowns. Śiva's hair is in ringlets and
 adorned at the front with a snake, and on the right with a skull; the crescent
 that was on the left has been destroyed. There is a nimbus behind his head.
 Other adornments of the god are snakes in his ears and a snake hanging
 down over his breast.

130

22 The four-armed goddess Durgā is depicted facing the front, astride a lion, which is facing forwards. Both her feet are supported by low plinths as if she wanted to take her weight off the lion. In her hands she holds the following attributes: sword (top left), club (top right), lotus bloom (bottom left), and discus (in front of right breast—the hand has been broken off). She is placed in a niche between two columns, on each of which sits a bird. In the arch (torana) above her is a monster (distortion of a garuda) with open jaws (kīrtimukha), which is grasping and tearing to pieces a snake that curves round on both sides. Like the monster in the archway above, Durgā's lion has his mouth menacingly open, with his tongue hanging out.

23 One of the distinguishing marks of Śiva, the third eye in the forehead, can just be seen; the snake-like earrings (sarpa-kundala) are also peculiar to him; but instead of the ascetic tuft of hair and the garland of human heads or skulls normally associated with Śiva, there are crowns ornamented with round discs, and a broad garland of flowers (vanamālā), similar to those shown in Plate 20 and in fact typical of Visnu. Of the hands of the central main arms in front of the figure, one is held up in the gesture of protection (abhaya), and the other hangs loosely down (lola-hasta). The side arms on the right reveal the following attributes or gestures, from top to bottom: gesture of the mirror (ādarśa-mudrā), drum in the shape of an hour-glass (damaru), sword (khadga), arrow (śara), discus (cakra), gesture of donation (varada-mudrā); the left hands, from top to bottom (partly destroyed): cudgel surmounted by a skull (khatvānga), shield, bow (dhanu), club (gadā), lotus (padma), and pot (kalaśa).

24 The goddess, distinguished by a high and elaborate crown and a nimbus, can be identified as Laksmī or Śrī, goddess of fortune and beauty, by means of the rouge container (sindūra-pātra) which she is holding in her left hand. The same colour is used by Indian women (except widows) for the red spot which they put in the centre of their foreheads. Similar containers are still in use today. The broken right hand of the goddess once contained a mirror— another feminine attribute already seen in Plate 20, on the female side of the androgynous figure Laksmī-Nārāyana.

25 Despite the broad, mask-like demon-face with the third eye in the forehead and the bristling hair, this sculpture of the 'Great Black One' is fairly mild in comparison with others, for here he is standing quietly, and has only a normal quota of arms. On closer observation, however, one can see several other symbols of horror about him: his diadem is decorated with little human skulls; his earrings are made of snakes; from his shoulders to his knees hangs a chain with human heads dangling from it; he is standing on a naked corpse; in his left hand he is holding a dish made from a human skull (kapāla), and in his right a knife (kartri) which merges into a thunderbolt (vajra); with his left arm he is also clutching to his breast a club (khatvānga)

which has human skulls at the top and also merges into a 'vajra'—the name of the club actually refers to the torn-off leg of a bedstead (*khaṭvā*). Blood is meant to be dripping from his mouth—indication enough that it is inadvisable to pick a quarrel with him. In paintings, the god is depicted with dark blue skin and reddish hair.

26 The seer Nārada, who in Indian mythology is master of the heavenly musicians (*gandharva*) and mediator between gods and men, is portrayed here as a gaunt recluse with protruding ribs and bones. The design on the plinth suggests that the sage lived in a rocky landscape.

27 This figure, sitting cross-legged (*utkaṭāsana*), is to be identified as a holy man by the piled up tuft of hair and the ornamental beads on his forehead, ears, neck, and chest. The siddha (i.e. a man endowed with perfection) is aided in his exercises by gripping a stick (*yogadaṇḍa*), which helps keep the top half of the body erect, and by a band of material (*yogapaṭṭa*) round his knees, which helps him to maintain his squatting position.

III TERRA-COTTA FIGURES

28 The goddess Cāmuṇḍā—a horrific guise of Śiva's wife Kālī or Durgā—is always portrayed with an emaciated, skeletal body and a generally ghastly appearance (see notes on Plate 10). The head reproduced here can be identified by its hollow cheeks and temples, and it has all the distinguishing features of a daemonic being, such as the large third eye in the forehead and the fang-like teeth in the wide mouth. According to mythology, this terrible goddess slew the demons Caṇḍa and Muṇḍa—which is reflected in her name—and then drank their blood.

29 An inscription on the plinth gives the name 'Strange Eye' (*virūpākṣa*) to this form of the god Bhairava. He is a squat, somewhat round-bellied figure, comfortably seated (*sukhāsana*), who would look quite cheerful were it not for his staring eyes. He also has his left hand raised in a gesture of warning (*tarjanī mudrā*). His right hand held a skull-bowl (i.e. a drinking bowl made out of a human skull) which has been lost; this drew attention to the frightening side of Bhairava-Śiva's character.

30 Bhīma is the second of the five Pāṇḍavas (sons of Pāṇḍu) in the great Indian epic poem 'Mahābhārata'; remarkable for his size, strength, and

132

appetite. The first two of the qualities are shown clearly in this little sculpture: Bhīma is a gigantic figure in comparison with his five adversaries, and is dealing with all of them at the same time. In this 'unarmed combat', Bhīma is holding two of his adversaries at shoulder level by an arm or a leg, is crushing another between his chest and his left arm, and the fourth between his left calf and thigh, while in the lower left-hand corner a fifth is falling backwards to the ground.

IV BRONZES

31 In India the female powers or components of the great Hindu gods are often brought together in groups of seven or more maternal deities (*mātṛkā*) and portrayed next to one another. In this Nepalese group of three goddesses, Mahālakṣmī, Viṣṇu's śakti, has pride of place. She is seated on a lotus-throne above her mount, the lion, which is looking up at her and roaring (*siṃhanāda*), in similar fashion to the lion in the well-known Buddhist group of the Siṃhanāda-Lokeśvara. According to a verse (*dhyāna*) relating to Mahālakṣmī, the goddess has three eyes and a lion as her 'vehicle' (*trinetrā siṃhavāhinī*). She smiles slightly (*īṣatprahasitā*), and holds her main hands in the gestures of giving (*varada*, bottom right hand) and of bestowing courage (*abhaya*, left hand in front of breast). Growing out of both sides of the lotus plinth at the very bottom is a lotus shoot culminating in a lotus-seat for each of the attendants, two smaller maternal deities. To the left, sitting on her mount the peacock, is the goddess Kaumārī, wife of Śiva's son Kārttikeya, who is also known as Kumāra; to the right, squatting on a corpse, is Bhairavī, the śakti of Bhairava-Śiva, whose daemonic face has a third eye in the forehead.

32 In Hinduism, Vasudhā the 'treasure-giver', or Vasundharā the 'rich in treasures', are names for the earth and earth-goddess Bhūmi or Pṛthivī, who is the second wife of the god Viṣṇu (Lakṣmī being the first). In Tantric Buddhism, which contains many syncretic elements, Vasundharā is the wife of the pot-bellied god of wealth Jambhala. Obviously the goddess has long been very popular in Nepal, for there are many images of her (see Plates 51 and 73). What Vasundharā has to offer in the way of treasures is shown by the attributes which this resplendent six-armed goddess is holding in four of her six hands. In the left hands these are, from top to bottom: a book (*pustaka* = abundance of knowledge), ears of rice (*dhānyamañjarī* = abundance of food), and a pot (*kalaśa*) containing jewels (= wealth). A

shining gem sticks out of the pot. In her middle right hand is another gem, with a string or brooch of jewels (*ratna-mañjarī*) suspended from it (see also Plate 51). The top and bottom right hands make significant gestures. The goddess's right leg hangs casually down (*lalitāsana*), with the foot resting on a lotus. The seat itself has been broken off (cf. Plate 31). The crown and different ornaments, including the gem on the pot, contain genuine inlaid jewels, such as rubies and emeralds cut *en cabochon*.

33 The face reveals the characteristically gentle smile of the introspective 'Bearer of the Lotus' (Padmapāṇi = he who holds the lotus in his hand). The slender figure, expressive of beauty and mildness, stands on a lotus plinth, and with his lowered right hand is making the gesture of giving (*varada*); in his left hand he is holding a lotus stem, which rises behind him to shoulder level and there blossoms out into its flower.

34 Other-worldliness and deep introspection are perfectly expressed in the features of this Bodhisattva. The texts prescribe for him a meditative expression in the eyes (*dhyānanayanaḥ*) and a smile (*smerānanaḥ*). The gestures of the three pairs of hands in front of his body are remarkably eloquent. The lower hands, resting on legs bent in a meditative sitting position (*vajraparyaṅka*), are linked in the gesture of deep thought (*dhyānamudrā*) and hold a bowl of nectar (*amṛta*). The hands above are placed in the gesture of sprinkling the nectar contained in the bowl (*pātrastha-amṛta-kṣepaṇa-mudrā*). The gesture of the hands in front of the breast ought to be that of protection (*hṛdayapradeśe abhayamudrādvayam*), but is in fact the similar one of explanation (*vyākaraṇa*). The next pair, held away from the body, express repletion (*tarpaṇamudrādvayam*), while those at shoulder level did hold emblems, though now only a club, with a vajra and human skulls at the top (*savajra-khaṭvāṅga*), remains; this is held like a stick in the left hand, but the sword with vajra (*viśvavajropari khaḍga*) which should have been in the opposite right hand has been lost. The figure has twelve arms altogether. Two of these are difficult to see, as they are held above the head, and seem to merge with the god's headdress and nimbus. The hands are laid together over his crown (*mukuṭopari-kṛtāñjali*) and hold a thunderbolt.

35 Lokeśvara, the Buddhist 'Lord of the Universe', has four heads and eight arms, and is seated in the meditative position (*vajraparyaṅka*) on a lotus plinth. His main hands are held together in front of his breast in the gesture of preaching (*dharmacakramudrā*). Sitting on his left knee, in normal human form, is his female complement (*śakti* or *prajñā*); this pose is typical of the combined representations of Śiva and Umā (*umāsahita maheśvara*, see Plates 12 and 21). Of Lokeśvara's four heads, one is placed above the other three. The secondary hands on the right show, from top to bottom: a string of beads (*akṣamālā*), an arrow (*śara*), and the gesture of donation

(*varadamudrā*). Those on the left are holding a book (*pustaka*) and a bow (*dhanu*), while the third is embracing the śakti. The third eye in the forehead is again reminiscent of Śiva, whom the Buddhists believe to have merged in Lokeśvara.

The separately constructed halo is not unlike a laurel wreath. At six places, there are small seated figures among the leaves. At the very top is Vajrasattva, the Primordial Buddha of the Vajrayāna, holding a thunderbolt (*vajra*) in his hand. Below him is the Buddha, touching the earth. The two little four-armed figures to the left and right look very alike; the book in the left hand, the lotus seat, and the gesture of preaching indicate that these are images of the Prajñāpāramitā—incarnations of transcendental wisdom. Lower down are personifications of the sun (right) and moon (left), each in the circle of his own light; the moon-god is sitting on the wild goose (*haṃsa*) and the sun-god on two of the steeds that draw his chariot.

36 Indra, the Vedic king of the gods, has become a figure of lesser importance in Hinduism: Buddhists worship him as king of the heaven known as 'Svarga'. There are many images of him in Nepal, and the Indrayātrā, a feast in honour of the god, includes a procession in which members of all the religious sects take part, together with their images of him. This beautifully made little figure depicts Indra sitting comfortably (*sukhāsana*) on a lotus plinth. His right hand is raised in front of his chest in the gesture of explanation (*vyākaraṇamudrā*), and his left arm is hanging down, resting lightly on his knee. The god can be identified by the third eye in his forehead, which is set horizontally and not vertically as in images of Śiva. In early literature Indra is described as the god of a thousand (or many) eyes, a version of which can be seen in a painting (Plate 82) where eyes cover the whole figure, including his clothes.

37 The Buddha is depicted facing the front in the position of meditation, with his legs crossed and tucked right up against his body, soles upwards (*vajraparyaṅka*). The gesture is characteristic of him, with the right hand hanging down palm inwards on to the socle. This is the gesture of 'touching the earth' (*bhūmisparśamudrā*). It recalls a legendary event during the attack on the Buddha by Māra, the Buddhist devil, shortly before the Enlightenment. The Buddha faced the Evil One and touched the ground in order to call on the earth-goddess to be a witness to his moral virtues in earlier lives. Although he is without the rich ornaments usual in images of the gods and Bodhisattvas, the Buddha is distinguished by his outer appearance, which bears the marks of 'The Great Man'. These include the lock of hair in the centre of the forehead, the short curls turned to the right, and an excrescence on the skull which he was supposed to have had. His body is almost covered by a simple monk's robe which, contrary to ancient directions, is decorated with a broad ornamental border. The draping and curve of the folds are Tibetan and East Asian in style.

38 The Dhyāni-Buddha Akṣobhya, one of the five Dhyāni-Buddhas described in the introduction, is characterised by the gesture of touching the earth with his right hand (see Plate 37). The left hand is laid meditatively in the lap (dhyānamudrā).

It appears that in Nepal the Dhyāni-Buddha Akṣobhya is often depicted without a lotus socle (as here), which is an aid to identification.

39 Typical of Lokeśvara—also called 'he to whom the six syllables (oṃ maṇipadme huṃ) belong'—are the two main hands laid together in front of the chest in the gesture of adoration. His secondary left hand is holding a lotus, and his right a string of beads (there is a corresponding figure in the painting reproduced in Plate 74). An antelope skin is draped over his left shoulder. The Bodhisattva is seated in an ascetic posture on a lotus throne, and behind him is a separately made stand or frame of dark bronze which is fixed on to the plinth. The frame consists of fabulous creatures (leogryphs—see Plate 59) supporting a kind of archway of geese, whose tails swirl up in ornamental curves. On top of it are the head and human hands of a 'garuḍa', and over this is a loosely fixed canopy. The elaborate ornamentation of the thickly gilded central figure is inlaid at various points with agate. There are similar inlays in the plinth and in the frame behind the figure.

40 The 'Enlightener' (dīpaṅkara), one of the earliest of the many assumed predecessors of the historic Buddha, is standing on a lotus plinth. The facial expression is serene, and he wears a crown and kingly ornaments, while his robe is that of a heavenly being. His right hand is raised in the gesture of protection (abhayamudrā), and his left arm is bent at the elbow, with the hand open in the gesture of donation (varadamudrā).

Every five or twelve years in Nepal there is a public veneration of Dīpaṅkara, for which as many images as possible are brought from temples and private houses.

41 Vidyādharas, spirits or demi-gods 'possessed of knowledge or spells', according to the conceptions of Indian mythology are genii of the air that live in the regions of the Himalayas. The little bronze illustrated in Plate 41, with a sorceress hovering in the air, reveals something of the talents of these air-sprites. She is one of the Tantric group of four females 'skilled in yoga' (caturyoginī). Only on close inspection can one appreciate the acrobatic skill of this alluringly beautiful woman, who has the normal number of two arms and two legs. Her right leg is bent upwards at the knee, so that she is not touching the corpse (śava) that is lying face down beneath her; at the same time she has thrown her left leg so high that it is actually vertical, with the toes almost touching her forehead as she leans slightly backwards. The flying 'yoginī' giving this virtuoso performance is a slim young woman with a splendid crown, round earrings, chains round her neck and over her

breasts, and bands round her upper arms, wrists, and ankles. From her shoulders hangs a long garland of human skulls (*kapālamālā*). She has raised her left hand as if to drink from a bowl made out of a human skull (*kapāla*), which is used especially for the sipping of blood. In her right hand is her weapon for killing, a razor (*katri*).

42 This sharp-clawed mythical lion, with his mane bristling forwards over his head, has a pair of goat's horns in his forehead and wings on his shoulders and haunches.

43 The snake goddess (*nāgī*), suspended between scrolls, is a secondary figure from the top part of the gilded, copper-chased framework or halo of a Buddhist metal image. Judging by the usual decoration of such frameworks, she is one of the snakes that are being seized by the bird Garuḍa and are trying to escape outwards—a theme frequently found at the top of aureoles (see Plates 58 and 64). All these snakes are given human form, but their real nature is shown by snake heads above them. Here there remain just a few snake heads over the left arm of the nāgī, who is holding a precious stone in her left hand. The aureole of the image was enclosed by a scroll border. On the right-hand side of this fragment there is a tiny Buddha figure. The work was acquired by A. v. Le Coq in Leh, and first reproduced by Leonhard Adam in *Hochasiatische Kunst*, Stuttgart 1923, Plate 19 (then No. IC 35124).

44 This vessel is a combination of lamp and fuel-container. Fuel was stored in the main section, the large pot, and burnt in the bowl beside the neck with the aid of a wick. The filling was done with a metal spoon. Both parts of the vessel are decorated with figures and designs, and the lower section of the pot, which is narrower at the neck and foot, is adorned with stylised lotus-leaves. The broad centre portion is ringed with skulls, and the handle formed by the curving body of a snake (*naga*). At the very top of the pot, the snake rears up and spreads out its eleven heads to form a canopy over the little figure of a four-armed Viṣṇu riding his mount, the bird Garuḍa. Crawling along the snake handle is a child, probably the sweet-toothed shepherd-boy Kṛṣṇa, an incarnation of the god Viṣṇu. The leaf-shaped lamp bowl, opposite the handle, is joined to the centre of the pot by a support which is ornamented with an upright winged lion carrying a pair of *kinnaras*. These are siren-like beings, half human and half bird, that are skilled in the art of song. They are standing next to each other, their legs crossed in a dancing pose, and their outer arms raised high as if in triumph. On the edge of the bowl stands the elephant-headed god Gaṇeśa close up against the pot, enclosed in a garland of leaves. He has ten arms and two heads, one on top of the other. In his arm he is holding his śakti. On the other side of the rim of the bowl, in front of Gaṇeśa, stands a little lion.

45 A fairly modern work. Of the Bodhisattva's eleven heads, the first nine, in groups of three, are of the normal, benevolent appearance; above these is a daemonic head, and at the very top is one of a Buddha—probably that of the Dhyāni-Buddha Amitābha, of whom Avalokiteśvara (Lokeśvara) is believed to be an emanation (cf. Plate 77). The main hands of the Bodhisattva are laid together in adoration in front of his chest; the secondary left hands hold the following attributes, from top to bottom: (1) lotus, (2) bow and arrow, (3) water-pot. The right: (1) a string of beads, (2) mirror (cf. depiction of this attribute in Plate 20)—in this case erroneously put there in place of a wheel; the bottom right hand is making the gesture of donation. The Bodhisattva is standing on a lotus socle, and is surrounded by a separately constructed openwork halo, trefoil in form. An iconographic counterpart to this figure is Mahāsahasrasūrya Lokeśvara, who is No. 57 in the 108 forms of Lokeśvara.

V WOOD-CARVINGS

46 The identification of this figure as a human form of Garuḍa is based on the unusual hair style, as the nose, which is the normal source of identification and is usually curved in the shape of a bird's beak, has been badly damaged. The strands of hair are arranged in three overlapping tiers, and each ends like a peacock feather in a round eye-shaped design which is suggestive of feathers.

47 The female donor is turning towards the right and kneeling, with her right leg on the ground and her left knee drawn up. In her left hand she is holding a dish which contains her offering. Her right hand is open, as if to receive a favour. The woman is sturdily built, and has an oval-shaped face with high eyebrows and long almond eyes (white) with black pupils that are half-concealed by the eyelids. This may be the portrait of an actual person.

48 The almost naked dwarf is leaning far forward, holding out a large sack with both hands towards the hoped-for donor; he is gripping the edge of the sack nearest him in his mouth. This is the way in which country people in Nepal, even today, hold out their bags when gleaning. Here the boy is meant to stand as a supplicant before a particular form of the Bodhisattva Avalokiteśvara (Cintāmaṇi Lokeśvara) and wait for a blessing.

49 The dancer is leaning slightly forward, with her left leg bent behind her right, and her left foot lightly touching the ground. Her right hand is raised in front of her breast, while her left arm is pointing downwards, palm facing her body. Her white face has Mongolian features, especially in the shape of the eyes (cf. Plate 47). The narrow bridge of her nose is very distinct, and she has a small mouth.

50 Bhṛkuṭī, the Tārā 'who wrinkles her eyebrows', is also to be found in an angry form. Here the goddess appears as a gentle, benevolent helper. As described in the texts, she has four arms and one head (*caturbhujaikamukhī*), is yellow in colour (*pītā*), has three eyes (*trinetrā*), and is in the prime of youth (*navayauvanā*). With the left hip bent slightly outwards, her body is in the position of the double curve (*dvibhaṅga*). She is standing on a crescent-shaped plinth (*padmacandrāsanasthā*) which is decorated with lotus leaves. The gestures made and attributes held by her four hands underline the gentleness of her character. The top right hand is meant to be making the gesture of giving (*varadamudrā*), and the lower holds a string of beads (*akṣasūtra*). The attributes in her left hands are a triangular flower (*tridaṇḍī*) and a small water jar (*kamaṇḍalu*). The feet of the Tārā are of gilded brass, and have been made separately. They emerge from the red-painted brass plate which covers the top of the socle.

51 The significance of the goddess Vasundharā has already been explained in the notes to Plate 32. Iconographically the two six-armed figures, one in bronze and one in wood, correspond to each other exactly. In this case, as in the other, the top right hand is making the gesture of the mirror (*ādarśa*) (which we had already met with in Plate 23), the lower is forming the sign of donation, and the central hand is holding a bunch of jewels. In her left hand are a book (*pustaka*), ears of rice (*dhānyamañjarī*), and a pot (*kalaśa*). As with the bronze figure, a gem is sticking out of the pot, to indicate that it is full of jewels.

52 The construction of the scene on different levels and the setting of the main group in front of a cave-like background, resemble the scene depicted in Plate 12, with the same pair of gods in a rocky cave in the Himalayas—which may also be indicated here. The couple are seated on a lotus resting on the backs of their mounts—the bull (under Śiva) and the lion (under Umā). In his top right hand the four-armed Śiva is holding the hourglass-shaped drum (*ḍamaru*), and in the top left the trident (*triśūla*). The bottom right hand has been broken off; with his hidden main left arm he is embracing his wife—one can see his hand by her waist, holding the water jar (*kamaṇḍalu*) of religious people. At the top, in a halo, directly above the pair, the god Indra is sitting above a lotus on two personifications of his mount, the elephant, and beside him are two deities, one male and one female, who are named by an inscription as Nārāyaṇa and Nārāyinī

(four-armed). Beside and below the divine pair kneel donors and worshippers, whose names have been preserved in inscriptions. The two figures on either side of the gods are Kṛṣṇa Deva and Ananta Deva, and of the two women squatting below, the one on the right with a child is called Mahālakṣmī. The bottom row contains seven more people, mostly women (cousins), who are bringing offerings.

53 Typical image of a seated Tārā. Her right leg is resting casually (*lalitāsana*) on the lotus seat. If the right hand were still there, it would be lowered in the gesture of giving (*varada*), and the left would be holding a lotus stem. According to the skin-colours ascribed to them and to be seen in paintings of them, the Tārās can be differentiated into varieties of green, white, and various other colours.

54 Durgā, the wrathful form of Śiva's wife, is killing the demon (*asura*) Mahiṣa, the buffalo, as already described in Plate 18. The scene is depicted much more compactly than in Plate 18, showing the ten-armed goddess, legs astride, in the act of destroying the half-human, half-animal buffalo demon. The goddess has her right foot on the lion, her mount, while the left is on the back of Mahiṣa, which has an animal's body from the waist down. The goddess has caught up this buffalo body with her bottom left hand (which has perhaps also seized the demon's hair) and she is thrusting her trident (*triśūla*) into his armour-plated chest. In her main right hand Durgā is holding the skull-bowl (*kapāla-pātra*) in front of her breast. Her main left hand is forming a significant gesture, while the other hands are holding, from top to bottom: sword (left) and shield (right), hourglass-shaped drum (left) and club (*khaṭvāṅga*, right). The two hands below are empty and are making eloquent gestures.

55 The vertical third eye in the forehead, the fangs at the corners of the mouth, the bristling hair, the staring eyes protruding from the sockets, and the coiled snakes as earrings, are all indications of the frightening character of 'Horse-Neck' (who has a little horse's head at the very top of his hair). Somewhat in contrast to this head is the smooth, almost childish body of the demon, though it is painted in what may once have been a fiery red. The body is normal, but there is a snake-like band (*nāgabhūṣaṇa*) falling from the left shoulder in place of the cord worn by the 'twice-born' (*yajñopavīta*). According to the texts, Hayagrīva has a red body which is squat and bulging, frowning eyebrows (*bhṛkuṭīkuṭilabhrūkaḥ*), carries a stick as a weapon, and has his right hand raised in greeting (*dakṣiṇakareṇa vandanābhinayī*). In Hinduism he is the demon of fever and assistant to the god of death (*yamakiṅkara*). A similar looking stone figure is reproduced in Leonhard Adam's *Hochasiatische Kunst*, Stuttgart 1923, Plate 3.

56 As in Plate 16, Viṣṇu is four-armed, with a club and a conch in the left

140

hands, and discus and lotus in the right. A huge garland of flowers is hanging from his shoulders. His standard-bearer is the bird Garuḍa, who is depicted mainly in animal form except for his human arms, but at the top of the standard is another smaller figure of Garuḍa, this time in human form. The name of the god, Śrī-Viṣṇu, is carved in the upper pennant. The canopy-bearer behind the god is holding the three-tiered canopy in both hands, and the flat war-chariot is drawn by horses. The piece probably has the same origins as that reproduced in Plate 57.

57 Rāvaṇa, the prince of the devils and lord of Laṅkā (Ceylon), has carried off Sītā, wife of the hero Rāma. In order to get her back again Rāma comes in pursuit, and there follow many adventures and battles which are described in the epic of Rāmāyaṇa. This wood-carving represents a battle-scene, with Rāvaṇa standing on a war-chariot. He is depicted as a ten-headed, twenty-armed demon, lunging with a sword in his main right hand, while the left arm points downwards, with a round shield hanging from the elbow. The other outstretched hands and arms are holding various kinds of weapons. His heads are all crowned with diadems and are in two rows, four at the top and six at the bottom. He is wearing a breast-plate and a wide robe, and a large garland of flowers hangs from his upper arms down to the ground. Before and behind him squat two attendants. The one in front is holding a standard with two pennants in his right hand, and a fly-whisk in the left; the follower in the rear is also holding a fly-whisk, and in his right hand is carrying a three-tiered canopy, which denotes the sovereign rank of his master. The box-like chariot on which the figures are situated may be four-wheeled, although only two wheels are actually shown; near the left-hand wheel are the heads and fronts of three winged horses galloping—one of them cut deeper than the others. The top pennant on the standard contains the word *rāvana* (sic).

58 The elephant-headed 'Lord of Hosts' (Gaṇeśa), bringer of success and patron of learning, is shown with eight arms, enjoying a dance. His four right hands show the following attributes or gestures, from top to bottom: elephant tusk, string of beads, hammer, gesture of protection. The first and second top left hands contain an axe (*paraśu*) and a sling (*pāśa*). The next left hand is missing, and the bottom hand is holding a dish of buns (*modaka*, *laḍḍu*) which he is nibbling with his trunk. On either side of him, at his feet, lies his mount, a rat. Further away are two small figures: on the left, a dependant with a club (?) in his left hand, and on the right a woman, perhaps one of Gaṇeśa's wives, Siddhi (success) or Buddhi (intelligence).

Above Gaṇeśa's head is an elaborate arch, containing figures that include the bird Garuḍa (in worship, top centre), and two sea monsters (*makara*), one on each side. Between Garuḍa and the monsters are two snake deities, part animal, part human, which Garuḍa has seized in his

talons. The whole composition is to be found again in the tympanum illustrated in Plate 64, which has a fuller description.

59 This Tantric conception of the dancing Śiva is considerably richer in detail than the comparatively simple depiction of the same subject in Plate 23. It is even further developed in the picture illustrated in Plate 79, where Śiva is shown dancing in the embrace of his śakti.

In this wood-carving of the god in all his forms (viśvarūpa), the multiplication of heads and arms creates a positively whirling effect. There are no less than seventeen heads, in five rows of 1, 3, 3, 5, 5 (from top to bottom), and there are thirty-four arms in three groups (4 in front of the body, 2×5 in the inner circle, and 2×10 in the outer). There are also eight legs, but this is not quite so obvious as each visible leg is merely doubled, making two double pairs. The feet of each outer pair are standing on the back of a bull—Śiva's mount; those of the left inner pair are on a tortoise (kūrma), and those of the inner right are on the head of a kneeling human being, who is Mother Earth. On the belly of the god is a daemonic face with a wide mouth, and hanging from his shoulders almost to his feet is a garland of human heads (muṇḍamālā). The two arms in front of the breast have been broken off; the hands at waist level and those on both sides hold various emblems and small figures of deities. Śiva is wearing a broad necklet and coiled snakes as ornaments in the ears of his main head. Most of his heads are crowned and have a third eye in the forehead, but in the middle of the second row there is a daemonic face without a crown but with bristling hair.

On the outside of the sculpture, to the left and right of the main figure, are creatures from the animal world and from mythology. On each side at the bottom is a snake rearing up, and their bodies go along the top of the lotus plinth and are wound together in the middle. Above these, one on each side, are two rampant, lion-like creatures (vyāla) (which are shown on a larger scale in Plates 62a and b as struts). The small representations of them here are on posts on either side, and on these stands an arch (toraṇa) which rounds off the whole group at the top. In the vertex of this arch is the head of the bird Garuḍa, who holds two snakes in his beak and in his human hands. Below these are sea-monsters with unfurled trunks—the so-called makaras. (For further information about the Makara, see notes to Plate 17.)

60 The plinth is an open lotus flower, and on it stands a bulky round vessel, whose neck is enclosed in a pyramidal canopy that consists of five tapering tiers, one above the other. From the top of the canopy a garland of flowers falls down each of the sloping sides. The body of the vessel is adorned with a ribbon inlaid with what look like pearls; the ends of this hang down on either side at the back of the vessel.

61 The gods Śiva and Pārvatī, here portrayed in their benevolent form, are

standing affectionately together. Pārvatī has her right arm round the neck of her husband, and Śiva's top left arm—to be imagined behind his wife's neck—emerges near her left shoulder. In the left hand he holds a bowl made from a human skull (kapāla). Another hand of this once four-armed god can be seen at his wife's waist (the fourth arm has been broken off at the elbow). They both have their right hands up in front of their breasts, each holding a string of beads. They are standing on a lotus plinth on both sides of which sits a wild goose (haṃsa) facing outwards. There is a cheerful scene on the plinth, containing three small figures. In the centre is Śiva, dancing; here he has five heads and four arms, and is in his guise as Nṛtyeśvara, 'Lord of the Dance' (see Plate 23), accompanied by two drummers who both have four arms. The one on the left, with a trident in his left hand and an hour-glass shaped drum raised in his right, is Śiva's dependant Nandin, usually shown in the form of his mount, the bull, but here given human form. On the other side, Śiva's follower Bhṛṅgin is beating a drum of a somewhat different type (mṛdaṅga). In his top left hand he is also holding a cudgel (khaṭvāṅga). He is to be seen again in Plate 66. In Nepal, Nandin and Bhṛṅgin usually appear as drummers at the sides of entrances to Śiva temples.

The top head of the dancing Śiva is that of an animal—possibly a bull.

62a A Vyāla figure, probably meant to be female, matches the male figure in Plate 62b. The left paw and wings are missing, and other parts are also damaged. There is a pastoral scene between the hind legs of the creature—not clearly visible on the photograph—with two monkeys squatting amongst rocks and plants. The one sitting on the ground has a yak-fruit in his hands, and the smaller one above him is carrying a canopy.

62b The monster is standing on a base decorated with stylised rocks. Between his legs is a tiny monkey, which is holding a three-tiered canopy (chattra) in both its hands, as if to honour the Vyāla and to indicate its rank.

Lion-like monsters of similar form are known to have been used since the early Middle Ages in India, as supports for thrones and on posts serving as columns in temples.

63 On the four sides of the box-like base of this spinning wheel is an undulating border which is interrupted at the corners by crudely-made lions, whose bodies are continued on the adjoining sides; these act as supports for the top of the base which in turn has a relief of Viṣṇu, shown as a four-armed figure, seated on a snake whose heads form a canopy over him. At each end are parts of the spinning apparatus; on the right, the transmission wheel, made up of 18 spokes; instead of a felly this has a 'rim' of cane plaiting, and the hub turns between two blocks which are fastened on to the box itself. The tops of these blocks are decorated with cats' heads, and the hub goes through their open jaws. Below, standing in a kind of

archway, are a man and a woman (perhaps bride and groom) with garlands of flowers round their necks. The handle that moves the hub is decorated with the figure of a snake-prince (*nāgarāja*) standing on a lotus beneath the shelter of an inflated snake's head. The movable parts on the left, through which the thread runs, are decorated with various patterns. A detachable part of the apparatus is a whorl, the end of which is made in the form of a snake-girl.

See M. Lobsiger-Dellenbach, Népal, Catalogue de la Collection d'Ethnographie Népalaise du Musée d'Ethnographie de la Ville de Genève, 1954, Plate V/13 and p. 9 *et seq.*

64 This pediment comes from a Buddhist monastery or shrine. At the bottom of the crossbeam is an inscription in Newari naming a religious community (*guṭhi*—Sanskrit *goṣṭhī*) as donors of the carving.

In the semi-circle directly above the inscription on the base is the three-headed, eight-armed figure of a Bodhisattva called Mañjuśrī, seated in the position of meditation. His three crowned heads, which still bear traces of white colouring, are silhouetted against a circular nimbus, and an aureole completely encloses the figure, which holds out seven of its eight arms like the spokes of a wheel. The eighth arm is holding what may be a sword in front of the right shoulder. In the decorative panel surrounding Mañjuśrī—again bordered by a circle of flames—the bird-god Garuḍa is poised directly above the Bodhisattva, with wings spread wide as if to protect the entrance. He is facing the front, and has the body of an eagle with an almost human face except for the nose, which is like the beak of a bird of prey. He is decorated in human finery, with a crown. Beneath his talons are the curving snake-bodies of two *nāgas*, human from the waist upwards except for their snake-hoods; these are mythical hybrid beings (half-human and half-snake) which occupy a set place in Buddhism as well as in Hinduism. With their human upper bodies the nāgas are straining outwards to try to get away from Garuḍa's claws, while lower down their tails wind round in decorative coils. In each of the two bottom corners of the broad outer frame there is a makara (i.e. fabulous sea-monster), as has already been described in the notes to Plate 17. The large and hideous head has an extended top jaw forming a trunk, and the mouth is open. The body rests on crocodile-like feet, and at the back it merges into a plant decoration.

65 Among the ornamental foliage and scrolls on the mirror's handle are also figures of gods. On the front, where the mirror is convex, these are Viṣṇuite images: Viṣṇu's mount, the bird Garuḍa, mainly in human form, and above him Viṣṇu himself, with his wife Lakṣmī on his left knee, surrounded by an aureole which forms the oval top of the handle and holds the metal disc. The god is four-armed, is wearing a crown, and carrying the attributes of conch, discus, and club. His fourth arm (not visible) is round his wife. Garuḍa has both his arms stretched out in front of his wings, as if in flight. In his talons he is gripping the shoulders of two snake-spirits (nāgas), which have their human bodies (left male and right female) on the front of the handle, while their snake-bodies coil round the handle and intertwine at the back. At the bottom, under a criss-cross pattern of leaves and twigs, stands Kṛṣṇa, blowing his flute and dancing in characteristic fashion, with one foot crossed over the other.

On the back, corresponding to the Viṣṇu-Lakṣmī scene at the top are the gods Śiva and Umā, in the same grouping (umāsahita maheśvara) as in Plate 12 etc. Here too the top of the handle holding the mirror is in the form of an aureole. Beneath the Śiva-Umā group are the entwined bodies of the snake-spirits, and at the bottom, corresponding to the Kṛṣṇa figure, is a girl dancing. Two other girls, in slightly different poses, are on the narrow sides of the handle, so that the flute-playing Kṛṣṇa is accompanied all round the handle by three dancing girls, who are the Gopīs or shepherdesses of Vṛndāvan.

An engraving in Newari on the edge of the concave back of the mirror shows that this is an offering from a barber (named Sikurabhāna) to Ratneśvara, 'Lord of Jewels', in the year 853 of the Nepalese Era, i.e. 1733.

66 Bhṛṅgin is a worshipper and follower of Śiva. There is a small image of him on the bas-relief shown in Plate 61, in which Śiva appears as 'Lord of the Dance'; there he is drumming and dancing as here, but has four arms, whereas in this ivory sculpture he formerly had eight arms, all of which are now missing. Here Bhṛṅgin appears as a frightening figure with a broad daemonic face—bulging eyes, an open mouth with fangs, a third eye in the forehead, and bristling hair. On the lower jaw are tufts of beard that look like strings of pearls. His right leg is tucked up against his body as he dances, and the toes of the left are on a fully-opened lotus flower. On the sole of his right foot is an emblem; from his shoulders falls a broad garland decorated with human skulls. Creeping away in fear from the lotus are the small figures of a man on the left (mostly missing), and a woman on the right. Bhṛṅgin is holding his drum (mṛdaṅga) in front of him, and is wearing an ornamental breast-plate. His high crown, decorated with seven discs, is framed by two rings of flames (jvālāvali).

67 In accordance with the Viṣṇuite contents of the book, the inside of the cover illustrates the incarnations or 'descents' (*avatāra*) of the god Viṣṇu. The wide painting is divided into twelve sections framed by arches and columns. The background is red and the columns blue. The Viṣṇu incarnations are placed within these arches, and beginning in the second arch from the left, they are as follows: (1) fish (green, with four-armed human body and fishtail); (2) tortoise (yellow, in conception similar to 1); (3) boar (grey-black, with animal head and human body); (4) man-lion (red, tearing apart the demon Hiraṇyakaśipu); (5) dwarf (yellow, Brahman boy with sun-shade and water receptacle); (6) Paraśurāma (green, with battle-axe and bow); (7) Rāma (blue, with sword and bow); (8) Balarāma (with club and ploughshare); (9) Buddha (meditating, yellow body, red robe) and (10) Kalkin (green, on horseback, with sword and bow). The two outer arches contain (left) two women—possibly donors—smaller than the Avatāras, each with a lotus in her right hand; and (right) a priest, white-skinned, worshipping a *śālagrāma* (i.e. an egg-shaped Viṣṇuite symbol); behind him stands a noble donor, hands clasped in front of him in worship.

The leaves of the manuscript itself (the text is the 'Viṣṇudharma') are of blue paper with gold lettering. The manuscript is dated the year 340 of the Nepalese era. There is a colophon that says: '(Written) in the year 340, on the eighth of the light half of the (month of) Aśvinī, in the glorious reign of the king of kings, the highest sovereign, the illustrious Abhayamalladeva.' The date is the equivalent of September 19th 1220.

L. Petech, *Mediaeval History of Nepal*, Rome 1958, p. 86, No. 6 (gives colophon of manuscript in Sanskrit).

68 The lid and all sides of the box are covered in paintings. At the front of the box, near the catch, are two figures, both reclining on cushions: on the left a man smelling a flower, and on the right a woman with a bowl (of flowers?) in her lap. Between them is a symmetrical pattern of flowers and leaves, and this decoration continues on all sides of the box, with various other figures in between.

On the steeply-inclined lid, there are religious and mythological themes shown between more plant decorations. In the middle is a blue-skinned four-armed god, sitting in a frontal ascetic pose, surrounded by a red mandorla; he probably belongs to the Viṣṇu circle, but is no longer recognis-able. On each side of him is a yellow-skinned ape offering him a gift. At the back of the gable are a pair of *kinnaras* (long-tailed bird-creatures, with yellow peacock's feet and human bodies)—on the left a male, and on the right a female. Together they are holding up a large jewel (or possibly a flower).

69 These are four leaves with miniatures from a palm-leaf manuscript:

(1) Protective goddess (Mahā)pratisarā (white), on folio 93, front. **Four heads.** Four right hands, holding, from top to bottom: sword (*khaḍga*), arrow (*śara*), thunderbolt (*vajra*), jewel (*maṇi*). Four left hands: axe (*paraśu*), bow (*dhanu*), trident (*triśūla*), sling (*pāśa*).

(2) Dhyāni-Buddha Vairocana (white), on folio 92, back. Hands: gesture of preaching (*dharmacakramudrā*).

(3) Protective goddess (Mahā)śītavatī (green), on folio 89, front. Three heads. Three right hands, from top to bottom: arrow (*śara*), thunderbolt (*vajra*), gesture of protection (*abhayamudrā*). Three left hands: bow (*cāpa*), ensign (*ratnadhvaja*), sling (*pāśa*).

(4) Dhyāni-Buddha Amoghasiddhi (green), on folio 88, back. Right hand: gesture of protection (*abhayamudrā*).

All four figures are seated on lotus blooms above a rectangular plinth, have haloes round their heads, and are enclosed in aureoles.

The manuscript is dated 367 of the Nepalese era. A colophon states: '(Written) on Sunday, the eleventh of the light half of the (month of) Phalguṇa, in the glorious reign of the illustrious king Abhayamalladeva.' The date is the equivalent of February 17th 1247.

The manuscript is written in Newari script (Gomo version) in black ink on palm-leaves, has 131 folios between wooden covers, and in the vacant spaces two eyelets for the string which holds the book together.

L. Petech, *Mediaeval History of Nepal*, Rome 1958, p. 88, No. 15 (has colophon of manuscript in Sanskrit). Durbar Library III, 367.

K. P. Shastri, Catalogue of palm-leaf and selected paper manuscripts belonging to the Durbar Library, Nepal, 2 vols., Calcutta 1905 and 1916.

70a The centre of the composition is the blue-skinned, four-armed god Viṣṇu with his wife, Lakṣmī (white-skinned). They are divided off from the rest of the picture by a lotus socle and an aureole (*prabhāvali*), and the dancing pose of the god would seem to identify him as Kṛṣṇa, with his beloved Rādhā.

On each side of the gods are five incarnations or descents (*avatāra*) of Viṣṇu; each figure is standing against the red background of a mountain with a white top to indicate the snow and ice of the summit. Above the mountains is blue sky with white cranes flying across it. The incarnations, which are comparable with the older images on the book cover shown in Plate 67, are as follows: left, (1) fish (four-armed human body, blue, coming out of the mouth of a white fish); (2) tortoise (four-armed human body, reddish, coming out of the yellow mouth of a brown tortoise); (3) boar (human body, possibly four-armed, with dark-blue boar's head); (4) man-lion (four-armed human body with white lion's head, dancing, tearing apart the demon Hiraṇyakaśipu); (5) dwarf (Brahman boy, two arms, carrying sun-shade and water-container). On the right of the gods: (6) Paraśurāma, Rāma with the Axe (blue, two arms, battle-axe in right

hand); (7) The Raghu Rāma (hero of the Rāmāyaṇa Epic, green, two arms, holding bow and arrow); (8) Balarāma, or Rāma with the Ploughshare (*halabhṛt*, or *halāyudha*, white, two arms, ploughshare in right hand); (9) Buddha (monk in dark red robe, with begging-bowl and possibly pilgrim's staff); (10) Kalkin (future incarnation, warlike hero, green, four arms, with sword and shield, mounted on white horse).

70b As in the cover illustrated in Plate 70a, which belonged to the same (lost) manuscript, the central figures are distinguished by a lotus plinth and an aureole. On each side are four symmetrically arranged figures, and the background is the same as in the cover of Plate 70a. The dark green main figure is a five-headed, twelve-armed Viṣṇu, seated in meditation; under his right knee is the upper body of his mount, the bird Garuḍa who is in human form with red skin, except for a beak and wings. This is a syncretic image of Viṣṇu, as can be seen from the five heads: on the left of the main head is a white lion's head, signifying his incarnation as 'man-lion' (*narasiṃha*); on the right is the yellow head of the god Brahman, which is next to a green boar's head, indicating Viṣṇu's incarnation as a boar. The fifth head is above the main one, and the third eye in the forehead, with a red horizontal stroke, shows that this is the god Śiva. Thus we have Viṣṇu united with Brahman and Śiva, with a simultaneous reference to his third and fourth incarnations as boar and man-lion. Viṣṇu's main right hand is raised protectively in front of his breast, and his left is holding a pot of nectar (*amṛtakalaśa*) on his lap. His other ten arms circle the background. In the right hands, the emblems are predominantly Viṣṇuite—discus, club, lotus, arrow; but amongst those in the left hands are a few that are typical of Śiva: from top to bottom, trident, *vajra*, shell, bow, and flag.

Placed symmetrically on either side of the god, their faces turned towards him, are his two wives Sarasvatī (left), with a book in her top left hand, and Lakṣmī (right), with a flower in the same hand. Both of them have four arms, and are carrying strings of beads in their top right hands. Next to them, in a lunging position and each carrying a sword and a shield, are the four-armed protective deities (with daemonic faces), Victory (*Jaya*) and Conquest (*Vijaya*)—the former green-skinned, the latter blue. On the outside are the smaller figures of royal worshippers kneeling on striped carpets; on the left, two men in everyday clothes (turban, robe, scarf, and belt); on the right, two women, correspondingly dressed in bodice, skirt, and shawl. All four have their hands clasped together in worship.

71 This section of a long roll of pictures, containing 86 individual scenes, depicts the climax of the tale of Viśvantara, the prince 'who gives away everything'. This prince was banished because of his generosity, which threatened the financial security of the state, and withdrew from the world with his wife Madrī, his son Jāli, and his daughter Kṛṣṇājinā, to live in the mountain forests, where they fed on roots and fruit. The seven consecutive

episodes in Plate 71, running from left to right, show how he lives up to his name and gives away his children to a persistent suppliant, an old Brahman.

The following translation of the Newari text (Nos. 46–52) is reproduced by kind permission of Professor S. Lienhard, Stockholm:

(1) Then came the one (God Indra) in Brahman clothing and asked Prince Viśvantara for both (children), the prince Jālini and the princess Kṛṣṇājinī.

(2) When the pious prince Viśvantara saw the one (disguised) in Brahman clothing, he felt pity, and he promised to give (him) the children.

(3) Renouncing all love (for the children), prince Viśvantara gave to the one (disguised) in Brahman clothing both (children), his son and (his) daughter.

(4) While they were crying the one (disguised) in Brahman clothing drew the two children (to him).

(5) The one (disguised) in Brahman clothing bound both, the prince and the princess, to a rope, and took them away with him, while he beat them with a stick and (the children) cried.

(6) After she had picked fruit and flowers, the princess Madrī, (who) wished to give the children (the fruit and flowers), looked round (for them both), and when she could not find the children, she asked prince Viśvantara, who was practising asceticism.

(7) When prince Viśvantara did not answer princess Madrī, she was dismayed; she wept and swooned. Then the prince Viśvantara, by sprinkling (her) with water, brought her to consciousness (again).

The mountainous background to the individual scenes is like that on the manuscript covers in Plates 70a and b, but is more detailed, especially in the richly contrasting colours of the trees, with pink, ochre, dark green, indigo, vermilion, and light blue. Below each scene is the text describing the action, and at the very end of the roll is an inscription concerning the donor, together with the date given in the caption.

72 Pictures of battles, obviously those of the Mahābhārata, but unrelated to the text of the manuscript, which is written in a mixture of Sanskrit and Newari. The pictures are, from the top:

(1) The hero Arjuna, with Kṛṣṇa (blue, four-armed) as his charioteer, in a chariot battle with Kaurava heroes (cf. battles illustrated in Plates 56 and 57).

(2) Collection of gods (including four-headed Brahman and Śiva), with their wives (on higher level). They are watching with horror as a demon tries to drown a warrior.

(3) Two frightening, red-skinned demons fighting warriors in green armour. On the left-hand side are Kṛṣṇa and Balarāma in conversation, recognisable from their attributes and each distinguished by a nimbus.

(4) and (5) A battlefield, on which jackals, crows, and birds of prey are feasting on the fallen. Above lies Bhīṣma on a bed of arrows; two birds on a tree seem to be waiting to set on the dying man, and three armed men are hurrying towards him.

VIII PAINTINGS ON CLOTH AND PAPER

73 We have already met the 'Rich in Treasures' (Vasudhārā) in Plates 32 and 51. Here she is at the centre of a circle or sphere (*maṇḍala*) of deities, heavenly palaces, and symbols of fortune, which are allotted to sections of different geometrical patterns. A wheel consisting of several rings is set in a large square, and within this wide circular section are more squares within squares. At the very centre the goddess, in the same form as in Plates 32 and 51, sits on a raised throne with a high cloth-covered back. Above her is an archway which is painted with makaras and a Garuḍa seizing snakes. Two dependants of the goddess, one red and one green, are seated on lotus leaves, the stems of which grow out of the left and right sides of the plinth. Three other secondary figures are to be seen at the bottom of the plinth. The whole group is enclosed in a flaming, yellow-red aureole. In the area to the left and right of this, there are servant spirits carrying flowers, food, or delicacies in bowls or in their hands, to sprinkle over the goddess. In the border at the top of the aureole sits the Dhyāni-Buddha Ratnasambhava, making the gesture of donation. There are numerous other gods and spirits within the various bands and circles of the picture.

Not reproduced here is a band of small individual scenes, which completely surrounds the picture. At the bottom of this, in the centre, is a female dancer with donors (a married couple) at her sides. These are accompanied by various deities and other donors. Underneath, in 2–3 columns, is the inscription naming the donors and giving the date, which is *samvat* 650=1529-30. In Stella Kramrisch's book *The Art of Nepal*, there are illustrations (Nos. 88 and 92) of maṇḍalas of Vasudhārā dating from around the same time as this Berlin painting. For detailed study it might be rewarding to compare these pictures, as well as another similar painting in London.

74 The central figure of this picture, the four-armed Lokeśvara, completely overshadows the many secondary figures surrounding him. His main hands are placed side by side in front of him in a gesture of worship (*hṛdi sampuṭāñjali*), perhaps in veneration of Amitābha, the Lord of Immeasur-

able Brightness, from whom the Bodhisattva emanated and in whose western paradise he now is. In his right side hand he is holding two strings of beads, and in his left a lotus. Lokeśvara is facing the front and sitting on a huge lotus, in the position of meditation (*vajraparyaṅka*, or *dhyānāsana*). The same figure with corresponding gestures and attributes is repeated three times, though on a smaller scale and in a kneeling position facing sideways. Two of these small Lokeśvaras are on the left and right of the lotus, each accompanied by two female servants, one of whom is carrying a canopy with fluttering bands and decorations. Below the little Lokeśvara on the left is a half-figure of the four-headed god Brahman in worship, while on the right there is a half-figure of Viṣṇu, to be identified by the conch in his hands. The third miniature Lokeśvara is in the left-hand corner of a paradisal pool immediately below the great lotus. Opposite this figure, on the right hand side, is a Tārā image. The pool is enclosed by a high wall with a door in the centre, and together with the wall and trees in front, it is floating on clouds. Below are the swirling waters of the ocean (*mahāsāgara*), crossed by two very narrow bridges, one on each side, each bearing two human beings who are making the difficult journey to the realms of bliss, where Lokeśvara sits, enthroned before his many-storeyed temple or palace. At the very top of the palace is the tiny figure of the Dhyāni-Buddha Amitābha in meditation, with a begging-bowl in his lap (cf. Plate 77). The secondary figures not yet mentioned include Vajrasattva (top left) holding a *vajra* in his raised right hand, and (right) a seven-eyed (*saptalocanā*) Tārā with a flower-stem in her left hand. There is one more green Tārā image lower down at the very bottom of the picture, in the centre. Concerning the main figure, see Plate 39.

75 The crowned Buddha is making the gesture of 'touching the earth', and is seated in the position of meditation known as 'firm as a diamond' (*vajrāsana*). Gesture and attitude are equally characteristic of the historic Buddha Śākyamuni (Plate 37) and his earthly predecessors, and of the Dhyāni-Buddha Akṣobhya, 'the Unshakable' (Plate 38). This picture must be an image of Śākyamuni or one of the other Mānuṣi Buddhas (see p. 29), as the figure has a vermilion skin and a carmine patchwork robe, and as Akṣobhya ought to have a blue skin. The Buddha is squatting in front of a cushion which is placed before a throne, and is set in a niche formed by an arch resting on pillars; the arch is decorated on both sides with the makara motif (see Plate 17) and, at the top, with a Stūpa. Left and right, next to each pillar, stands a Bodhisattva; the one on the left may be the Bodhisattva Maitreya (blue-green, with a fly-whisk in his right hand and a nāgakeśara flower in his left), and on the right the Bodhisattva Avalokiteśvara (light-skinned, carrying a fly-whisk and a lotus flower). Above each of the Bodhisattvas are two Stūpas placed one above the other. Next to each of the top Stūpas is a god floating on a lotus throne: to the right, Candra the Moon-God (white, on a wild goose), and to the left, Āditya the Sun-God

151

(red, on a horse). At the very top are the five Dhyāni-Buddhas, from left to right: Ratnasaṃbhava (yellow, gesture of donation), Akṣobhya (blue, gesture of touching the earth), Vairocana (white, gesture of preaching), Amitābha (red, gesture of meditation), and Amoghasiddhi (green, gesture of protection). Like the Dhyāni-Buddhas in the miniatures illustrated in Plate 69, all five are dressed in royal garb. At the bottom of the picture, beneath the two-lined inscription of donation, are a pair of donors together with four members of their family; in the centre is a figure that is difficult to identify but may be the god Brahman, four-headed, at the altar; and on the right are various other members of the donors' family.

76 The central subject of this picture is a Buddhist shrine, a Caitya or Stūpa, with the goddess Uṣṇīṣavijayā inside it, and the other deities above and to the left and right. The scenes that are depicted in the two rows of pictures below are, however, essential to the understanding of the over-all composition. In the upper of these two rows, there is a family feast as is held for a man when he reaches the age of 77 years, 7 months, 7 days, and 7 hours, or a woman of 66 years, 6 months, 6 days, and 6 hours. On such an occasion the whole family assembles together, and after certain religious rites (see right hand side of the upper row), there is a big procession, headed by the younger members of the family. Amid much excitement they all pass with the 'guest of honour' beneath a shower of blossoms (*puṣpavṛṣṭi*) (see left hand side of same row). At the bottom of the picture there are some members of the family who act as donors—left, four men near a priest clad in white; right, five women, all kneeling in worship. In the middle is the image of a bearded saint, made conspicuous by a halo of flowers.

As a memento of such a family feast, it was usual to commission the painting of a deity chosen by the person whose jubilee it was. It had to recall both the celebration itself, and the participation of the Buddhas and gods in the joyful event. This is shown here by the fact that the goddess seated in the Stūpa is accompanied by numerous other deities. At the very top of the picture are the five Dhyāni-Buddhas floating on clouds, and there are also a number of deities from the Tantric Pantheon, including female figures and even four terrible, daemonic guardian spirits, such as the Thunderbolt-bearer (*Vajrapāṇi*), in golden-yellow, dark blue, red, and green. Some deceased members of the family, squatting on clouds, are also included—they are very small and can be seen at the end of the garland of flowers hanging down from the top of the Stūpa.

The Stūpa in the centre of the picture stands on a lotus that grows out of a pool, and it is to be assumed that the shrine is in fact floating in the air. On the plinth is a red, eight-armed figure, with a śakti on his left knee. Within the dome of the Stūpa one can see the very popular goddess Uṣṇīṣavijayā, who is an emanation of the Dhyāni-Buddha Vairocana. In the texts she is called the one who is 'placed in a hollow within a Caitya' (*caitya-guhāgarbhasthitā*), and is described as white, three-headed, three-eyed,

eight-armed, and youthful (*śuklā trimukhā trinetrā navayauvanā aṣṭabhujā*). Two maidservants with fly-whisks are squatting on either side of her. At the top of the Stūpa is a thirteen-storeyed tower crowned with a canopy, and garlands of flowers hang from the tip.

77 The composition of the picture is similar to that in Plate 74. In both the scene is Sukhāvatī, the paradise of the west. Here, however, the central figure is not Lokeśvara but Amitābha ('of immeasurable brightness'), who was to be seen in Plate 74 as a small figure at the top of the temple or palace. Once again he has the begging-bowl in both hands on his lap. Lokeśvara, Amitābha's emanation, is also shown on this picture, standing at the bottom in the middle, with eleven heads and eight arms (*ekadaśamukha lokeśvara*, cf. Plate 45). On either side of him kneels a monk with a begging-bowl, and next to the monks are the tiny figures of a male and a female donor.

 The many-storeyed temple in which Amitābha sits on his lotus plinth is more towards the foreground than it was in the previous picture, and the walls enclosing this paradisal region are to be seen at the very bottom, left and right. Only a very small part of the pool is shown, and behind it is the platform on which Lokeśvara stands with the same secondary figures as in Plate 74. To the right and left of Amitābha's lotus-throne at the edge of the picture are two pairs of small figures arranged in symmetrical order, one above the other, and it may be assumed that these are Bodhisattvas or Siddhas (those who have reached perfection and are versed in magic). At the top of the temple sits Vajradhara, 'The Thunderbolt-Bearer', embraced by his śakti. To his right, floating on the clouds, is the embodiment of transcendental wisdom, Prajñāpāramitā, four-armed, and identifiable from the book held in his top left hand. On the other side is a four-armed Bodhisattva personifying the Buddhist community. Thus the top row symbolises the trinity of Buddha (centre), Teaching (left) and Community (right).

 Beneath the painting is an inscription in Newari giving its date as 943 of the Nepalese Era=1823. A certain Kulavanta Siṃha Tuladhara, probably a merchant, had the picture painted in commemoration of a fast which he undertook after a journey to Lhasa.

78 Vajravārāhī, the śakti of Saṃvara (see Plate 81), is described by the relevant texts as being red as the blossom of the pomegranate, one-headed, two-armed, three-eyed, with loose hair, naked, filled with the five-fold knowledge, and embodying incomparable pleasure.

 This picture shows her as a woman hung with ornaments and dancing, and she seems to express a voluptuous cruelty. She stands with her left leg on a naked human figure cowering down on a lotus flower, and has her right leg tucked up in a dancing position (*pratyālīḍha-tāṇḍava*). In her left hand she is holding up a dish made from a human skull, and in her raised right

hand she has a razor (*vajrakartri*) merging into a thunderbolt. Her left arm is round a long thin staff, a varied form of the club with thunderbolt and skulls (*karota-khatvāṅga*). A green shawl with a white lining flows round her shoulders. The small boar's head sticking out from behind her right ear is a play on her name 'Diamond-Pig' (*vajravārāhī*). It should be noted that the liberal supply of white chains and bands round her head, neck, breasts, arms, and body are made of human bones, and there is no mistaking the little skulls on her headdress and on the garland falling from her shoulders to her thighs. According to one text she should in fact be attired in a garland of freshly cut, dripping human heads, and drinking their blood.

The whole apparition is enclosed in a mandorla of angry flames. In the blue sky above, one can see the sun and moon, and the green below represents water.

On Vajravārāhī cf. R. O. Meisezahl, *Oriens* 18/19, 1967, pp. 228–303.

79 The dark red of the mandorla behind the main figures of Śiva dancing with his śakti Durgā is the dominant colour of this highly animated and impressive picture. There is a similar image of the Nṛtyeśvara with 17 heads and 34 arms, though without the śakti, in the wood-carving in Plate 59. In this picture, however, the god is painted white, and the number of his heads is limited to five and his arms to twenty, ten on either side. Three of the secondary heads are at the sides of the white main face—two on the left and one on the right—and these four heads are joined together beneath a many-sided crown. Instead of the hair one would expect above the crown, there is a phallus (*liṅga*), which together with the heads suggests a *caturmukha-liṅga*. The left of the liṅga is decorated with a tiny crescent moon, the right with a skull, both next to snakes. Above is a fifth head, again coloured white, and all the faces have a third eye in the forehead.

The gods are dancing between their winged mounts: on the left, at their feet, is Nandin the bull in red, and on the right Durgā's lion, coloured white. The pedestal on which they are dancing is decorated with five human heads, and it stands on a multicoloured lotus. Round Śiva's shin is a chain hung with more human heads, and fitting in with this mood is a decapitated woman (*chinnamastakā*) standing in the right hand corner near the white lion, offering her head to the gods. All round the edge of the mandorla is what looks rather like a string of pearls, but is in fact made up of skulls, and round the waist of the naked goddess are pearls and pendants made of human bones, similar to the ornaments described in Plate 41.

In the lower corners of the mandorla are the tiny figures of four animal-headed creatures, and these are Crowhead, Owlhead, Pighead, and Doghead.

In the panels above, below, and at the sides of the central picture are numerous deities. Briefly, these are as follows: at the top, Śiva in five different guises, each time with a śakti on his left thigh; most of the figures in the bands to the left and right of the picture are female, dancing or

making other animated movements, and probably include the śaktis of different Hindu deities, grouped together as 'Mothers' (*mātṛkā*)—top right, for instance, one can see Vārāhī, with a pig's head. (See the description of Plate 31.) In the bottom row are Śiva's sons Kārttikeya and the elephant-headed Gaṇeśa.

An inscription in Sanskrit and Newari along the bottom edge of the picture names King Jayapratāpamalla, a king well-versed in the arts and sciences, as having commissioned this painting of Śiva in all forms (*viśvarūpa*) in the year 779 of the Nepalese Era=1659.

80　The buffalo-headed Saṃvara is invoked and worshipped in Nepal as a god of protection against enemies. His image in this picture corresponds almost exactly with the description given by A. Grünwedel in his *Mythologie des Buddhismus*, Leipzig 1900, p. 102, from the Vajrabhairavatantra for the god Vajrabhairava or Yamāntaka. This runs as follows: 'The figure is given sixteen feet, thirty-four hands, nine heads; (it is) naked, black in colour, the feet astride, the appearance more than frightening, the Liṅga erect . . . The first head (is) that of a bull, and there are three faces next to the right horn: one blue, one red, one yellow, all dreadfully wrathful; next to the left horn, one white, one grey, and one black. Between the two horns . . . a terrible red one . . . the right hands (hold) the knife Gri-gug, a pointed weapon, a pestle, a knife, a thunderbolt-dagger, an axe, a conch . . . an arrow, an iron hook, a sling-stone, the club Khaṭvāṅga, a wheel, a thunderbolt, a stone hammer, a sword, the drum Ḍamaru. The left hands (hold) a skull, a head, a shield, a leg, a snare, a bow, (together with) entrails, a bell, a hand, shrouds from a graveyard, a man impaled on a spear, a stove, a piece of skull, a warning finger, a trident with pennants, cloth whipped by the wind; two hands hold a freshly-killed elephant's skin. Beneath the feet on the right (lie) a man, a bull, an elephant, an ass, a camel, a dog, a sheep, a fox; below those on the left, a hawk, an owl, a raven, a parakeet, a falcon, a peacock, a coot, and a swan.'

Although the number of heads is the same in the painting as is mentioned in the text, the distribution of them, in three rows of three, is somewhat different. Three of the daemonic heads are enclosed within the buffalo-horns. Of the god's thirty-four arms, six are in an inner circle close to his body, and these three pairs of hands are holding the attributes named first in the text, including the thunderbolt-dagger and the skull in the right and left hands in front of the breast. The inner left hands below are holding not one head, as mentioned in the text, but three, dangling from their hair. The top inner hand holds the shield. The continuation, with the torn-off leg and the snare, begins at the top of the outer circle of arms. Towards the middle one can see the man impaled on a spear and, at the bottom, one of the two hands with the freshly-killed elephant's skin—here represented by an elephant's leg—another leg being held in a corresponding hand on the opposite side. One individual feature is the composition of sixteen legs,

which are brought together in two pairs, each consisting of four legs and feet. The sixteen feet can best be counted by the conspicuous claws on the toes; these are set in four groups of four times five claws. Cowering at the feet of the god are the human beings and animals mentioned in the text, together with a row of crowned gods, thus showing that the worlds of gods, men, and animals all lie at the feet of the guardian god and bow to his might.

The background to the main figure is formed by a mandorla of burning flames, and beyond this is a kind of frame containing forty-eight small daemonic figures. Forty of these are also Mahiṣasaṃvaras, with one head and two arms, that stand on the prostrate figures of naked human corpses. Amongst them are occasional figures with crows' or owls' heads (*kākāsya* or *ulūkāsya*)—for instance the outside figures at the very top and bottom.

81 This image of the Buddhist guardian god Mahāsaṃvara — 'The Great Defender' (cf. the buffalo-headed 'Defender' in Plate 80) reaches a peak, as far as the number of heads and arms is concerned. There are 17 heads in five rows (4, 4, 4, 4, 1), larger at the bottom and smaller at the top. The main head of the four in each row faces the front, and is blue on the right and green on the left; the heads on the blue side are yellow, and the pairs of heads on the green side are blue-green and red. All the faces are daemonic, i.e. square-shaped, with three bulging eyes, heavy eyebrows, gaping mouth, and fangs. The colour division of the main faces is continued all the way down the body as far as the testicles, the right half being blue, the left half green. It is very difficult actually to count the number of arms growing out of the god. On each side he has two sets of 17 and 18 arms—i.e. $2 \times 35 = 70$ arms, and there are also four main arms, making 74 in all. In these four arms Saṃvara is holding his śakti Vajravārāhī (see Plate 78), who is sitting with her legs round his waist in a 'position of high pleasure' (*mahāsukhāsana*). In the hands supporting her back, he is holding the attributes of thunderbolt (*vajra*) and thunderbolt-bell (*vajraghaṇṭā*). There are many other emblems, of which the elephant-skin in the top outer hands is especially noteworthy; corresponding to it is a tiger-skin in the top hands of the śakti. Each of Mahāsaṃvara's feet has six toes, and he stands with legs astride in the 'lunging' position (*ālīḍha*).

Vajravārāhī's body is red in colour, and she is naked. She has two main arms, which are round Mahāsaṃvara's neck, and twelve side arms. (The girdle round her waist and her other adornments have already been described in the notes to Plate 78.) Mahāsaṃvara has two ornamental chains, one with dangling human skulls, and the other with heads. He is standing with his right foot on the goddess Cāmuṇḍā (see Plate 28) who is literally as thin as a skeleton, and with his left on the god Bhairava—two Hindu gods to whom Saṃvara is thus shown to be superior. The plinth is in the form of a lotus flower in water. The whole scene is set against a background of graveyards, four on either side, conventionally portrayed: the features of a

graveyard are, amongst other things, snakes, jackals, 'hunger-ghosts' (*preta*), a Liṅga, and a Stūpa.

82 At the top of the picture is the King of the Gods, Indra, in garb and appearance scarcely distinguishable from an earthly prince. He is seated on a high-backed throne with ornate feet and a canopy that is attached to the back. The scene is a green meadow containing many plants all set at regular intervals. Indra, the 'Thousand-Eyed' (*sahasranetra*), can be identified by the eyes that cover his whole body (including his clothes). His 'court' consists of six men who, like himself, are crowned and adorned with garlands of flowers, and are close to the throne. The two at the front are waving fly-whisks, one made of white yak's hair, the other of peacock-feathers. A third is carrying a round, long-handled Indian fan, and a fourth a water-pot (*kalaśa*). These are followed by two more men carrying fly-whisks of the same kind as the first, though with rather less animation. Indra and the lords of his court are wearing 18th-century royal costume, derived from the Muslim fashion. The frock coat is fastened at the left shoulder, reaches to the feet, and is made of transparent muslin, with long sleeves and a sash round the waist. They are all looking towards the right, where a young girl-dancer is performing at the head of a group of ten female musicians. It can be assumed that these women represent the alluringly beautiful heavenly nymphs (*apsaras*) entertaining their king, Indra. The little dancer, who wears a garland of flowers to distinguish her from the others, has her arms spread wide and appears to be spinning round in the dance. Amongst the instruments of the musicians, one can see a drum, cymbals, and three stringed instruments. Other women are clapping their hands or carrying different objects, and one of them is waving a fan.

In the lower section of the picture, against the same background except that the colouring is slightly more vivid, are three gods. It is not altogether clear whether or not they are attending the scene depicted above. First is the elephant-headed Gaṇeśa, riding on his mount, a huge long-tailed rat. In his two right hands he is holding a string of beads (top) and a radish (*mūlaka*), and the two left hands hold a battle-axe and a bowl of buns. Next comes the god Śiva, white-skinned and four-armed, on a pink bull with garlands of flowers round its chest and hump. In his top right hand the god is holding the hourglass-shaped drum (*ḍamaru*), while the bottom hand is making a significant gesture, and the left hands hold the trident (*triśūla*) and a water-pot (*kalaśa*). He is three-eyed, has a snake over his breast, and—as an indication of his powers of destruction—a garland of heads (*muṇḍamālā*). He is followed by his wife Pārvatī. She has green skin and is riding quietly on a white lion with wide-open jaws showing its red tongue. It has a thick red mane and a tuft of red on the end of its tail. There is a suggestion of wings on the front and back legs.

6—N

Bibliographical Note

Nepal Bibliography—a comprehensive work by Hugh B. Wood, The American Nepal Education Foundation, Eugene, Oregon, 1959.

An extensive and well-arranged bibliography, mainly dealing with the geography of the country, is included in *Nepal, A Cultural and Physical Geography* by Pradyumna P. Karan with the collaboration of William M. Jenkins, Lexington 1960.

More information on the religious side can be found in the bibliography of *Buddhist Himalaya, Travels and Studies in quest of the origins and nature of Tibetan Religion* by D. L. Snellgrove, Oxford 1957.

Mainly concerned with history and art history are the bibliographies of the exhibition catalogues *The Art of Nepal* by Stella Kramrisch, The Asia Society, Inc., 1964, and *Nepalese Art* by Ramesh J. Thapa and N. R. Banerjee for the exhibition given in Europe by the Department of Archaeology, His Majesty's Government of Nepal, 1966.

Of especial importance for iconography are:

B. Bhattacharya, *The Indian Buddhist Iconography*, 1st Ed. 1924, 2nd Ed. Calcutta 1958.
Sādhanamālā (by the same author), two volumes, Gaekwar's Oriental Series, Baroda 1925, 1928.
J. N. Banerjee, *The Development of Hindu Iconography*, Calcutta 1956.

The history of Nepal or of individual periods is dealt with in:

Ancient Nepal, Medieval Nepal, Parts I, II, III, and *Modern Nepal*, by D. R. Regmi, Calcutta 1960, 1961, 1965–1966.
Mediaeval History of Nepal by L. Petech, Rome 1958.
Nepalese Inscriptions in Gupta Characters by R. Gnoli, Rome 1956.
Nepal and the East India Company by B. D. Sanwal, Asia Publishing House, Bombay, Calcutta, London, New York 1965.

Details given in this book about the 'Pagoda Style' are based on Percy Brown's *Indian Architecture* (*Buddhist and Hindu Periods*), reprinted Bombay 1965.